Publisher's Acknowledgements
Special thanks are due to the
Nicole Klagsbrun Gallery, New
York, and Galerie **Micheline
Szwajcer**, Antwerp. We would also
like to thank the following authors
and publishers for their kind
permission to reprint texts:
Documents, New York; Estate of
Esther Calvino, Castiglione della
Pescaia; **Kala Press**, London;
Miwon Kwon; **Helen Molesworth**;
**Museum van Hedendaagse
Kunst**, Ghent; **Michael Taussig**;
West End Press, Albuquerque, and
the following for lending
reproductions: **Art Front Gallery**,
Tokyo; **Bart de Baere**, Museum van
Hedendaagse Kunst, Ghent;
Melvin Edwards; **Bernard Jazzar**,
Franklin Mint Collection,
Pennsylvania; **Fridericianum
Museum**, Kassel; **Claude Gosselin**,
Centre international d'art
contemporain, Montreal; **David
Hammons**; **Marian Goodman
Gallery**, New York; **Institute of
Contemporary Arts**, London;
Robin Klassnik, Matt's Gallery,
London; **Lucy Lippard**; **Orchard
Gallery**, Derry; **Juan Sanchez**; and
Jack Tilton Gallery, New York; and
Fred Wilson. Photographers: **Dirk
Bleicker, Philippe de Gobert, Jim
Dow, Cal Kowal, Benjamin Katz,
Morris Lane, Guy L'Heureux,
Dona Ann McAdams, Tatsuhiko
Nakagawa, Sue Ormerod, Rory
Poland, Dirk Pauwels, Adam
Reich** and **Fred Scruton**. Special
thanks are due to Kate Bush,
Claire Doherty, Jean Paul Jacquet,
and Clare Manchester for their
assistance.

Artist's Acknowledgements
It is good to have here a (spatial)
moment to express heartfelt
gratitude to Iwona Blazwick, who
conceived of this book and then
saw it through to finish with
several frustrations along the
way.

Iwona's co-workers, Gilda
Williams and Clare Stent, were
also constant and ready with
generous help.

The entire staff at Phaidon, Stuart
Smith, who has done such a
beautiful and thoughtful job, the
not-often-seen accountants and
everyone else, have my sincere
thanks.

Nicole Klagsbrun and two friends
who work with her, Sandra
Gillespie and Ruth Phaneuf
deserve praise and gratitude for
a great many solved problems.

All works are in private collections
unless otherwise stated.
Captions retain spelling of
original artworks.

cover, **Self-Portrait** (detail)
1987
Canvas, wood, paint, feather,
shell, turquoise, metal
172.8 x 86.4 x 28.8 cm

backcover, **Untitled** (detail)
1992
Acrylic on canvas, plywood
78 × 82.8 cm
Collection, Franklin Mint,
Pennsylvania

page 4, **Manhattan Festival of the
Dead (Store)** (detail)
1982
Skull, wood, leather, paint, cloth,
glass
24 × 84 × 13 cm

page 6, **Maria Thereza Alves**
Untitled
1984
Color photograph

page 32, **Savagism and You**
1993
Wood, glass, metal, plastic, fabric
Approx. 24-48 × 9.6-16.8 cm
Elements from performance

page 76, **Small Action Painting**
1992
Paint, dirt, on paper
49.2 × 48 cm

page 90, **Untitled**
1992
Acrylic on canvas, plywood
78 × 82.8 cm
Collection, Franklin Mint,
Pennsylvania

page 148, **Self-Portrait
Pretending to be Rosa Levy**
1994
Pencil, acrylic paint, color
photograph
48.6 × 39 cm

Laura Mulvey Dirk Snauwaert Mark Alice Durant

Jimmie Durham

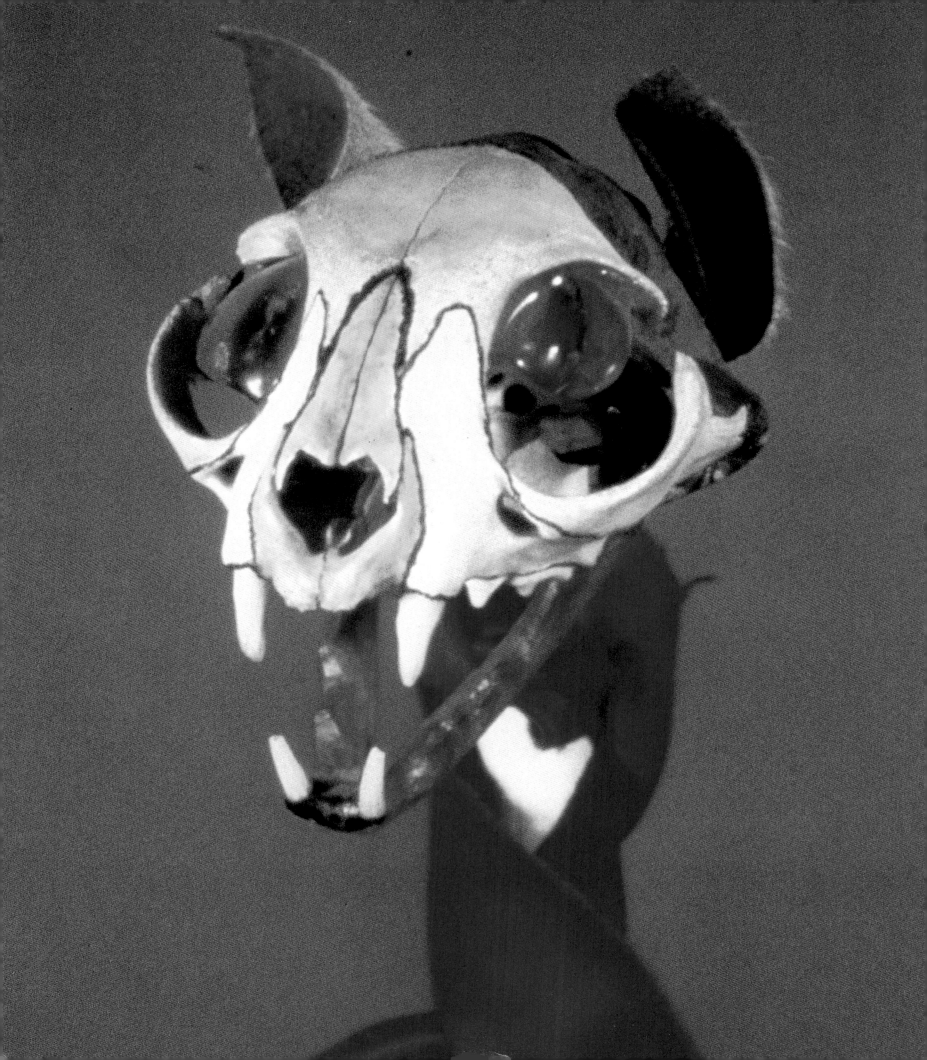

Contents

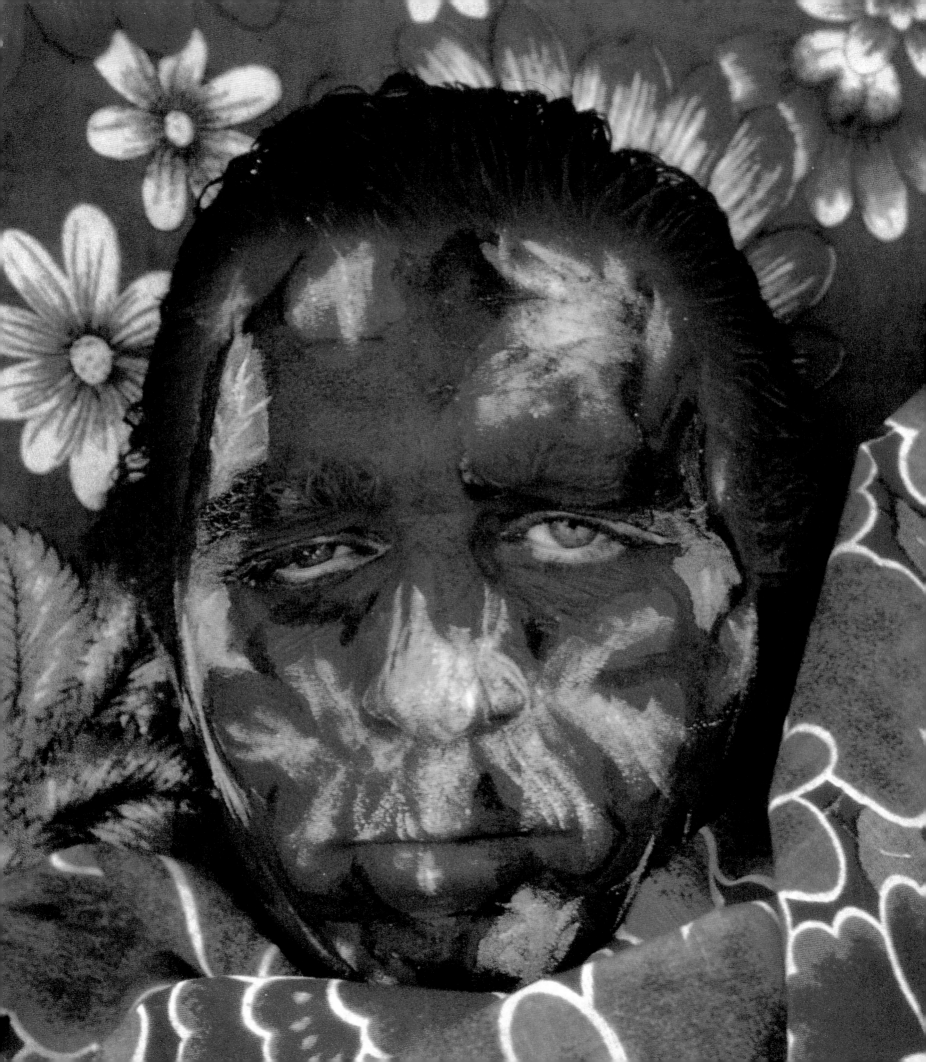

Contents

Dirk Snauwaert in conversation with **Jimmie Durham**

Dirk Snauwaert You worked as an artist before you decided to become an activist, and then you went back to art again. Art and activism are strangely intertwined in the work of several artists from the late 1970s and 80s. Do you think that your work as an artist gave you a different point of view on activism, and vice versa?

Untitled
1970
Drill, feathers, enamel paint,
pencil
43.2 × 28.8 × 7.2 cm

Jimmie Durham **Of course it must be true, but I never thought of it. People usually assume that I began as a political activist and then went into art. And if not, people often kind of assume that since I was a political activist, that that must be more legitimate for me, that it's more authentic for me in some way and that art is the same struggle with different weapons. The assumption is that there is a difference in working, but it's not so different, actually. I don't think it comes from something obvious like racism, but if you're looking at a European or a white American or white South African or something, who had a similar history as a political activist and artist, I think the assumption would always be the opposite: that this artist had a political situation confront him or her and had to react, which is the case of Athol Fugard, the South African playwright. He was just a playwright, but he was from South Africa so he was confronted by a situation he could not deny. And everyone understood that that was true. Everyone said immediately that his first job was artist, his second job was political activist. With me the assumption is that I began as a political activist and then chose art when the struggle failed. In New York and certainly in Europe, people have been surprised that I am a serious artist, that my art does not stop at the boundaries of identity struggles.**

Snauwaert But then in your 'pre-history', let's call it, were you already consciously working as a critical artist? And was this level of consciousness later transposed, transferred to a political activity that you further developed?

Durham **Even now I often have to defend myself from accusations by my own crowd, politically active Indian people of being an artist first and a political activist second and I have had to defend that and say it's legitimate. When I went to Pine Ridge, to Wounded Knee, I went straight from Geneva and put myself in the American Indian Movement just as a worker, not as a big shot, and stayed completely submerged in the organization for a long, long time. I was in a very privileged position that other Indians didn't have. It was not that I was smarter, it was that I had a privileged position to learn things. So I came back to Pine Ridge, throwing myself into the struggle right there on the reservation but with already a great deal of mental space that was allowed to me by that privilege of having lived in Geneva. Before going to Geneva I was pretty typical in that I wasn't educated. There is always a tendency to be a kind of criminal as a way to get by, as a way to do this, as a way to do that. I was rough, a stupid kid. I was a typical Indian in that sense, but because of meeting different people I was an artist. I was not a good artist, but I wasn't a horrible artist. I was not a completely dishonest artist, I was never an artist with the idea of doing art as a way of representing some Indian-ness for sale. Not once. I had a mixed up idea that it was a way to make some money, but certainly not very much money; not as much as I could make driving a truck, not as much as I could make as a carpenter. You had more freedom as an artist, more time to yourself, so you could take a cut in pay, that's the way I thought of it. I tried to see what sort of art could work, what art could do,**

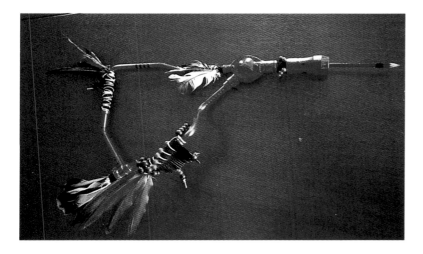

but with no vocabulary, no discourse, no education, so I was groping in the dark, but I wasn't pretending that it was a beautiful twilight. I had my own something as an artist, as an Indian who was an artist. The leadership of the American Indian Movement as a group were like me, rough, uneducated, doing whatever job came along. For many people in the American Indian Movement, the destruction of the movement was the destruction of the person. This is what I have seen over and over in generations of Indians on reservations. The destruction of the plan of that moment is the destruction of the person, you can't see another way, you can't see anything else that could happen. And you make your personhood from that thing. It's not so easy for an artist to make a person, to make personhood, it's not the thing they want.

Snauwaert We have this very vague notion that art is like the last 'free space', a podium where you can still do things without having to legitimize yourself continuously, a kind of temporary, autonomous zone. Is there anything like this 'free space' in the Indian community, or does the artist have a different position?

Durham **People often ask me a silly version of your question, people say, what do Indians think of your work? And the answer is, Indians love my work, because they don't look at it *(laughs)*, they have no use for it. They have use for me being successful, so they can say, 'oh, isn't that pretty or weird', or, 'look, Jimmie's in New York, he's getting a big art show'. But to function as an artist on an Indian reservation is not a possibility at all. There is no art discourse there; what would be my function there?**

Snauwaert You saw art world things in the 1960s-70s?

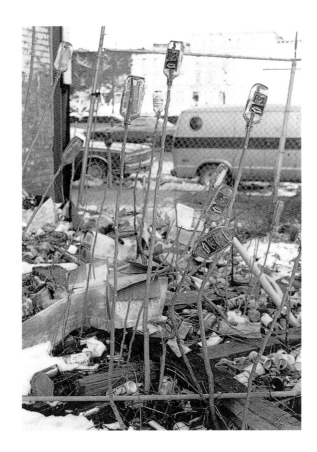

Durham **Practically not. I think I started doing artwork in '63, I started showing in about '63, '64 in Houston, Texas. I didn't really know much in the 60s, even in the '70s. In, maybe it was '67 or so, I saw a bunch of work in Houston, Texas, by Oldenburg, and I was very excited by it. It was the giant soft fan and those works. But I think that is the only art show that I went to and that was by accident. And I had vaguely seen, in the 60s, photos of Duchamp's work. I had seen some Picasso, I don't know where, it's just there in the world. I was operating from pages filled with misinformation, filled with stupidity, my own defensiveness. When I look back at my history, well, yes, I was part of things, in the way that I was in New York in the 80s. I was part of a Lower East Side art scene, but very much from places like Kenkeleba Gallery, which was for minority artists. When I first met Haim Steinbach we were talking about how we were in New York at the same time in the early 80s and we were both showing on the Lower East Side, and he was trying to figure out where I was and I wasn't anyplace that he had heard of. It was a completely different world, at the very same time and place, we were just further east and further down on the Lower East Side. And just in Kenkeleba Gallery, for example, David Hammons and I, and Fred Wilson and other people showed maybe every couple of months, but it wasn't really seen as part of the art scene by the critics. Things were more complex, more simplistically complex for me, I think.**

** I was making things. Some people said, that's art, you should put it in a gallery – that was in '63. I didn't know where a gallery might be. There was a**

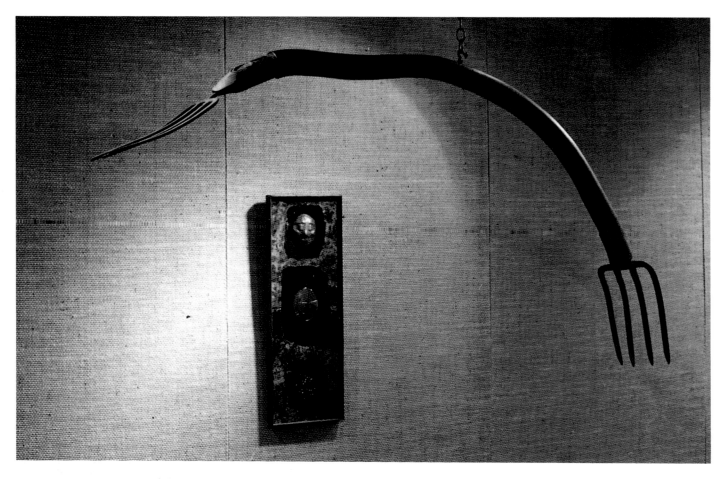

above, **Untitled**
1965
Pecan root, iron chain
210 × 15 cm diam.
below, **Untitled**
1965
Tin, mirror, acrylic paint, wood,
leather
86.5 × 29 × 7.2 cm

gallery in the shopping mall, I went there and said, would you take some of my things to sell, and she did and she sold them. And I said, yes, I'm an artist, I like this art business. I can make things and get money. Little pieces of money, $200, $300, for what basically were tchatchkas, little decorative things that would sit around your house to collect dust. But at the same time I was trying to do something, I was trying to make sense of something, I was trying to see if I could investigate certain things with objects, with doing things with materials. And I didn't know that that was an art project, it was just my own personal project. Then I had a solo show at the University of Texas in Austin, maybe it was '66 or '67. I tried to get people to experience the work differently, so there was one set of objects that I made that were not to be looked at at all, and I would take a small group into a private room and blindfold them and they had to feel the objects instead of looking at them. They never got to see what they looked like. It was the only thing I could think to do at the time, an eccentric little piece of nothing. And I didn't even know why I was even trying to think to do it, I didn't have an articulate reason for doing such a thing. But I didn't connect all of that with some project to be an artist. Then much later, when I went to art school in Geneva, I learned that you could be more serious, that you could try to use art as a serious something in life. That it wasn't about making things to make money and you didn't have to do little tricks like blindfolding people, that it was some serious undertaking worth your while. But there never was a point when I made a decision, unless it was in the 80s; maybe that was when I decided to be an artist, much later.

Untitled
1971
Beech wood, glass eyes, leather,
metal buckle
130 × 10 cm diam.

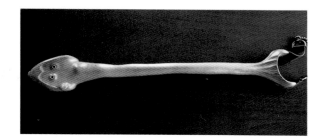

Snauwaert But when you were living in Geneva, what were the influences that affected you, and what did you reject? That was the heyday of post Minimalist and Conceptual art, the politicization of art. Did the art school you went to follow what was happening in other academies, where disciplines were being merged together, playing around with the art -is-life idea, and considering any part of human life as a part not only of art practice but of political practice? Or the very provocative fluxus actions going on then; were you aware of those things?

Durham I was in Geneva '68 to '73 and it was as though it was not that time. There was a whole lot of free love, but we hardly knew there was an art world outside of Geneva. I knew some people from Geneva, having met them in Texas; that was my way of choosing Geneva. I wanted to be in Europe, I wanted to leave the Americas, but I really was not educated and it made me stupidly defensive. I wasn't even very young by that time, I was in my late twenties, early thirties, not young enough that I could excuse myself very well. I kind of vaguely knew that there were art magazines, but I'd never seen one in my life until let's say 1980. So Geneva was isolated, but no matter how much you try, the world creeps in. The art school was in trouble, it had no

Street performance, Geneva
1971

Untitled
1970
Red and grey granite
12 × 57.6 cm

Untitled
1972
Oak, iron nails, sheet iron
115 × 41 × 36 cm

vision. There were some good teachers, but there was absolutely no idea of what they might be teaching, or why they might be teaching it. I had one teacher and one class for four years. I wrote a very long, long paper which I researched for four years. It was a comparison of Swiss masks and American Indian masks from a socio-political point of view of doing things originally for yourselves and then for tourists. And then it also became a paper about what folk art might be, the idea of folk art and where we get it. In fact it's a very recent invention. I went to all the Alpine villages and I was a real anthropologist. But, aside from doing that paper, my teacher tried to teach me that art is a serious endeavour, but there is no politics. He was Lithuanian, very cynical about any political involvement in the world. He was a classical artist; I go to my studio and I paint my pictures, and the world can go fuck itself. I felt safe with him in a certain way. We started a group, four of us, a French woman, me and two Spanish guys. Our group had the idea of making art and presenting art in ways that were not within the very restrictive little Geneva bounds, which was all we knew: the gallery, the museum and the pretty object. So the world had to have been telling us to do that, especially me. But let me add complexities to it, because it's all so eccentric, that's the problem. In Texas, before having gone to Geneva I was reading John Berger. I had read what I took to be a beautiful book on the history of the Surrealists by Maurice Nadeau. I was very impressed with the endeavour of the Surrealists, not stupidly. I knew an eccentric art history; I was a Marcel Duchamp fan, I told you I saw by accident a Claes Oldenburg show, I was very impressed with it. I didn't know the current discourse of art; I tried my best to make an eccentric discourse of art. I remember seeing some film, a visual moving image of Jim Dine doing a happening. He was drinking his paint in the frenzy of the happening. I knew that there was this word 'happening' in the 60s, I knew that Jim Dine was drinking his paint, therefore I must have had the typical overload of these kinds of images. Everyone must have, but without a discourse to put it into. We started this group and we tried to do things more seriously. We worked with a gallery, with Jacqueline Vauthier, we worked with whomever we could work with, art centres in and around Geneva, even tried to work with Chase Manhattan Bank because they had bought some of my work and were friendly with me. But if I had gone someplace else, if I had said, Geneva is not big enough for me, Geneva is too provincial, and if I had known there was a place to go, if I had heard of Joseph Beuys – and I didn't even know his name at all in those days – I think I would have gone overboard. I think I would have used all my stupidity to become successful in a certain vein, maybe similar to Joseph Beuys, similar to somebody, instead of using my intelligence to develop something. I could have escaped into success if I had been less fearful and I think it would have been to my detriment; I would not have developed at all. I might be one of the famous has-been artists of that time by now.

Snauwaert Was it an overt choice right from the beginning, to address the complexities of the situation, also aesthetically? It is intriguing that you never chose any of the defensive reactions that exist in art, the hermetic, non-communicative position, like hard-edge abstraction, that must have been popular at the academy in Geneva.

Durham **Again there I had a privilege very early on, or I had a potential**

Costumes by **Sonia Delauney** for **Tristan Tzara**'s Le Coeur a gaz
1923

Jim Dine
The Smiling Workman
1960
Performance, Judson Church, New York

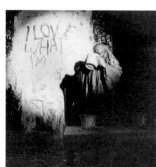

Juan Sanchez
Bandera #1, Danza Guerrera
1982
Oil and mixed media on canvas
67.2 × 158.4 cm

privilege, of learning an easy lesson, easy because it was so obvious. I could have become a Fritz Scholder, who was the famous Indian artist in the US, who paints pictures of Indians. I can paint, I can do all the things that artists do, I can sculpt, I can do all the arty things. I had the privilege of knowing to refuse that at an early age, because I could see how silly that was, it was so obvious. This Indian art world is so little, it makes everything quite clear. You have to avoid answers at all costs in a certain way, at least I knew that from an early age. The other privilege I had was that of seeing Geneva and its stupidity; that was a privilege because it was something that you had to refuse, you couldn't say yes, I will participate.

Snauwaert There was the second part of this transfer, after your activist period. How did you formulate the political discourse that you had before and join it to your previous art practice?

Durham I left the Indian movement and my idea was to write a history of the Indian movement of the 20th century, to put our movement in its proper context. It was all too close and it was all too hard. I had no money; we were shoplifting for food, we were really in bad shape for money so at the same time I was free for the first time after a very intense decade. We were on the job 24 hours a day, so in my free time I started doing artwork. But the artwork I started doing was still within where I had just come from, so I did a series of collage assemblage paintings. They were about our political situation, they tried to have nothing to do with aesthetics, which I had already been trying to do in different ways. You would get something from them emotionally and visually, but not at a typical aesthetic level, something much stronger, I thought, in a kind of a romantic way maybe, but the reason for them was a political text. Each one had a text about a situation at the moment, what they're doing on the Rosebud Reservation at that moment which could be stopped and should be stopped. Death and destruction kinds of things, poverty and where we are. And I wasn't making them with any kind of idea in mind, I was just making them. I didn't have an art scheme, I thought my job was to write that book, not to do art. I was just trying to continue a conversation with the world that the world never wanted and still doesn't want. The way that I normally knew to do it was with the plastic arts instead of with words; it's just a normal way that I work, that I speak. Then the artist Maria Theresa Alves went to apply to Cooper Union, a little art school with a big reputation in New York. This was still in 1980, I think, and she met a guy named Juan Sanchez, a Puerto Rican painter, whose work she had admired. He was doing a show called 'Beyond Aesthetics' of third world artists who were doing strong political work. So he came to our little place in New Jersey where we were living and looked at those collages and said, yes, yes, I want all these in 'Beyond Aesthetics'. Then they were very popular, people liked them very much. I felt very insulted; I saw the weakness of doing that kind of work. It looked like the art crowd of New York was being entertained by the sorrows of my people and I was the agent who allowed them to be entertained. I felt that I had betrayed my own folks and betrayed my own struggle because the work was popular. I had to stop and say, if I'm going to do art once more I have to do a little research about art, once more I have to go back to see what the hell we're talking about with art. So that was the third time I had to do that in a very serious way, and all three of those times,

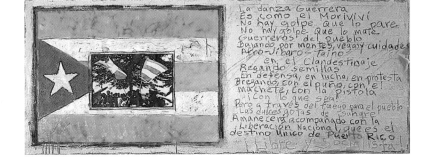

it was a time of success, not a time of failure, a time when I could have gone on to become an angry Indian political artist, which is a beautiful trick the art world likes to play on you. And they played it on Juan Sanchez. He's a good artist; he was doing his marvellous paintings about that time, outstanding, without any idea of what sort of thing painting should be, always about the political situation in Puerto Rico. He was the darling for not even six months, and then they said no, not political painting, and then suddenly Jean Michel Basquiat came along. And I love Basquiat, I love his work, I have no problem with that at all except when I look at the history of New York at that time, the history of the early 80s when things were beginning in New York for the minority syndrome, it's just a disease. What was the discourse in the New York art world that said yes to Basquiat and no to Sanchez? It was, you can't have this blatant political message, we don't like that. It had nothing to do with whether or not this was good in the artwork. But their discourse and watching how that all played out – I suddenly realized I was in the middle of an art discourse. I was in the middle of a heated conversation about art, and that was completely unseparable from politics.

Jean Michel Basquiat
Untitled
1984
Acrylic, silkscreen, oilstick on canvas
223.5 × 195.6 cm

Snauwaert Was that when you also started to reflect very strongly about questions like what is political engagement in art, how can it be transmitted and how can it be accurately communicated without losing yourself in the discourse? How can one address different audiences and not just oppositional patterns of dominated/dominating, and can aesthetic engagement also be political engagement? That was also the time when other artists emerged who used agit prop and advertising-like, aggressive media techniques.

Durham **It was exactly what you described happened at that time. I said, I can make these people part of another audience, I can change these people's expectations in some way. I can be part of the discourse by completely disagreeing with it, but I can do it intelligently instead of just making an interruption. I can make this audience itself strange to itself and I can try and expand an audience and make it not so silly. At the same time I was working alongside this artists' organization, the FCA, they did a newspaper and so on. Once I had changed my mind about what the New York art world was, then I started working with them. I started knowing everybody, Basquiat, Haring, Rosenquist, Oldenburg and Sol LeWitt, and thought of them as friends. I didn't know the right critics but I knew some writers. I assumed that they had similar thoughts about me, and I was quite surprised that I was not perceived as a fellow artist exactly, I was perceived as an Indian artist. I was kind of stunned by seeing that at least some people had this perception. No one had a perception of me as a fellow artist because I did not have the proper signs in my work, and that was exactly what my work was trying to do, not having the proper signs. Let's see how we can be postmodern, that's what I wanted, a postmodern situation.**

Snauwaert And you started to make the animal skulls, not icons of American consumerism. But they're icons in a different way, over-structured symbolically.

Durham **I only remember thinking how quickly there came to be a recognizable style, a visual style we could recognize as postmodern. I remember being mad that it only took about six months or so. It was a style that said to you, I**

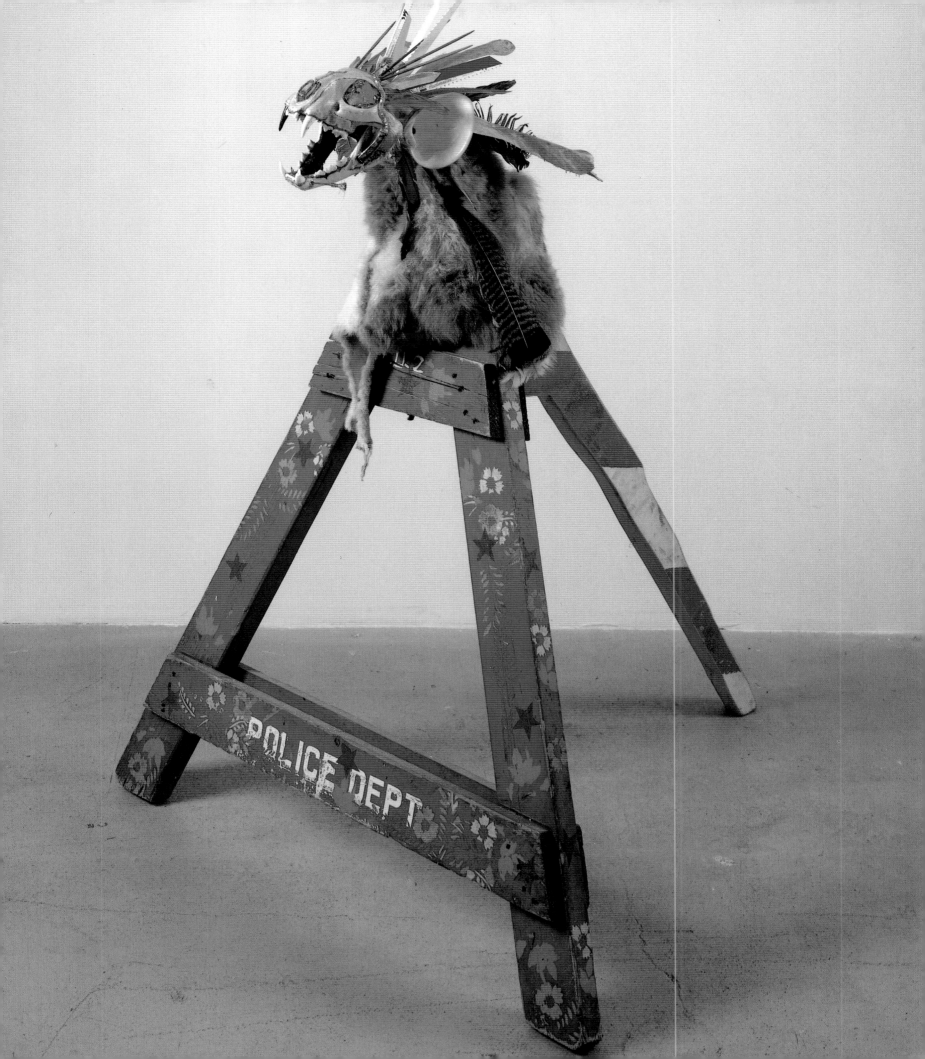

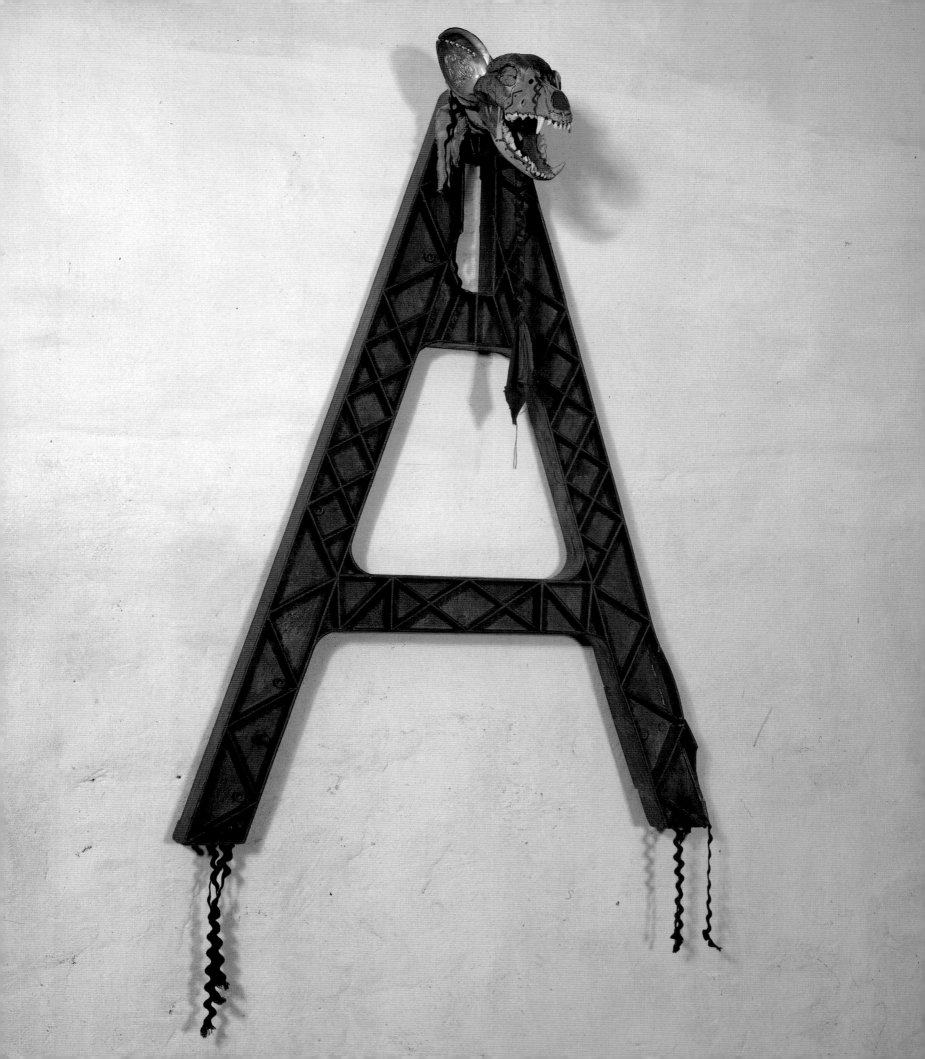

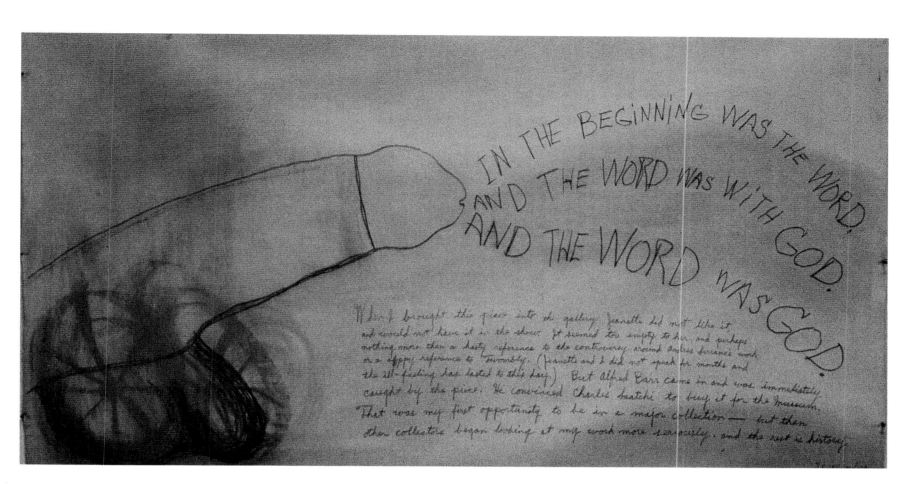

am sophisticated, this is the sophisticated style. How naive that seemed, how childish. So I started doing animal skulls and that kind of thing, after going through a short period of doing instructional political work, which is what I first showed in New York. Immediately after that I started doing the fake Indian artefacts from car parts, *Bedia's Muffler* and *Bedia's Stirring Wheel*[1] which were not seen much, even though I was in some group shows away from the minority art set up. I showed those fake artefacts first; people liked them, but they didn't go anywhere. So then I started doing the animal skull things. I did it as postmodern work, animal skulls as part of my tradition, you can't say it's a bad tradition. And I wasn't doing it traditionally, I wasn't making new folk art. I was trying to interrupt what I perceived as a very closed, very satisfied and self-congratulatory discourse on Postmodernism. I felt like New York art in the 80s was not speaking to the times, was not being contemporary, was being nostalgic without admitting that, without knowing that. From the point of really challenging Modernism, I think it was only the feminist artists who actually did so, who actually interrupted.

Snauwaert Can you describe the first works?

Durham The first works I did – I've lost the first works, and some I gave away – were automobile parts like *Bedia's Muffler* and *Bedia's Stirring Wheel*. But there were earlier ones than that, there was a muffler before *Bedia's Muffler* and there was a front of a car which Paul Smith has, and other automobile parts, that were done up to look like stupid Indian artefacts, artefacts from the future I call them. It was a time when art had to have text, so these works

had very involved text, but it was also a time when art had to have very specific signs of being postmodern. The visual style of Postmodernism I think must have taken three months or three weeks or three hours to develop. There developed in the Postmodernism style something that looked to me very romantically representational and very naively sophisticated, using cleanness and purity and simplicity as signs of sophistication, using stainless steel as a sign of sophistication, using text as a sign of sophistication. So you knew postmodern work even in those days by those signs of sophistication. And what I wanted Postmodernism to be was not Modernism. I wanted it to be the end of Modernism.

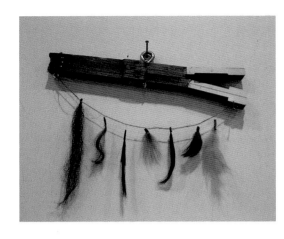

Snauwaert The last of the avant-gardist, generational ruptures? After the ruptures the idea of an evolution, or of tradition?

Durham **This was the discourse at the moment, but they were not my fathers whom I was trying to destroy. I wasn't trying to be the next generation. They were saying, Postmodernism is this, and I wanted it to be an ongoing discourse and not locked that way. You couldn't be Jimmie Durham in any way because if you make some crazy non-reliance reliance on your background**

Bedia's Muffler
1985
Metal, leather, beads, shells,
acrylic paint
86.4 × 115.2 × 12 cm

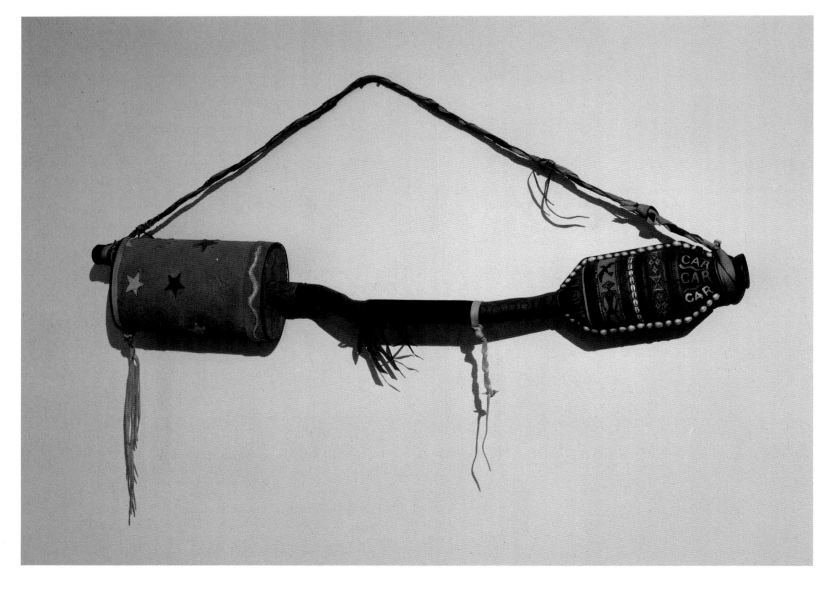

The last thing he • • wants is a handout.

He is the Navajo.

His roots are set deep in the land he fought for, lost and regained over 100 years ago. With his limited mineral revenues, he has set up his own government, established tribally owned industries and a 10-million-dollar college scholarship fund.

He knows the natural resources he has relied on will eventually run out. To avoid the economic disaster that would follow, the Navajo is drawing on his greatest resource: The Navajo.

He's bringing outside industry to his reservation by offering a pool of fast-learning people whose natural intelligence exceeds their formal education. He's combining that with favorable tax, leasing and construction advantages.

General Dynamics was among the first to discover that the Navajo's way works.

In our facility near the tribal capitol at Window Rock, Arizona, most production supervisors, all inspectors and assembly workers are Navajos. They're putting together highly complex electronic assemblies for aerospace systems and tearing apart a lot of popular misconceptions about Indians in general and Navajos in particular.

By building a new economy, the Navajo is making one thing clear...he's not about to be counted as a "vanishing American."

GENERAL DYNAMICS

DONATIONS ACCEPTED

OF SPECIAL INTEREST

HIS DRUM

WHY IS HIS DRUM SO SMALL? THE LAST INDIAN IN MANHATTAN WANTED TO BE CIVILIZED, AND TAKE HIS PLACE IN SOCIETY, BUT HE DID NOT WANT TO GO "COLD TURKEY", SO EVERY FEW MONTHS HE WOULD GET A SMALLER DRUM, AND WOULD SING SHORTER SONGS.

← HIS DRUM (SEE DISPLAY)

HIS BED

WHY IS HIS BED SO SMALL? LO, THE POOR LITTLE INDIAN WAS SO POOR HE HAD TO BUY IT AT A ½ OFF SALE.

because if you make some crazy non-reliance reliance on your background as an American Indian, there are only negative places that the art world can put it, only the most disgusting places, so I said yeah, this can work, I can use that. So I wasn't challenging some other generation, I was saying let's get this discourse going somehow, let's see if we can liven the discussion up a little bit and let me talk also. At the time the only way I could think to do it was say, oh, you mean anything goes, how about a car muffler dressed up as an Indian artefact, does that go? And I'm making it in a political situation that you don't admit. So look at my discourse, in other words.

Snauwaert But doesn't that bring us to a basic problem which is very much of interest now, where one sees a lot of reactions of repression, of not wanting to know, unconsciously, in the art world, among its players. You have the challenge of addressing an audience that has blacked out a certain topic, with all the historical and economic implications that go with it ...

Durham **I can only talk historically because your question makes me think historically, and it's very stupid, recent history. I left New York in about '86 or '87 or something, and moved to Mexico. Immediately after that I started showing in Europe. I had a show at Matt's Gallery in London and a show at Orchard Gallery in Derry, and they were important shows. In the Matt's Gallery show I tried to make the London art world think about art in ways that it didn't want to, in the way we did the installation, in the way the art was presented and made. There wasn't much art, but there was enough art, I hoped, to do two things. You couldn't refuse the show because there was no art, and you might actually get some encouragement, some energy from the art that was there. And to talk aesthetically about what kind of energy that might be, well, involves intelligence, not just craft. When I listen to Beethoven's Sixth Symphony, I can get into the pastoral mood – I have no choice, because he did it very well. But at the same time, every time I expect the next note, the next note doesn't happen. He challenges me to be smarter**

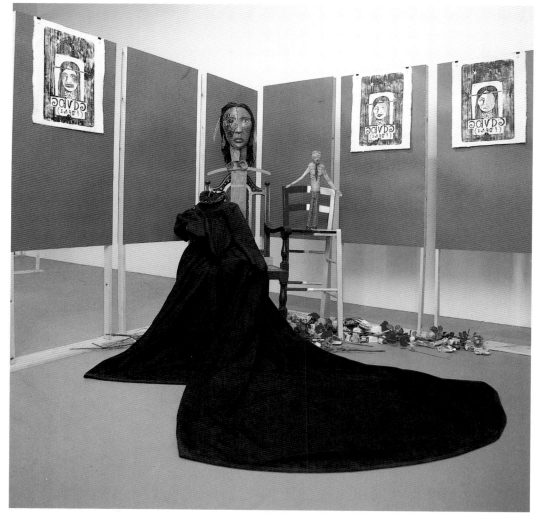

this page and opposite,
Pocahontas and the Little Carpenter in London
1988
Installation, Matt's Gallery, London

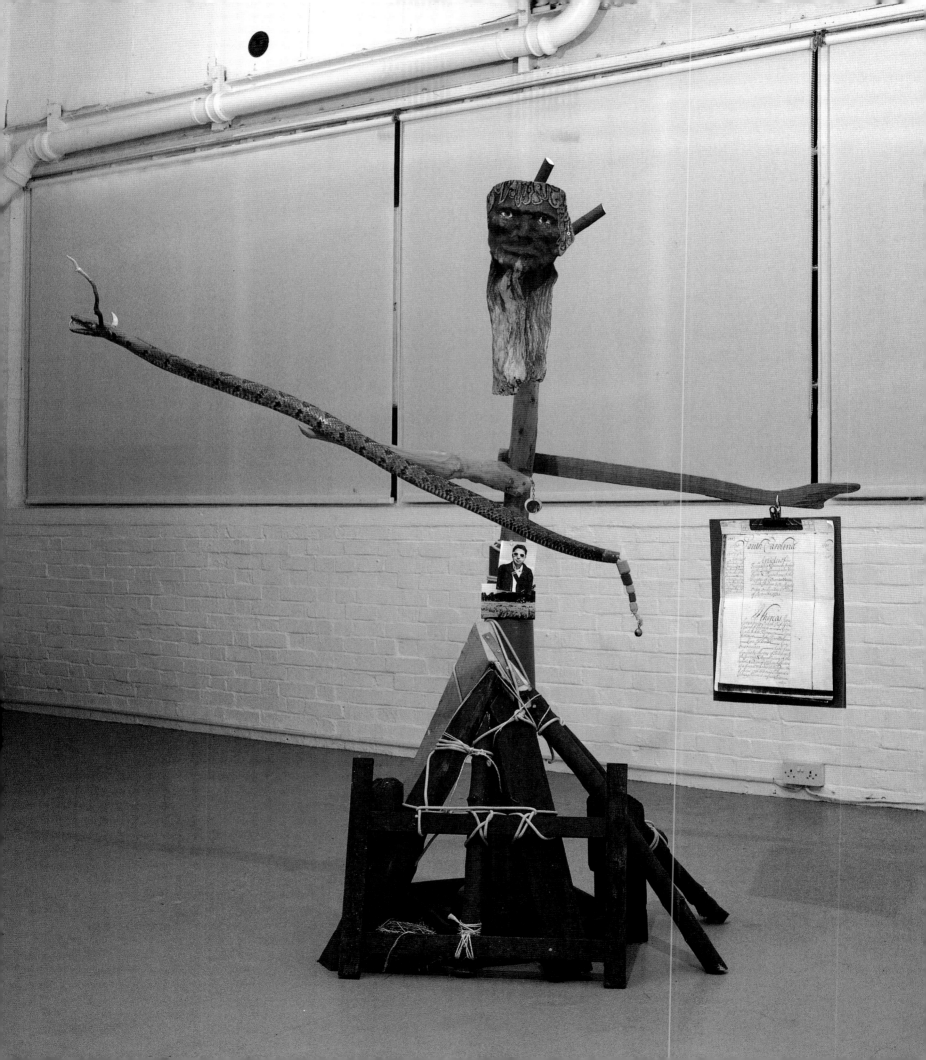

than what I want to be; at every moment I am delightfully surprised when it doesn't go the way I think it should go. I like that kind of aesthetic; I'm imagining doing the Sixth Symphony of Beethoven, as presented by Berthold Brecht where he throws in some Duke Ellington with his own voice explaining why he is doing this. That is what I would like to do in visual art, this kind of thing.

Snauwaert So the Brechtian idea of true disjunctions in the normal narration.

Durham Yeah, it's one of the things I like very much. The problem can't be solved. It's more than whether or not you're from some minority, it's how to have a voice these days – not a nationalistic voice, not an ethnic voice, and yet a voice all the same. Jean Fisher said her model was James Joyce, and I agree with that in a certain way. He didn't like Ireland enough to ever live there, all of his work was an attack on Ireland, but at the same time all his work was a new Irish voice. And you can't say he intended to do that, you have to say, well, his project was to attack Ireland directly as an Irish writer, and in that process not be an Irish writer. But I don't see how one might do that in plastic art, in visual art.

Snauwaert So you don't see any more possibilities to remain a critical artist, and the idea of art as critique is no longer possible?

Durham **Then I wouldn't have a reason to be working.**

Snauwaert But for instance in your last show at Micheline Szwajcer you were addressing architecture in the 19th century and in relation to context. Is it back to a new algebra, back to a new construction system?

Durham **Trying to invent investigate some possibility of new fundamentals. There is a fundamental silliness that I began with with that show, which is that the 19th century related the plastic arts to architecture, intimately, as if they were organically related instead of historically or politically related. And I see from having done that show that people still agree with that, people still have that 1860s idea of art and architecture being of the same family of endeavours. And I didn't expect it so much, I thought people would appreciate my irony more, but very many people take it at face value that yes, there is this organic relationship between art and architecture. So there I see a new something I can play with for the next year, maybe for the next six months. We only know that we want something that is not the monument, we want something that is not the painting, not the picture. So we've kind of spent this century fumbling about, saying, is it smaller than a bread basket? Asking investigatory questions about what sort of things it might be, but always within a political situation of the time. Now we can begin, it seems**

Environment (2 parts)
1994
Wood, paper, plastic, wool
'Some French guy, maybe Victor Hugo? said that it is no wonder art is sick; it is an orphan because it's parents – architecture – is dead. (Actually, of course, I should have written "are dead", but it is that kind of sentence structure where you're not sure)
I believe, in fact that it was Balzac. Architecture joins thought to stone and steel; art is somewhat more independent;'

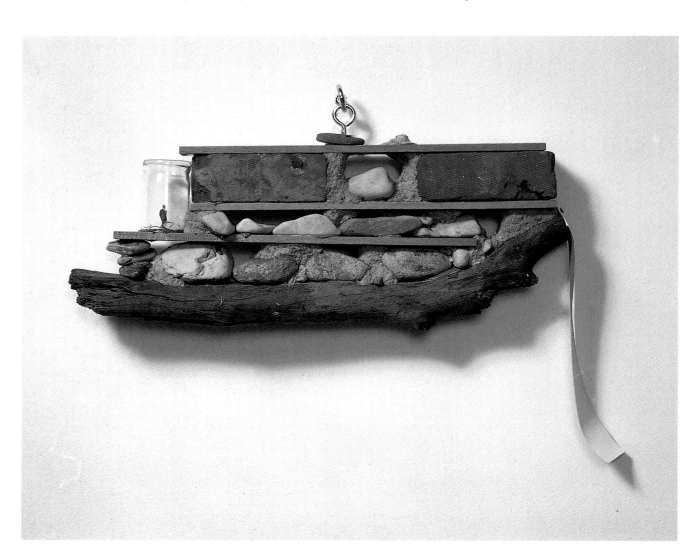

Un example
1994
Wood, stone, papier maché, glass, coal epoxy
46 × 65.5 × 11.5 cm

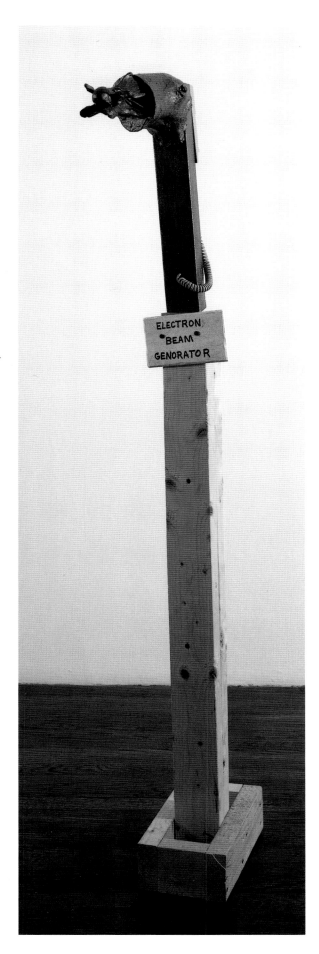

An Electron Beam Genorator
1989
Bone, wood, telephone cord,
acrylic paint
40.8 × 11.4 × 28.8 cm

to me, to be more seriously confused, to be more profoundly confused than we were before, especially if we can make a final break within that heroic project of art and architecture. I seem to trust that combination of physical and thinking process more than a strictly conceptual process. The conceptual artist, the minimal artist made so many monuments, and we're still stuck with them. I would like to make art each individual art thing there is, there would not be a time when you had to decide to keep it or to throw it away. And, it seems to me, one can do that sort of non-dictatorial thing by making things which don't have to do with craftwork at all, just intellectually joined to our normal physical world.

Snauwaert There is this bricolage side to your work ...

Durham Yes, which I want now to take away, to be rid of, because it's so there.

Snauwaert That's a very interesting part.

Durham Yes exactly. I have to take it away.

Snauwaert It's what for some people gives it the flavour and the charm.

Durham And in some circumstances it's charming to me too. If I can stick things together that are physical histories and they didn't want to go together, but then something intellectual happens when they are together, I'm just very pleased, I'm very charmed by it. And of course I don't trust it and I see now I'm going to have to find a way out of that.

Snauwaert I was struck by the fact that you read a lot of very advanced, purely scientific books. People expect your work to be the opposite.

Durham I actually love science and the Scientific Method, using capital letters. But I don't think it is European and I don't think that it is practised in the science world. I have a great criticism of science because it operates on belief, it doesn't question its basic beliefs. But science as an analytical concept of questioning and experimenting, and saying, let's see, how does this work and what happens here, that's genius, that's what humans are about. If we don't do that, we're not doing a human project, I think. Our project is not to believe, not to find answers, it's to be analytical, to do experiments that should lead us to the next experiment, it shouldn't lead us to a cheap answer. And that's why I love science; it's so scientific. It's not European, it doesn't belong to white people, it's a human thing. I don't want art to be separated from other parts of life, and I also don't want science to be separated from other parts of life.

Snauwaert I think the hybrid aspect of almost every part of your work is quite interesting, visually and also in terms of context. You don't take advantage of the 'art as a means to an end' maxim but adopt the most interesting part of post-Modernism: the fragmentation and continuous re-constitution of the subject through the reading of signs.

Durham It's just the usual problem for me, how to make plastic art which I

Science II
1990
Pastel, chalk, pencil on paper
38.4 × 48 cm

Untitled
1992
Wood, leather glove, acrylic paint,
Jimmie Durham's tooth, seashell
buttons, epoxy glue
108 × 31.2 × 62.4 cm

BOY! THOSE ARE PRETTY COLORS, AREN'T THEY?
OUR UNIVERSE IS MADE UP OF ATOMIC PARTICLES
HELD TOGETHER BY FOUR KINDS OF INTERACTION.
PHYSICISTS WANT TO BE ABLE TO DESCRIBE
THE INTERACTIONS IN A SIMPLE THEORY.

Zeke Proctor's Letter
1989
Paint, pencil on paper
76.8 × 52.8 cm

Zeke Proctor's Letter
1989
Paint, pencil on paper
76.8 × 52.8 cm

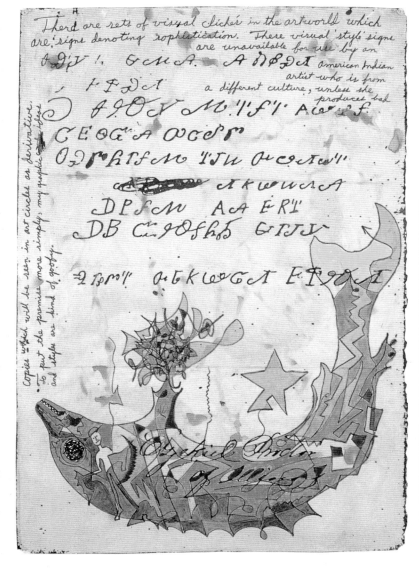

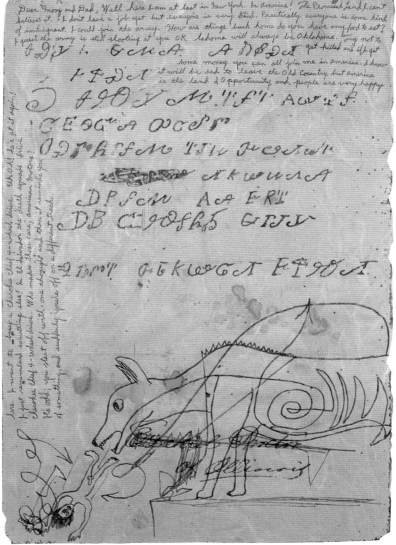

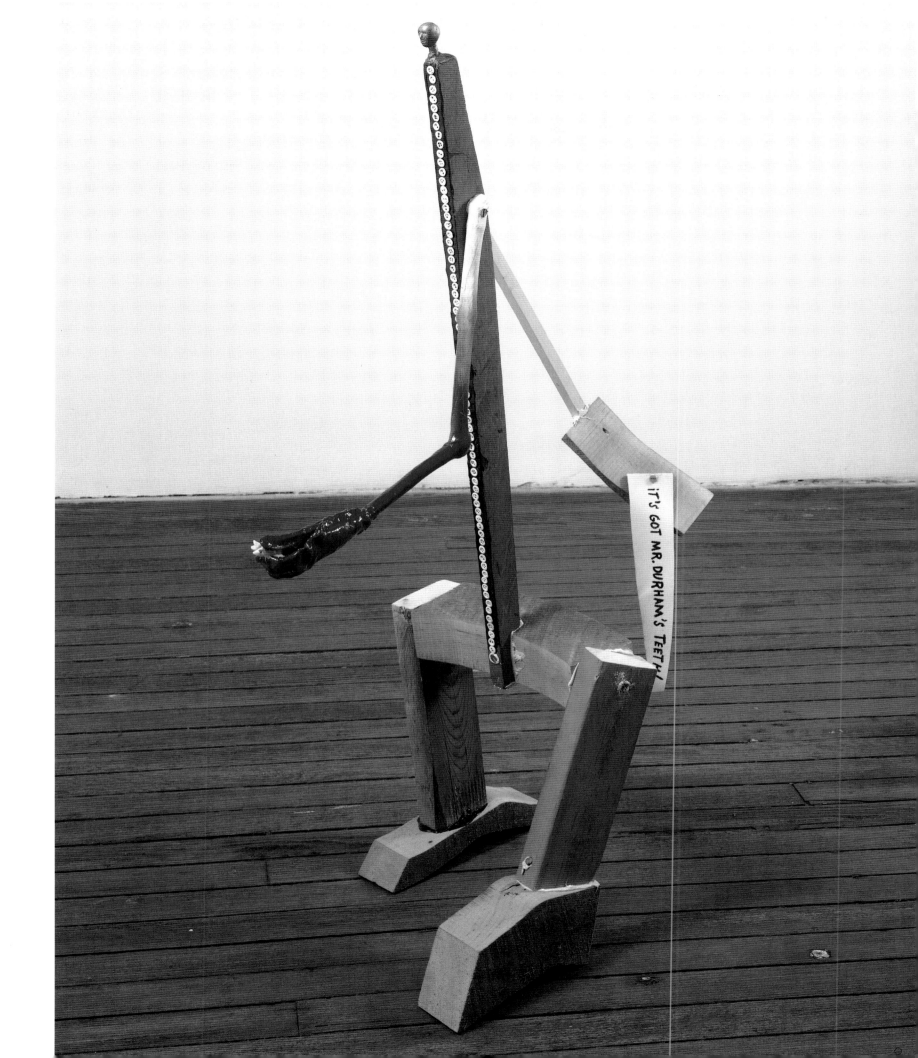

The Indian's Parents (frontal
view), from 'On Loan from the
Museum of the American Indian'
1991
Paper, photo
24 × 25 cm

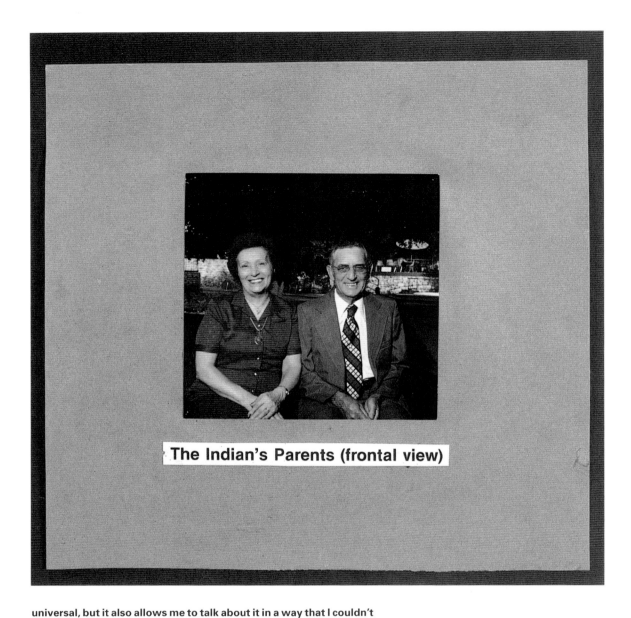

The Indian's Parents (frontal view)

universal, but it also allows me to talk about it in a way that I couldn't
otherwise. I have it with my own family, this is how universal this problem
is. My mother died and my brother had already died, other family members
had died and I was sitting with my three sisters, remembering our mother,
and each one of us had a different mother. We were strangers at that
moment, the four of us, and this is one small, very close family. It made me
think once again what everyone has known all these years, that we don't
know each other, that we don't communicate with each other, we only hope
we do. So if I put the problem of identity into that basic French concept, into
the Sartrian concept, we're all strangers, none of us can communicate with
each other. There is a place to do some work, an investigative work instead of
declarative work. There is a place that I like very much where you define
yourself. It's a problem with art in general. We know what art is because we
see it in the museum, we see it in the gallery, we see it in the art world and we
like that situation because therein we define ourselves, therein we get our
identity. If I want art to be a little more free so that our identities are also a
little more free, my choices are within the sphere of your already identifying
yourself.

left, **Melvin Edwards**
Elementary, from the 'Lynch
Fragment Series'
1980
Welded steel and barbed wire
194 × 182 × 15.6 cm

right, **David Hammons**
Untitled
1992
Rocks, reeds, hair
Dimensions variable
Installation, Documenta IX

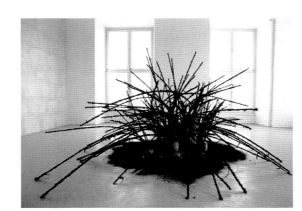

Snauwaert In relation to the current historical moment, there's this 'the dream is gone' feeling. And I think now that artists feel a greater responsibility in intentionally making art. I'm not talking about sociology, I'm talking about art. Maybe aesthetics, even, because it always comes to this point.

Durham **Except you can't separate these things, you really can't separate sociology and aesthetics.**

Snauwaert No, but there has to be a certain aesthetics in the work, otherwise …

Durham **There has to be and here is a difference. I will talk again about two artists, both friends of mine, I respect both of them. Mel Edwards, a Black artist my age, my generation, he has a teaching job so he has a life, he makes art that talks about the Black situation. David Hammons doesn't talk about the Black situation, except that that's what he always does. From way over in left field, from a different place, from a place that turns out to be strangely within the art discourse – the discourse we wanted all along. I think in this century there is this art discourse, Duchamp, Joseph Beuys, a certain list of artists that we think tried to take away limits in some way that was not so heavyhanded. This is the art discourse that we find interesting this century, I think, the art discourse that is still not recognized. David Hammons is doing his work completely consciously, he's not doing it innocently in the least bit. He's using the full discourse available to him, but it is in line with this other art discourse. So he is bringing his struggle, the struggle of his people, the absolute horror and hopelessness of Blacks in the US, to that discourse. They still try to refuse him because no one wants Hammons today, but they can't. He says yeah, all of this, and the American Black experience is part of that, it's not excluded from that. It's a genius thing to say, it's so important to say that, and it's exactly the thing that cannot be said. Don't bring your niggers into our living room, please. And it's at that point that he gets that rejection that he says, see, see, now you can't refuse me, now you have admitted.**

Snauwaert So does that also mean, and this is perhaps another contradiction, that you have to take up West European discourse?

Durham **That is the art discourse. Art is a European phenomenon, it does have a European history. Europe is a human project, it's not a European project, we have all contributed. But because of certain power structures everyone says it's a European project. I then say, there is this marvellous art history in Europe; it's so good I want to be part of it. I want to join that discourse; I don't want to interrupt it or stop it. But I want to join it as me, I want it to be as big as me, which was its original intention.**

Snauwaert Doesn't one lose one's identity? What does one give in?

Durham **You can't lose your own identity. I wish I could lose my own identity. All of my life I wish I could. The problem is you can't.**

Untitled
1992
Seaweed, wood, glass bottle,
tin can
100 × 45.6 × 40 cm

1 José Bedia, Cuban artist

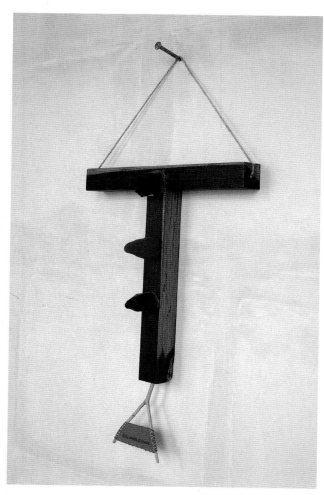

Untitled
1992
Wood, rope, iron nail, fabric
60 × 42 cm

Untitled
1992
Wood, iron, acrylic
28.8 × 64.8 cm

Installation, Documenta IX, Kassel
1992

background to foreground,
Jesus
1992
Wood, metal, mud, glue
144 × 86.4 × 86.4 cm

Untitled
1992
Wood, rope, iron nail, fabric
60 × 42 cm

Untitled
1992
Wood, iron, acrylic paint
29 × 65 × 6 cm

Treff
1992
Wood, iron, acrylic paint
215 × 205 × 107 cm

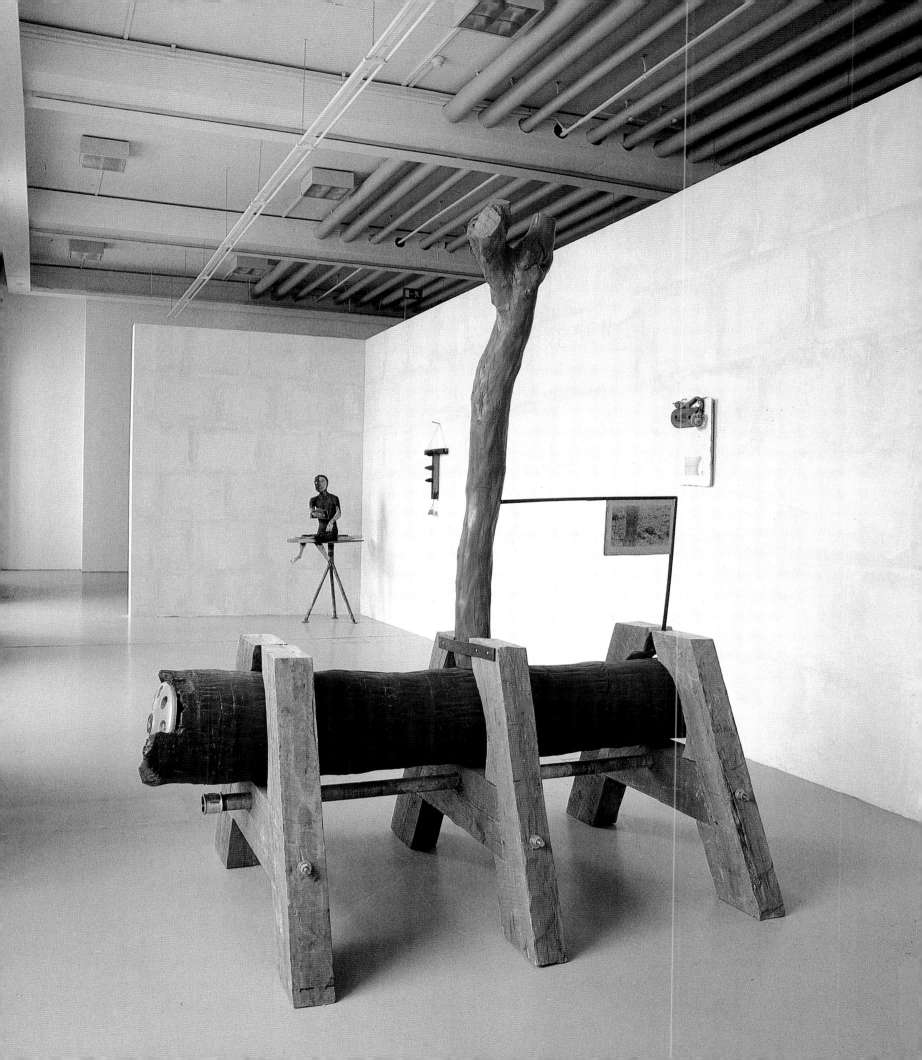

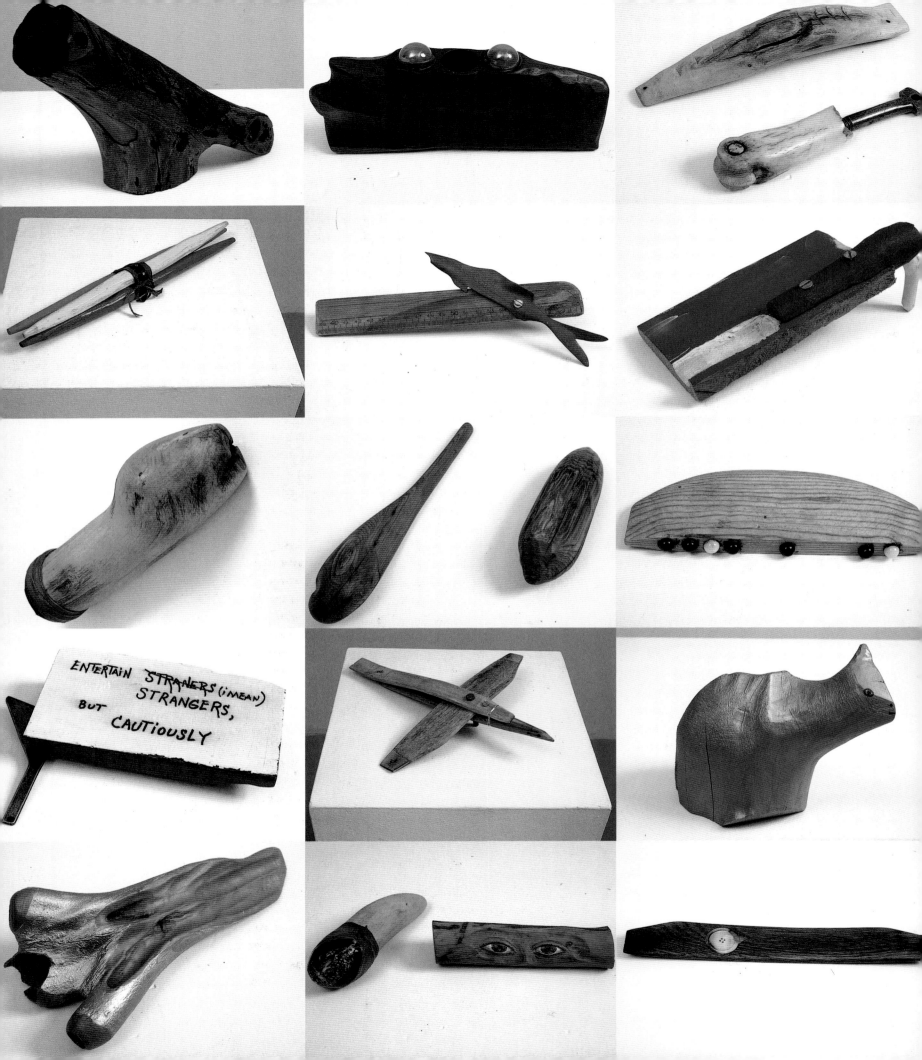

ENTERTAIN STRANERS (i mean) STRANGERS, BUT CAUTIOUSLY

Contents

Over the River and Through the Woods
1989
Wood, acrylic paint, beads, leather, twine
60 × 21.6 × 21.6 cm

'I was actually taught opposites in school … The teacher said that black was the opposite of white, sweet was the opposite of sour and that up was the opposite of down. I began to make my own list of opposites: the number one must be the opposite of the number ten, ice was the opposite of water and birds were the opposite of snakes.

But soon I had real problems, because if snakes and birds were opposites, where could I put the flying rattlesnake that we saw every night in the sky as the rattlesnake star? I theorized that in certain circumstances things could act like their opposites. If grey is the blending of the opposites black and white then the flying rattle snake could be seen as a grey bird'.
Jimmie Durham, 'The Search for Virginity'

'I believe that the acts and perceptions of combining, of making constant connections on many levels are the driving motivation of our aesthetic… So it is a system that attempts to break down separations, and is therefore an integral part of all other systems and activities. European culture has evolved into one of separations, of classifications and of hierarchies. I do not mean to imply that one culture is totally positive and the other totally negative, just that they are truly different. With that remarkable difference we find ourselves invaded by European culture. That directly involves artistic work with political work: two necessities that are inextricably bound to each other'.
Jimmie Durham, 'Ni' Go Tlunh A Do Ka'

Zeke Proctor's Letter
1989
Paint, pencil on paper
76.8 × 52.8 cm

Zeke Proctor's Letter
1989
Paint, pencil on paper
76.8 × 52.8 cm

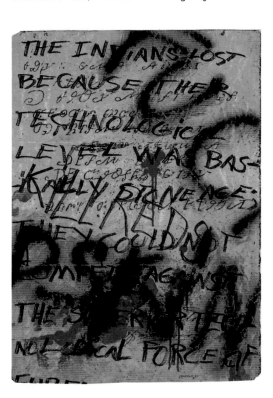

These two quotations from Jimmie Durham's essays draw attention to his interest in the forms in which concepts are materialized. Abstract concepts, both philosophical and common sense, latch onto modes of representation in a way that is both inevitable and questionable. Durham's art questions and makes visible the forms that inflect thought and, in these two quotations, he also draws attention to the way concepts congeal into patterns or configurations. The configurations formed by 'opposites' and 'hierarchies' suddenly begin to lose their obviousness and appear as means of clothing complex issues according to a system of patterning. The polar metaphor that governs opposites creates an unbridgeable gap that is fixed and naturalized by its spatial patterning. Hierarchy also implies a spatial, or topographical, ordering around the metaphors of high and low. Jimmie Durham is a

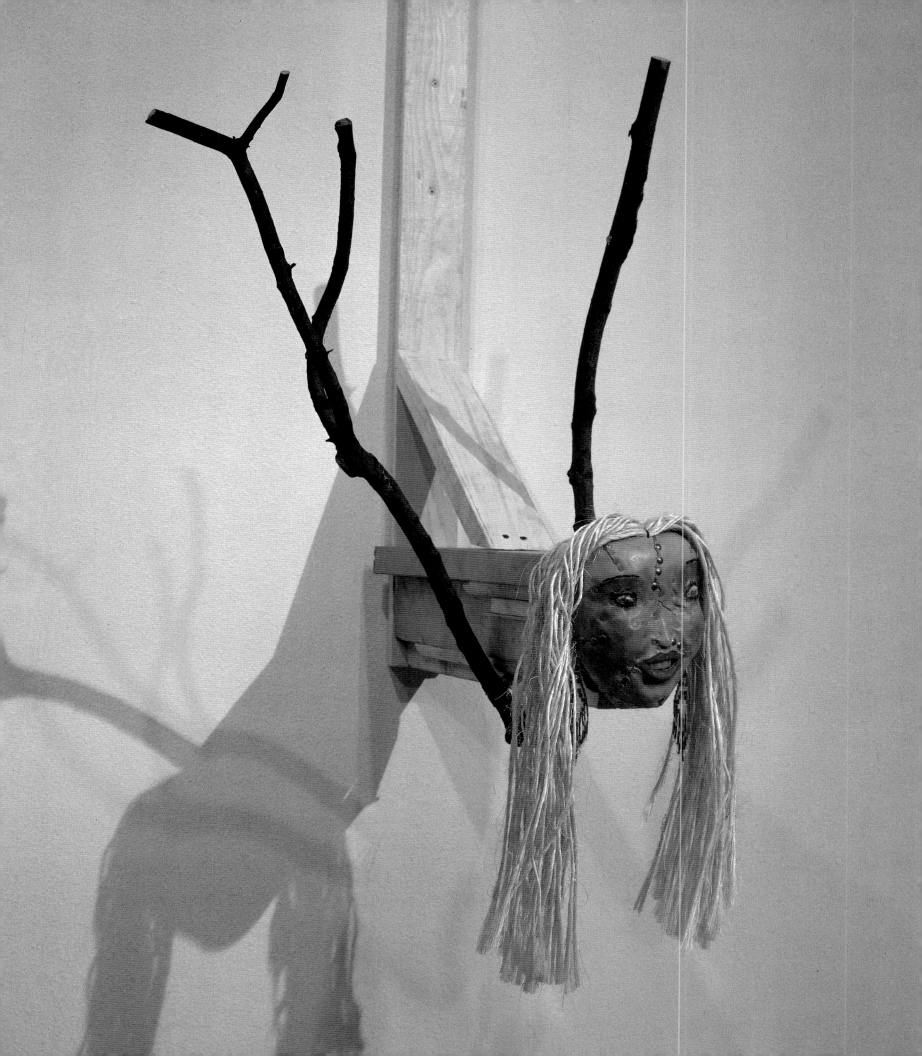

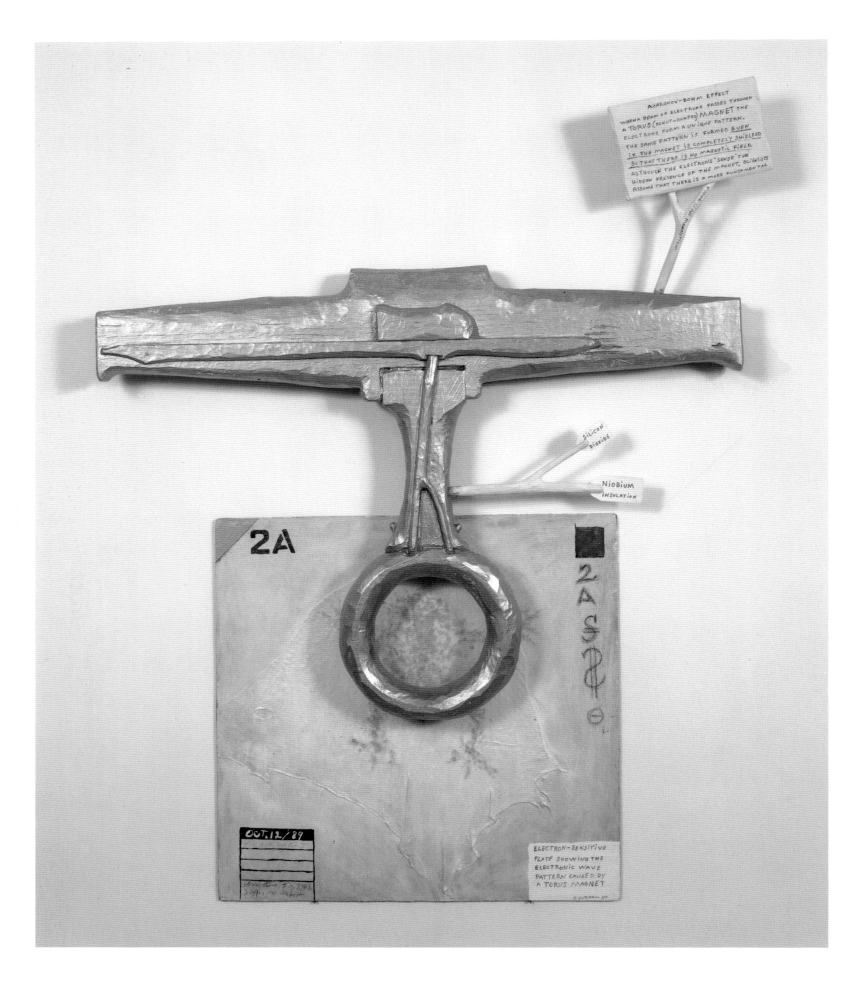

AHARONOV-BOHM EFFECT
WHEN A BEAM OF ELECTRONS PASSES THROUGH
A TORUS (DONUT-SHAPED) MAGNET THE
ELECTRONS FORM A UNIQUE PATTERN.
THE SAME PATTERN IS FORMED EVEN
IF THE MAGNET IS COMPLETELY SHIELDED
SO THAT THERE IS NO MAGNETIC FIELD.
AS THOUGH THE ELECTRONS 'SENSE' THE
HIDDEN PRESENCE OF THE MAGNET. SCIENTISTS
ASSUME THAT THERE IS A MORE FUNDAMENTAL

SILICON
DIOXIDE

NIOBIUM
INSULATION

2A

2A

OCT.12/89

ELECTRON-SENSITIVE
PLATE SHOWING THE
ELECTRONIC WAVE
PATTERN CAUSED BY
A TORUS MAGNET

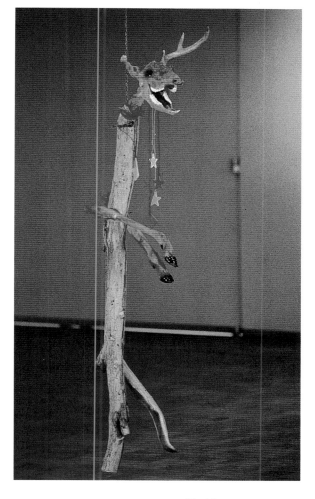

political artist, both from the point of view of the content of his work and its formal implications. But his politics also extend to exploring the relation between forms and concepts, including the ability of words to conjure up images and of images to convey ideas.

His 'acts and perceptions of combining' and 'breaking down of separations' form a conceptual point of departure for his art but also evoke the blurring of 'categories' that marks all aspects of his creative work, from poetry to politics to art. To begin with, his art work evades boundaries of genre. It is easiest to describe him as a sculptor, but only because so many of his objects are constructions that stand free in space and can be approached from every angle. Even the sculptural constructions break out of formal unity. They are often decorated with a heterogeneous collection of extraneous things, such as written messages, a photograph,

words, drawings and particularly found objects of various kinds. Titles are often an intrinsic element, emphasizing the importance of words, while the materials themselves might range from wood to paper to PVC piping to metal from cars, screens from TVs, antlers from animals (to name a few). Such a variety of material generates, almost incidentally, a variety in the ways in which the works create meaning. So, from a semiotic point of view, written messages, sometimes in English and sometimes in Cherokee, are only comprehensible to those who understand the linguistic system and are within a symbolic code; wood can be whittled into the likeness of a figure, recognizable through an iconic code; and found objects, included in their own right, maintain an indexical link with their origins. But once again, these categories of sign overflow into and across each other to include many other kinds of materials and meanings.

A Dead Deer
1986
Bone, wood, paint, string
120 × 72 × 14.4 cm

The Two Johns
1988
Wood, paint
54 × 61 × 6 cm

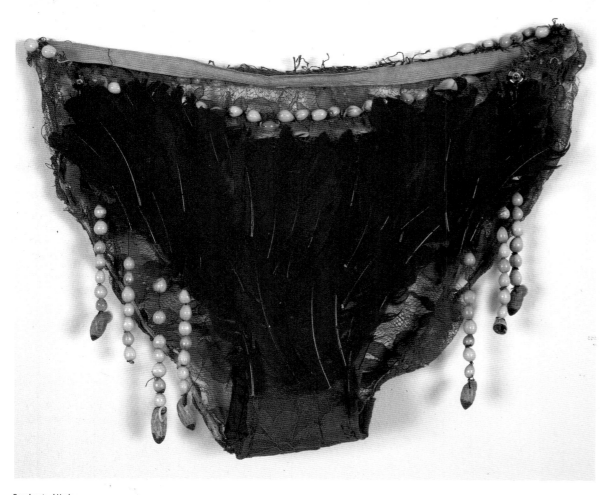

Pocahantas' Underwear
1985
Feathers, beads, fabric, fasteners
33.6 × 33.6 cm

It might well be possible to locate the blurring of boundaries that characterizes Durham's work within the negative aesthetics of the contemporary avant-garde. From this point of view, his ideas and motivations would converge and overlap with other challenges to homogeneous aesthetics. But the concept of negativity, with its dependence on a binary opposition, is not an important origin or motivation for Durham's thought. Negation depends on opposition and polarization and thus suggests a conceptual terrain in which ideas materialize into spatial relations, outside the mobility of contradiction. In Durham's work, ideas continually aspire to movement, breaking out of the purely visible into displacement, so that meanings are able to leap across objects with the agility of word-play and, above all, irony. Irony assumes an awareness of the implied, the unsaid, as a basis for its wit and thus necessarily activates the viewer's own train of thought, tracing the twists and turns of ideas hidden in a simple juxtaposition of objects or word and object. To take an obvious example: *Pocahontas' Underwear*, (a detail from 'On Loan from the Museum of the American Indian') in which a pair of feathered knickers sets up resonances between different kinds of fetishistic display (the museum and the erotic), while the reference to Raleigh and Astor evoke two 'robber barons' of different epochs, one travelling from England to the Americas, the other from the United States to England. The displacement of ideas and the displacement of journeys bounce off each other, while the reference to Pocahontas remains an ironic, empty sign. The art work demands thought by means of wit and

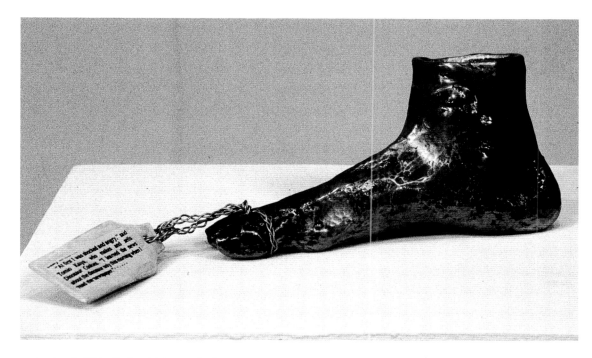

amusement then turns to the seriousness of the politics and history.

Jimmie Durham's art objects emerge from a radicalism in which links between things are more important than demarcations between them. In keeping with the blurring of boundaries, his objects cannot be framed, either actually or in imagination. None of his works have the appearance of finish or completeness that would give them a privileged autonomy in time and space. His early sculptures, dating from 1972, are the result of a negotiation between artist and material which has continued to be central to his work throughout his career. His material does not lose its own nature as object. Durham makes explicit, or visible, his chosen objects' own, inherent, formal properties and intrinsic beauty, be it, in the 1972 work, the facets of a piece of polished wood, or a more specifically anthropomorphic shape emerging out of oak. Some of these sculptures juxtapose two elements, such as a piece of black granite suspended on steel or black granite with iron, and the different materials are given a formal, unified pattern. In his later works, for instance those of the mid 80s, his sculptures are no longer organized around an aesthetic of formal unity. By this time Durham had begun to use assorted materials and ideas in discontinuity and dialogue. The sculptures still manifest an almost hedonistic pleasure in their materials and a confidence in their potential to evoke meaning and feeling. At first sight, these sculptures might often seem to be the product of 'bricolage', but in fact they are works of 'montage', in that the idea behind them is an essential part of their function. Although this emphasis on material could also be

understood within Modernist terms, Durham foregrounds material politically and intellectually as well as aesthetically. He draws attention not only to the material signifiers of art but to the forms, the conceptual equivalent of material signifiers, in which thought itself materializes.

Given that thought, in addition to being moulded and shaped by metaphor, tends to be patterned by formal systems of conceptualization, its content, and the materialization of its content, is affected by its form. A 'poetics of thought' would draw attention to these patterns which materialize thought and would analyse the way in which abstract ideas attract certain spatial shapes and organizing figurations. In Durham's art, ideas work through the juxtaposition and modification of one thing by another. It is a system that creates a conceptual space through displacement, with continuous shifts of meaning and resonance. Words, and the titles of the works themselves are an intrinsic part of the process. This system involves, implicitly, a polemical indictment of binary thought. It is in this sense that his work, while being the product of a history and a culture that stands in confrontation with the mainstream of American history and culture, stands outside the concept of negation.

Footnote
1989
Bronze, chain, card
9.6 × 31.2 × 7.2 cm
'"At first I was shocked and angry," said Tomio Kaiya, who makes and sells Dinosaur cookies, "I learned the news about the dinosaur only this morning when I read the newspaper ... "'

Untitled
1972
Black granite, steel
98.4 × 98.4 × 230 cm

Durham is a political artist. His work is the product of an aesthetic stance and mode of thought that has its own political integrity, and, at the same time, it is a critique of the world and its view that he rejects. His culture and the kind of art he produces do not invoke a simple continuity with the history, culture and art of the native American people; Durham's art is the end product of a very deep reflection on the losses of culture, art, history and a world view that has faced Indian people. From this point of view, confrontation supercedes negation. Almost like the witnesses to a disaster that evades articulate expression, Durham's objects 'give evidence' through symptomatic appearance; they fill the vacuum left by a history of denial and misunderstanding. As a native American artist and intellectual, he draws on the history that reduced his culture to traces and tatters, not iconically through an imagery of resemblances, but conceptually and aesthetically. Once again, his work collapses the boundary that demarcates the 'once upon a time' of nostalgia and invokes a potential mobility and flexibility of social being and a potential mediation and exchange of culture.

Native American history and culture fell victim to a binary mode of thought that had increasingly important legal and social impli-cations for the political development of the United States. Although this mode of thought was inscribed into the first encounters between European and native people (revolving around the familiar oppositions of nature/culture, wilderness/cultivation, savagery/civilization), this kind of binarism acquired an extra and disastrous significance during the nineteenth

century, as the United States attempted to assimilate different waves of mass European, mainly peasant, migration. Christian thought has always tended to revolve around a broad antinomy between good and evil, even though adherence to this belief in an extreme form was rejected by the Church as the Manichaean heresy in the very early days of Christianity. The term 'Manichaean' may be used nowadays to describe any conceptual outlook which revolves around moral binary oppositions and which can, of course, extend beyond the theological. The theological good/evil opposition links to a cultural hero/villain opposition which has flourished from folk tale to modern popular culture. The 'logic of the excluded middle' acts as an intellectual template and provides easy means of categorizing the unfamiliar or the threatening, and avoids the need to negotiate with 'foreign' patterns of thought or ways of living. In the native American subjection to the 'excluded middle', many aspects of indigenous culture were erased. For instance, although the products of Indian cultivation had supported early settlers at times of need, this aspect of their economy was forgotten and lost under the image of an essentially nomadic, hunting-dependent society.

Frantz Fanon invokes the term 'Manichaean' to characterize the world of colonialism as 'a world cut in two':

'The colonial world is a Manichaean world. It is not enough for the settler to delimit physically, that is with the help of the army and the police force, the place of the native. As if to show the totalitarian character of colonial exploitation the settler paints the native as a sort of quintessence of evil. Native

society is not simply described as a society lacking in values. It is not enough for the colonialist to affirm that those values have disappeared from, or still better, never existed in, the colonials' world. The native is declared insensible to ethics; he represents not only the absence of values but the negation of values'. [1]

As critics have so often commented, the mythology of the United States, while disavowing its colonial heritage, depends on Manichaean modes of thought, particularly as represented in its privileged manifestation, Hollywood cinema. In Ronald Reagan's political demonologies, the Christian, racial, Hollywood and Cold War forms of binary thought flourished to the point of absurdity, most obviously erupting in the Evil Empire rhetoric. Jimmie Durham's work confronts the rhetoric of

binarism in two ways. First, his objects create meaning and emotion through gradual, delicate modifications, displacements and ironies. On the other hand, he also addresses the chasm between native and colonizing Americans, as a site of political dispossession, repression in image and representation and the fetishization of a false history. The 'us/them' shifter of separation turns into 'I/you' shifter of address.

I would like to expand this rather abstract opening section by considering Jimmie Durham's actual art works in greater detail, starting with my reactions and responses to his exhibition 'Original Re-Runs', held at the ICA in London in 1994. The name, 'Original Re-Runs', with its Dadaist connotations, already implied a threat to familiar logic and usual ways of seeing and understanding.

Original Re-Runs
1993
Installation, ICA, London

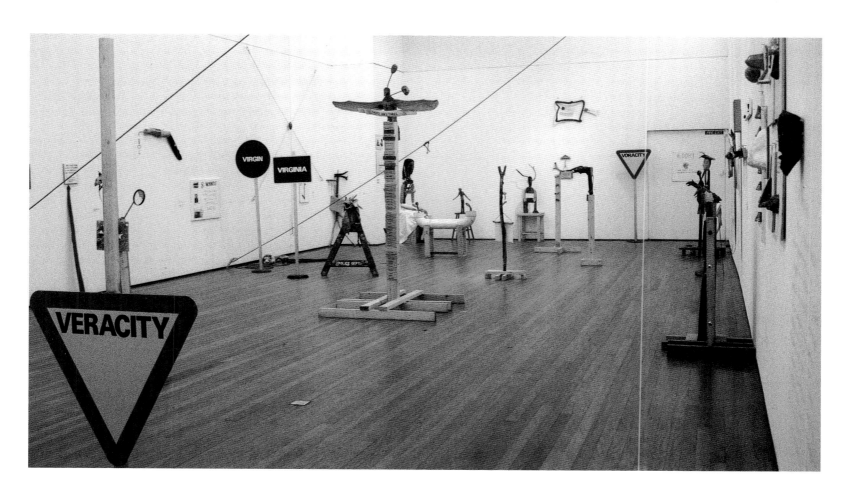

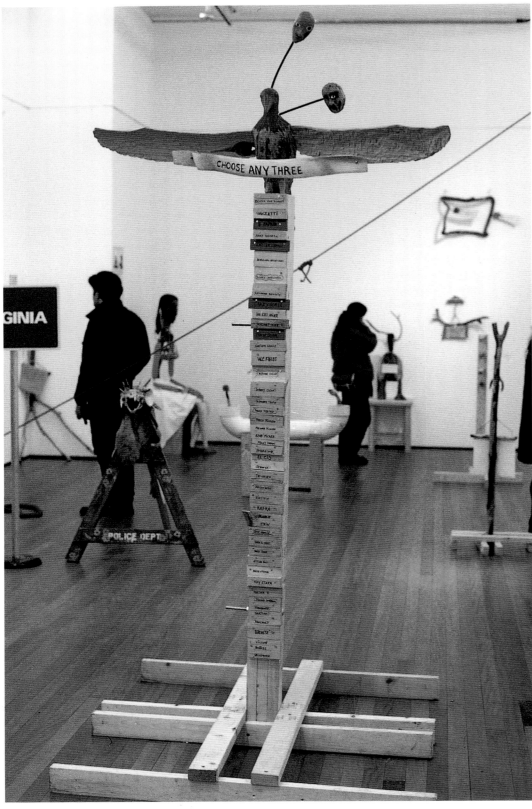

CHOOSE ANY THREE

Choose Any Three
1989
Wood, acrylic paint, paper
260 × 86.4 × 28.8 cm

Although all interesting art challenges the familiar and the usual, Durham uses his art, as I have argued above, to force an intellectual and political re-evaluation of the relation between seeing, the primacy of the visual, and understanding. But, looking at 'Original Re-Runs', these kinds of considerations only emerged very gradually through the slow process of working through the objects on display. And the theoretical impact of the work, and the thoughts I have outlined so far, could only come into focus in the aftermath of the exhibition's first surprising, disorientating, impact.

The first impact came from the sculptures and their sheer physical presence. They flaunt the rawness of their raw material whatever it might be, from wood with many forms and finishes, to plastic piping, to identifiable things which still preserve their original autonomy. And then, eventually, they became simultaneously a source of intuitive and intellectual reverie. They seemed to stimulate thoughts that combined free floating responses to the visual wit of the works and their curious beauty with a more concentrated, insistent, intellectual questioning. Looking around at the surrounding objects, I felt immediately addressed but also asked to stand back and think again. This is the sensation that I want to evoke while trying to write about Jimmie Durham's work. My response is personal. However, I hope it might reflect the way that his objects possess the power to force thought and challenge sight, almost imperceptibly, with a kind of careless, throw away style. Standing back at the time, questions began to take shape in my mind which have influenced the broad outlines of this essay. First and foremost, how did this work come

to be what it is, especially its mapping out of time and time into space? The gallery hand-out indicated the artist's origins and anyway, most people visiting the gallery would have some idea about Jimmie Durham's Cherokee descent, and considerable involvement in the American Indian Movement. I would like to focus my curiosity on the objects' political reflection on time, space and colonization and their insistence on a mode of understanding which derives neither from polarities nor from the immediate impressions of vision. To decipher Durham's work it is necessary to observe closely and to stand back and wonder.

I want to use the lay out of 'Original Re-Runs' as a way into this discussion. The exhibition created, in the first instance, an encounter with its space, so that one became aware of the space as a consciously produced environment before encountering the individual objects within it. Durham gave the ICA site a life of its own and it took on a momentum which carried one through a gallery space which had become a customized and vitalized place. The exhibition had several ropes stretching down from the very top of the walls to coil around on the floor. As the ropes dissected the empty areas of the gallery, dead or invisible spaces acquired an extra dimension. A visual and physical topography materialized that made itself felt and then had to be negotiated on the ground. The gallery had to be maneuvred with consideration and an awareness that was implicit rather than directed. Empty areas were drawn into a general spatial relation and the works were encountered, almost stumbled across, in a casual mapping with its own hidden agenda.

While the organization of the gallery integrated the sculptures and their surrounding space, it was also broken up by a series of signs that suggested confrontation rather than negotiation. Red, white and blue, free-standing, like street directions that would either bar or allow access, they jumped out at the eye, punctuating the implicit, moulded and mobile space towards an expectation of command. But a second glance showed that a complex spatial system was at work which contrasted two ways of looking. One system could only be taken in properly from the top of the steps at the entrance to the gallery. From this position, the signs could be seen all at once and their high impact visibility dominated the rest of the exhibition, like an overlay, or surface layer running across it. Looking from sign to sign, one series, in red and white, ran from the front, VERACITY, through the middle, VERACRUZ, to the very back wall, VORACITY. The words linked together through series and displacement of meaning, in a manner that undercut their immediate visual impact. These signs drew attention to two others, blue based with white lettering, VIRGIN and VIRGINIA, which linked back obliquely into the system. Later, I came across this quotation from Paolo Friere in an early essay of Durham's, which seemed to throw further light on the critical implication of the signs:

'In mass societies where everything is prefabricated and behaviour is almost automized, people are lost because they do not have to "risk themselves". They do not have to think about even the smallest things; there is always some manual which says what to do in situation A or B. Rarely do

Choose Any Three (detail)
1989
Wood, acrylic paint, paper
260 × 86.4 × 28.8 cm

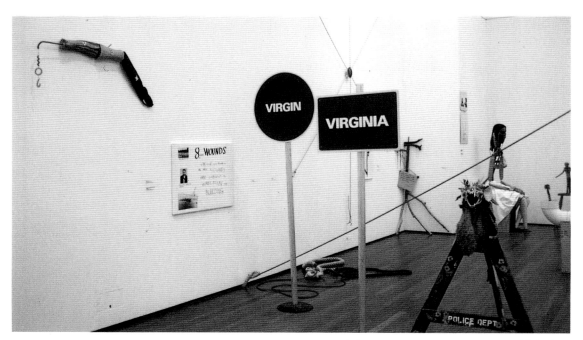

Original Re-Runs (detail)
1993
Installation, ICA, London

people have to pause at a street corner to think what direction to follow. There's always an arrow which deproblematizes the situation. Although street signs are not evil in themselves and are necessary in cosmopolitan cities, they are among the thousands of directional signals which, introjected by people, hinder their capacity for critical thinking'.[2]

The system set up by the metal signs inscribed a correct position for taking in and reading the words at a glance. Willy nilly, one was placed at a dominant position, able to survey the space in which the sign system mapped across the rest of the exhibited works. From this, initial, perspective, the two, the signs and the sculptures, were in opposition. The signs were like signs of colonial presence, literally inscribed across and over the gallery space. The metallic material, the industrially produced objects, the words themselves, the viewer's perspective, contrasted with the rest of the objects, which could not be accurately taken in from this position and which had, from a distance, a rough, organic resonance. Thus, at first glance, the exhibition's actual lay-out rendered visible the binary oppositions nature/culture, industrial/organic, word/object,

above/beneath, modern/archaic, civilized/ primitive, city/country, and so on. And the subsequent journey into the gallery and through the work would be one in which this first impression would be modified and finally transformed. However, the signs' highly visual network across the room, shining with the red, white and blue of the US and British national flags, was already, at this first glance, open to transformation and modification that challenged the binary assumption.

The word VIRGIN carries the concept of the 'virgin land', evoking European disavowal of any cultural, or perhaps even human, presence in the new world.[3] Such a disavowal, of course, not only stemmed from the logic of binary thinking, but also allowed the question of occupation and the establishment of ownership to be conveniently avoided. And the word VIRGINIA supplies a specific historical reference. The English colony of Virginia was only established in the mid-seventeenth century, after various false starts in the late sixteenth, and has not been easily integrated into the myths of American ontology. Peter Hulme quotes from Perry Miller's attempt to construct an 'American Genesis' as dating from the Puritan migration ('I recognize … the priority of Virginia, but what I wanted was a coherence from which I could coherently begin'). Hulme then comments:

'There is little in Virginia's early history to give a satisfying sense of an "innermost propulsion" at work. Even worse, perhaps, Virginia had difficulty in maintaining the coherence and integrity that its name had hopefully suggested, the proper boundary between the "self" and "other" that is necessary to any establishment of national identity'.[4]

And then, as every English schoolchild knows, the colony was named in honour of Queen Elizabeth I, whose virginity was as mythic as that of the 'virgin land'.

The other series (VERACITY, VERA CRUZ, VORACITY) sets in motion another concatenation of ideas associated with colonialism. Ironically sited between religion and greed, 'Vera Cruz' invoked the Atlantic port in Mexico, named by the Spaniards with the unconscious accuracy of the pathological symptom. The name irresistibly conjured up the fetishistic aspect of contemporary Catholic belief in the True Cross (little bits of which were sold in forest like proportions before the Reformation) and thus also the phantasmagorias that fuelled the Spanish conquest and colonization process. Any truth that is upheld with utter certainty implies an element of irrational belief and the pathological sense of rectitude that justifies intolerance. It was this pathological certainty that justified the colonization of Mexico in the eyes of the Catholic Kings (Ferdinand and Isabella) as a continuation of the expulsions and forced conversions of Muslims and Jews that unified the Spanish nation after 1492. VERACITY and VORACITY then bear witness to the inextricable imbrication of political and personal greed with religious convictions. The literal displacement of the letters, and the use of *city* as a shifting signifier, celebrates the displacement of meaning with the simple gesture of a joke. But the shifting signifiers, condensation and displacement, allow the viewer to consider the signs as 'signs' within a psychoanalytic and semiotic intellectual framework, and thus bring to mind the intellectual disciplines which have particularly attempted to challenge inherited political and religious certainties. Encountering the signs from the vantage point of the gallery steps, the viewer was introduced to the vision of perspective and then warned against trusting in its truth. Tzvetan Todorov brings a number of these themes together in the following point:

'European linear perspective may not have originated from a concern to validate a single and individual viewpoint, but it becomes its symbol, adding itself to the objects represented. It may seem bold to link the introduction of perspective to the discovery and conquest of America, yet the relation is there, not because Toscanelli, inspirer of Columbus, was a friend of Brunelleschi and Alberti, pioneers of perspective (or because Piero della Francesca, another founder of perspective, died on October 12, 1492) but by reason of the transformation that both facts simultaneously reveal and produce in human consciousness'.[5]

Just as the dead space of the gallery had been materialized into a place with rhythm and a presence, so the rigid truth of the word/name dissolved into wit, allusion and uncertainty. In this way, the gallery gained two extra dimensions in addition to the usual relation between viewer and art object in a gallery setting. First, the look that understands 'at a glance' was invoked and then discomforted. Interconnections between the signs had to be mapped by looks, and the looks took time, even if a short time, to read, to get the point, to be amused, and then to think about what it meant as a first step into the show as a whole. And once the show is stepped into, the signs will continue to reverberate as the visitor negotiates

the other topography shaped by the hanging and coiling ropes. Before even thinking about the individual works on display, the scene is set for curiosity and encounter and the actual sculptures and other works on display had to be approached without recourse to immediate assumptions or a unified perspective. They had to be viewed and understood from different positions and with various approaches. For instance, written messages had to be read close to, but may also be integral to work that, as an aesthetic whole, could only be taken in from a distance that renders the words illegible. After the initial experience of word displacement seen from a single position, the rest of the exhibition became a journey of subtle displacements through material and ideas.

For instance, *Red Turtle* (1991) places the turtle shell at the meeting point between two straight sticks forming a large X and two winding ones forming a horizontal snake shape across it. One red and the other blue, the snake sticks and the turtle shell are composed of the primary colours. Between the two lower sides of the X, a piece of paper is attached. *Red Turtle* caught my glance in the exhibition as a juxtaposition of shapes, emphasized with colour, that was extremely simple in design but held my visual attention and imagination. After looking at it from a distance for a time, I went over to read the words on the paper, watching it change from pure shape into legible message. Written in rough capital letters, it spelt out the colonial educator's classic cri de coeur: 'We have tried to train them; to teach them to speak properly and to fill out forms. We have no way of knowing whether they truly perceive

and comprehend or whether they simply imitate our actions'. The message affected the work as a whole, so that the straight lines of the X to which it was attached took on the significance of a cross, a mark, a substitute signature, an error sign, which stood in tension with the indeterminate, organic shape of the snake, caught but still slipping away. The message knows not only that appearance is no guarantee of certainty but that appearance can defend something secret, invisible and elusive. It is the paper message that comes across as exposed and fragile in juxtaposition to the turtle shell, with its ability to defend its inside from outside investigation. The fact that the Cherokee turtle dance involves rattles made from turtle shells is not, perhaps, immediately relevant, but the shell is a reminder of a system of relating to the world that was invisible to the colonizer's uncertain certainty and could not be reduced to the bureaucrat's paper, pen and ink.[6] At the same time the snake shape could act as a reference to the Crazy Snake Movement, the last ditch resistance of the so-called Five Civilized Tribes to the Congressional Act which imposed private property on the Indian people. While these thoughts and reflections are inseparable from the object that produces them, they also travel beyond it, towards the misunderstandings that are central to the confrontation between colonized and colonizer. Reading the message, it was impossible not to smile and think of the despair experienced by Dominicans in Mexico, who, having built their altars on indigenous sacred sites, suddenly realized that the people might not, after all, be truly worshipping the cross.

Walking around 'Original Re-Runs', I was

Red Turtle
1991
Turtle shell, paint, wood, paper
147.6 × 162 × 13.2 cm

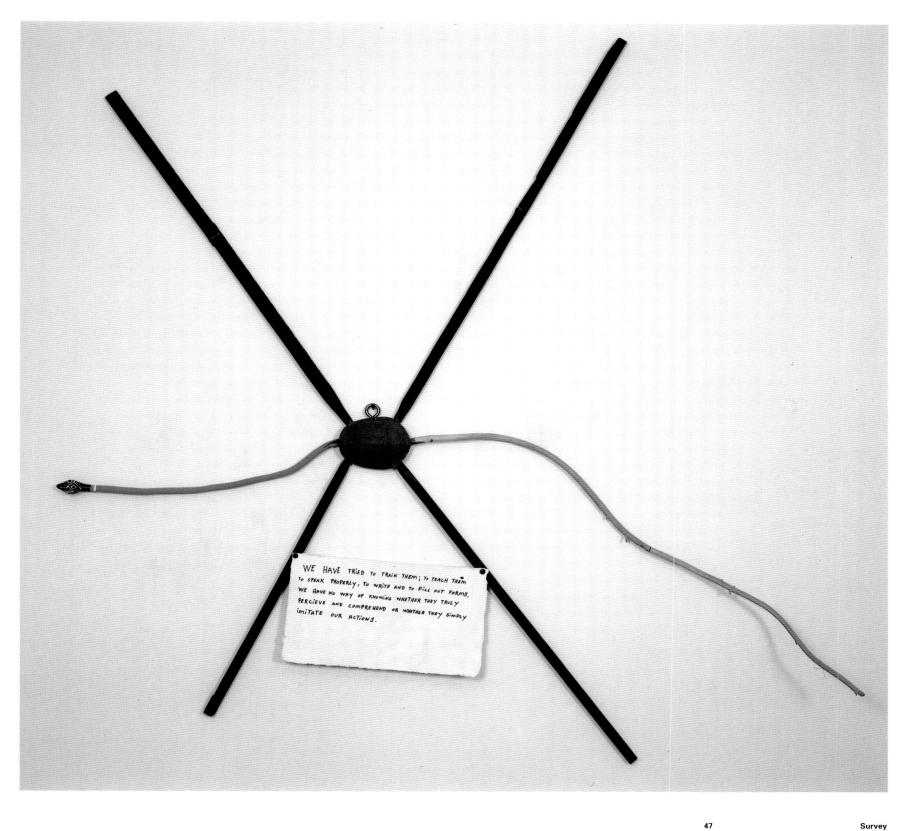

WE HAVE TRIED TO TRAIN THEM; TO TEACH THEM
TO SPEAK PROPERLY, TO WRITE AND TO FILL OUT FORMS,
WE HAVE NO WAY OF KNOWING WHETHER THEY TRULY
PERCIEVE AND COMPREHEND OR WHETHER THEY SIMPLY
IMITATE OUR ACTIONS.

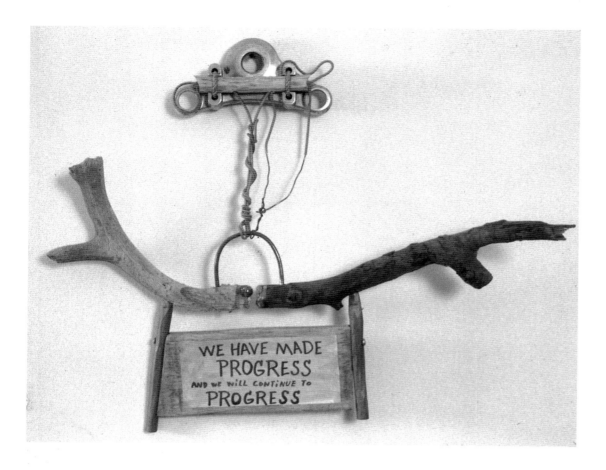

We Have Made Progress
1991
Wood, metal, plastic, glass, paper
60 × 50.4 × 7.2 cm

struck by the way that Jimmie Durham's art work grows out of two 'dialogues', or 'negotiations', first with his materials and second with his audience. In a sense, he addresses his materials and materializes his audience. His materials preserve their own presence as objects, so that the original shapes and textures enter into new configurations in his sculptures. A completed Jimmie Durham sculpture remains 'unfinished'. The raw material is not transformed into something born out of the artist's creative endeavour, into an original work of art whose previous existence is erased under the perfect finish of the new object. The creative process changes and affects the material but also treats it as 'found object'. The 'found object' has a tradition in twentieth century radical art that dates back to Marcel Duchamp's move away from Cubism, which had incorporated bits of real things into art work, to his readymades. When, in 1913, Duchamp placed a bicycle wheel on

a kitchen stool to make a sculpture, both objects still preserved a continuity with their previous existence but had undergone a radical transformation. The artist chose the objects and, by putting them on show, placed them in a limbo in which their use value disappeared and a new aesthetic value was asserted. However, the aesthetic value would only really come into its own as an address, albeit a Dadaist one, to the preconceptions and receptivities of its potential audience. The address was theoretical as well as aesthetic, while presenting itself overtly in a negative relationship to the tradition of authorship it contested. Although any work of art demands that its audience negotiates with its presence and potential significance, the Duchamp readymade satirizes the enigmatic moment of artistic creativity, which is then left exposed for reverie and critical examination.

Jimmie Durham puts these points together in a piece he wrote in June 1983, 'Creativity and the Social Process':

'In one of my more famous theories about sculpture (famous, that is, among the voices inside my head; it has never been made public except in some bars), I explain that what a sculptor does is change objects. We take a stone or pieces of metal or plastic and rearrange them to make some order, or non-order, that satisfies us in some way. After Duchamp, this re-arranging can often be simply a matter of placing an object in a different way or in a different place than we would normally expect to see it, or by consecrating it with a signature... From this perspective we could substitute "he created a new piece" for "she changed another object". The implied question would always be, "Why did she change that

object and what does it have to do with me?"[1]

The process then becomes a social process and one that puts the object into dialogue with its audience. Durham's pieces create openings for thought and possibilities for the viewer to ask the question 'why?' These openings and possibilities are offered in the first instance by the sculptures' 'montage' effect. The different elements fail to fit into an immediately perceptible aesthetic unity, preserving their own presence as object, albeit an 'object' that has been thoughtfully 'changed' through arrangement, decoration and exhibition. And the viewer, standing half in intuitive, half in intellectual reverie is brought to consider the way these objects exist in time, and then, more generally, the temporal dimension of art and its process of creation.

Duchamp challenged a concept of creativity that valued an artist's ability to transform raw material to the point where it became something utterly new. In its mythic apotheosis, this tradition merged the creation of the art object with creation itself, as, for instance, in the story of Pygmalion or in its reverse, Edgar Allen Poe's 'The Oval Portrait'. Throughout the twentieth century, radical art came to acknowledge the presence of its material, with the well-known Modernist emphasis on the specificity of the medium and pleasure in the presence of the signifier. However, the found object carries with it aesthetic factors that go beyond specificity into another kind of materialism. An object that maintains its own presence and significance within a sculptural work also maintains its dimension in time. For instance, *Untitled*, 1992 is a found object, a stick with the residual traces of

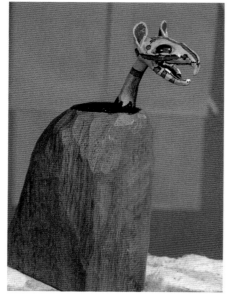

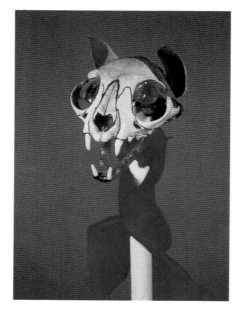

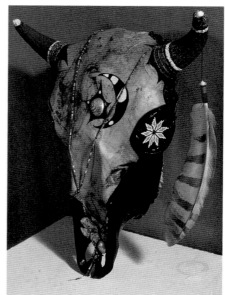

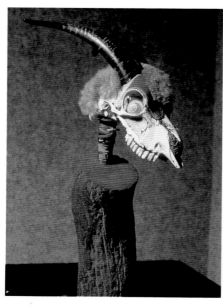

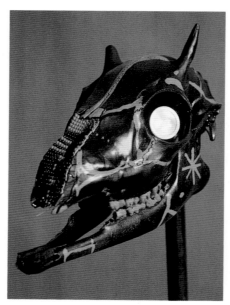

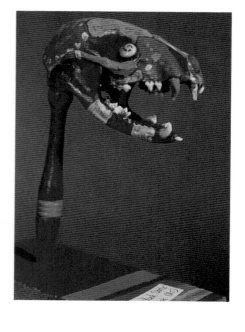

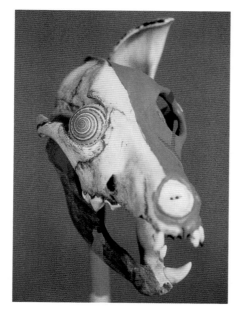

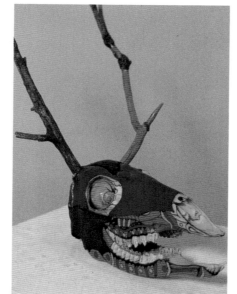

its branches forming an asymmetrical pattern, painted red. It maintains its original beauty, its particular line and form that have been shaped by the process of growing and then by the process of decaying. It then acquires the beauty of its colour, a dense but luminous scarlet. The work has no chance of seeming to emerge out of the artist's mind and skill alone. Rather, the artist's skill seems directed towards recognizing qualities and properties belonging to certain objects, while the artist's mind seems directed towards changing and arranging them for exhibition. The social process stretches backwards into the past and forwards into the future and the two materialisms, object and address, acquire a history. In the case of *Untitled*, 1992, which bears the appearance of a red stick, history is invoked beyond the history of the object itself; the Red Sticks was the name adopted by native people who attempted an armed resistance against Andrew Jackson's removal policy during the 1830s.

Time is a relatively contingent concept and one that is supremely subject to metaphorical representation and ideological investment. Durham's work raises questions about time itself and its relation to history. Perhaps the viewer is most immediately struck by Durham's use of animal skulls to create a temporal continuity between his objects' own history and their existence in the present tense of art work. In *Ritual and Rhythm,* a detail from the installation 'Manhattan Festival of the Dead' (Kenkeleba Gallery, New York, 1982), he incorporated a variety of animal skulls decorated with brightly coloured paint, shells, or pieces of wood. While the piece clearly refers to the Mexican Festival of the Dead, which celebrates the continued

presence of the dead among living people, these sculptures also vividly inscribe the presence of the dead into the living art work. Once again, this is not the 'life' that an artist breathes into his raw material; it is rather an image in which hard and fast boundaries collapse, so that the gap closes between the dead and their presence as living memory and the artwork's presence and its material past. Furthermore, the difference between Indian and settler attitudes to memory are evoked here. Durham is also drawing attention to the way that the past as presence was a central aspect of Indian culture.

During the late 1980s and early 1990s Durham made maximum use of recognizable objects in his work and continued to use animal skulls, decorated and adorned with the addition of colour, and mounted on wood. At this point, the animal presence is modified by their combination with other kinds of material. As a political artist, addressing the non-history of the United States from an Indian perspective, Durham's use of found objects is polemical from both an aesthetic and an intellectual point of view. On the one hand, he presents the artist as negotiator in the creative process, on the other, he challenges a concept of history that is built on an invention of tradition. It is easy to make a metaphorical connection between an idea of art that invests in the absolute novelty of the creative process and a colonial history that invests in the absolute novelty of the New World. Or, to put it the other way round, insisting on the presence of the past in the work of art can make a metaphorical connection with an insistence on the past of the people who had lived for so long on the

Manhattan Festival of the Dead
(details)
1982
Installation, Kenkeleba Gallery, New York

top, l. to r., **Untitled**
Skull, wood, acrylic paint, glass
14.4 × 4.8 × 7.2 cm

Untitled
1982
Skull, cloth, leather, acrylic paint, glass
19.2 × 8.4 × 9.6 cm

Untitled
Skull, leather, beads, shell, feather, acrylic paint
36 × 33.6 × 12 cm

middle, l. to r., **Untitled**
Skull, wood, cloth, leather, wool, shell, acrylic paint, beads
43.2 × 9.6 × 16.8 cm

Untitled
Skull, wood, buttons, beads, acrylic paint
28.8 × 7.2 × 12 cm

Untitled
Skull, shell, acrylic paint, text, wood
30 × 15 × 9 cm

bottom, l. to r., **Untitled**
Skull, shell, wood, acrylic paint, button
31.2 × 8.4 × 14.4 cm

Untitled
Skull, shell, wood, leather, acrylic paint
33.6 × 16.8 × 31.2 cm

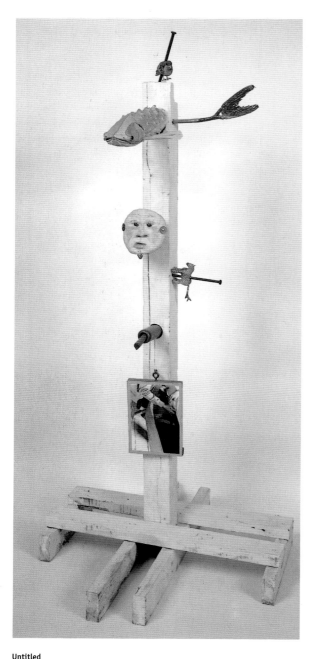

Untitled
1991
Wood, wooden fish head, wooden
fish tail, papier maché, black and
white photograph
163.2 × 78 × 72 cm

American continent prior to the arrival of European history.

From this point of view, the refusal of the moment of artistic creation as a zero point at which a new object comes into being from nowhere, condenses with a rejection of the moment when America was created, as a zero date in the history of the continent. Such a disavowal of the past dragged itself forward in time. While the culture of the Indian people disappeared behind the binary and the linear, the reality of the Indian people disappeared into a teleological concept of history. Durham's depiction of time counters the linear narration that goes with historical time. He juxtaposes a biological passing of time that can be represented by objects that have lost their living presence but still carry its memory with a heterogeneous concept of time. On the other hand, his consideration of time is conceptual. A skull carries the memory of its living creature as trace and continues to exist like a fossil, holding its past and carrying it into the future. The present tense collapses. The materials are, in semiotic terms, indexical. Reference is not made through an iconic image, but through the real trace now transformed into image through adaptation and presentation. The indexical sign is particularly relevant here, because it breaks down the antinomy between nature and culture. Whereas both iconic and symbolic signs make present an absent referent through image or emblem, the indexical sign bears the imprint of its referent, creating a link or continuity with its presence. It exists therefore in both camps, in culture and in history, or rather, it collapses the dichotomy between them. *The*

Cathedral of St. John the Divine (1989), consists of a moose skull mounted on a rough wooden plinth, painted blue and black and decorated with delicate yellow dots; it has one antler and on its other side, metal pipes supply a substitute. The moose-skull plays its part in a montage of elements, in which a pure homogeneity of the natural world has no more place than the purely iconic image. On another level, Durham's use of animal imagery, in whatever form, pays tribute to a culture which blurred, in mythology (particularly myths of origins) and custom, the hard and fast demarcation line between animals and humans.

Durham's sculptures that primarily use wood as their raw material further complicate a nature/culture opposition. Wood ceases to be a single raw material. Pieces are arranged to form the main body of the sculpture, making formal patterns through the relationship between machine finished shapes, sometimes juxtaposed to organic ones. The main body, in this set of works, is like a plinth, growing out of a wooden stand and evolving, sometimes across a photograph or written message, to a crowning figure head. One, for instance, contrasts industrial and organic shapes. Two planks, industrially produced by a saw-mill perhaps for floor boards and sawn off with straight, abrupt, diagonal lines, are juxtaposed to a piece of wood that retains its original shape, like a branch or perhaps the trunk of a small tree, with a slight curve that merges into the shape of the animal skull that crowns it. The easy flow of the line is broken up by the rough addition of small bits of wood that jut out at right angles, and seemed, to my imagination at least, to give a material shape to the animal's sad

top, l. to r., **Untitled**
1991
Wood, tie, antler, hat, iron pie
pan, acrylic paint
165.6 × 55.8 × 64.8 cm

Untitled
1991
Wood, wooden fish head, wooden
fish tail, papier maché, black and
white photograph
163.2 × 78 × 72 cm

A Man Looking for a Place
(destroyed)
1991
Wood, hair, black and white
photograph, paint, frying pan
160.8 × 60 × 97.2 cm

middle, l. to r., **Untitled**
1991
Wood, shirt, tie, polyester resin
156 × 63 × 60 cm

Untitled (Iguana)
1991
Iguana head, iron, plastic, wood
132.6 × 62.4 × 61.2 cm

Untitled (Armadillo)
1991
Cast head, beads, paint, wood,
photograph
124.8 × 60 × 22.8 cm

bottom, l. to r., **Untitled (Squirrel)**
1991
Cast head, beads, paint, wood
127.2 × 63 × 28.2 cm

Untitled
1991
Skull, beads, paint, wood, glass,
plastic tape
124.8 × 60 × 22.8 cm

Untitled
1991
Wood, hammered iron, animal
horn, glass, insulating tape,
plastic, text on board
159.6 × 76.8 × 62.4 cm

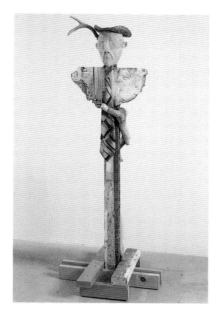
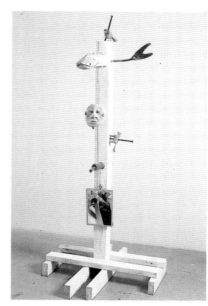
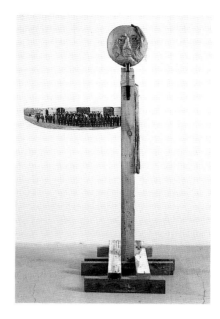
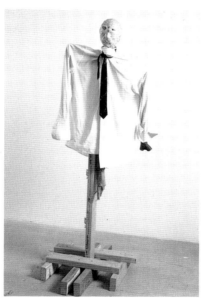
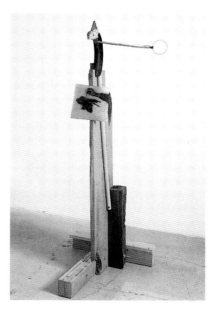
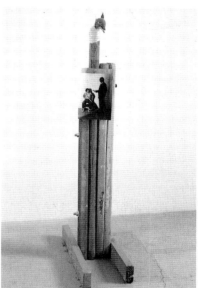
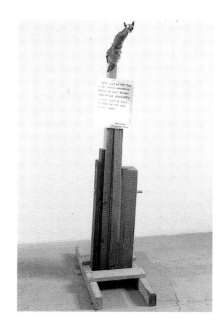
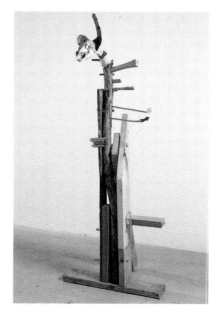
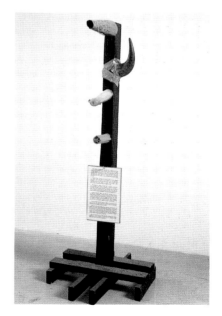

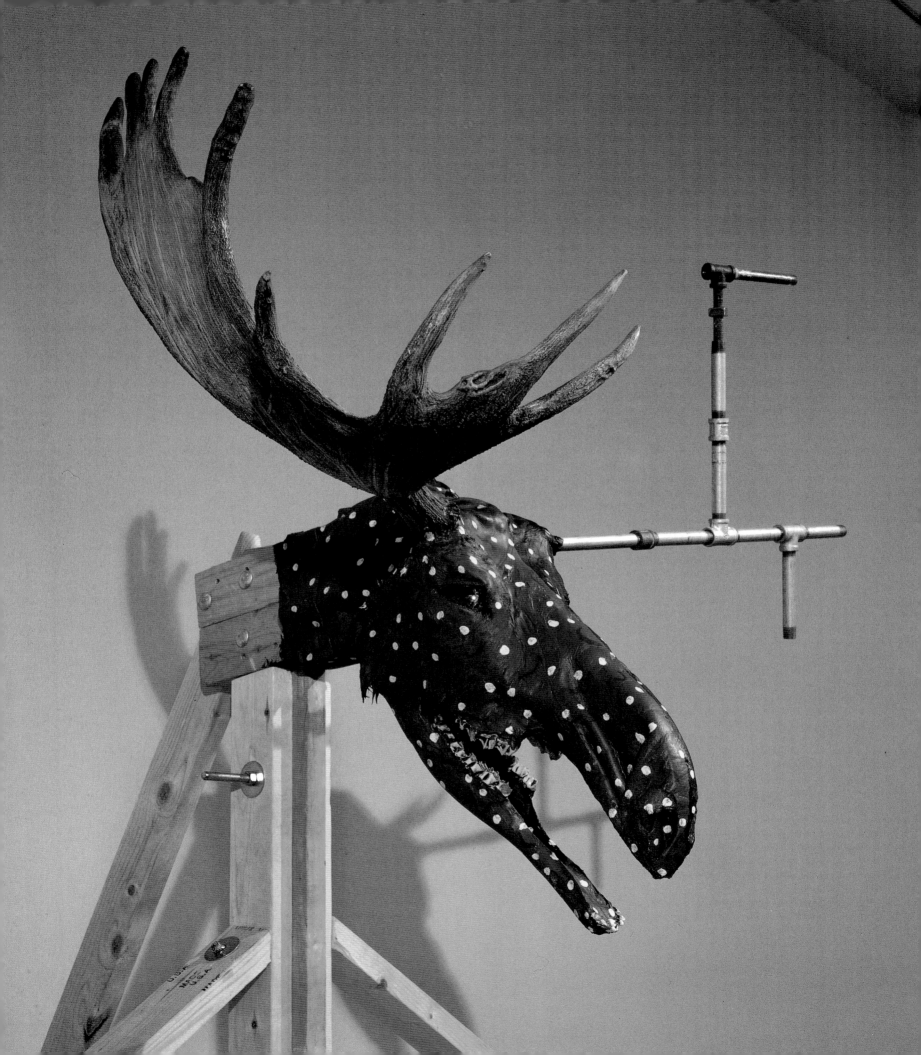

The Cathedral of St. John the Divine

1989

Skull, wood, antler, paint, metal

216 × 144 × 129.6 cm

'The Cathedral of St. John the Divine in Manhattan is the World's largest Gothic Cathedral. Except, of course, that it is a fake; of being built in Manhatten, at the turn of the century. But the stone work is re-inforced with steel which is expanding with rust. Someday it will destroy the stone. The cathedral is in Morning Side Heights overlooking a panoramic view of Harlem which is separated by a high fence'.

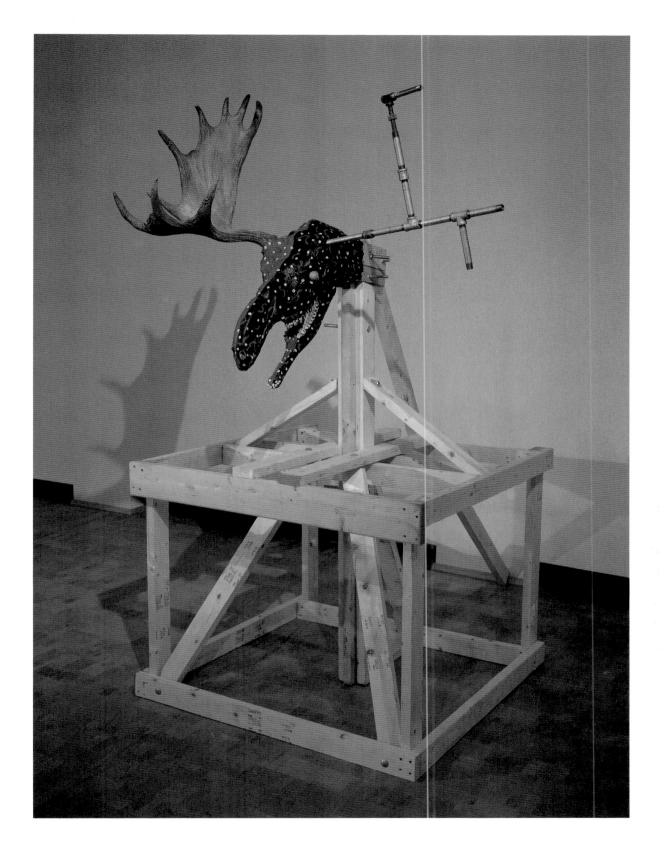

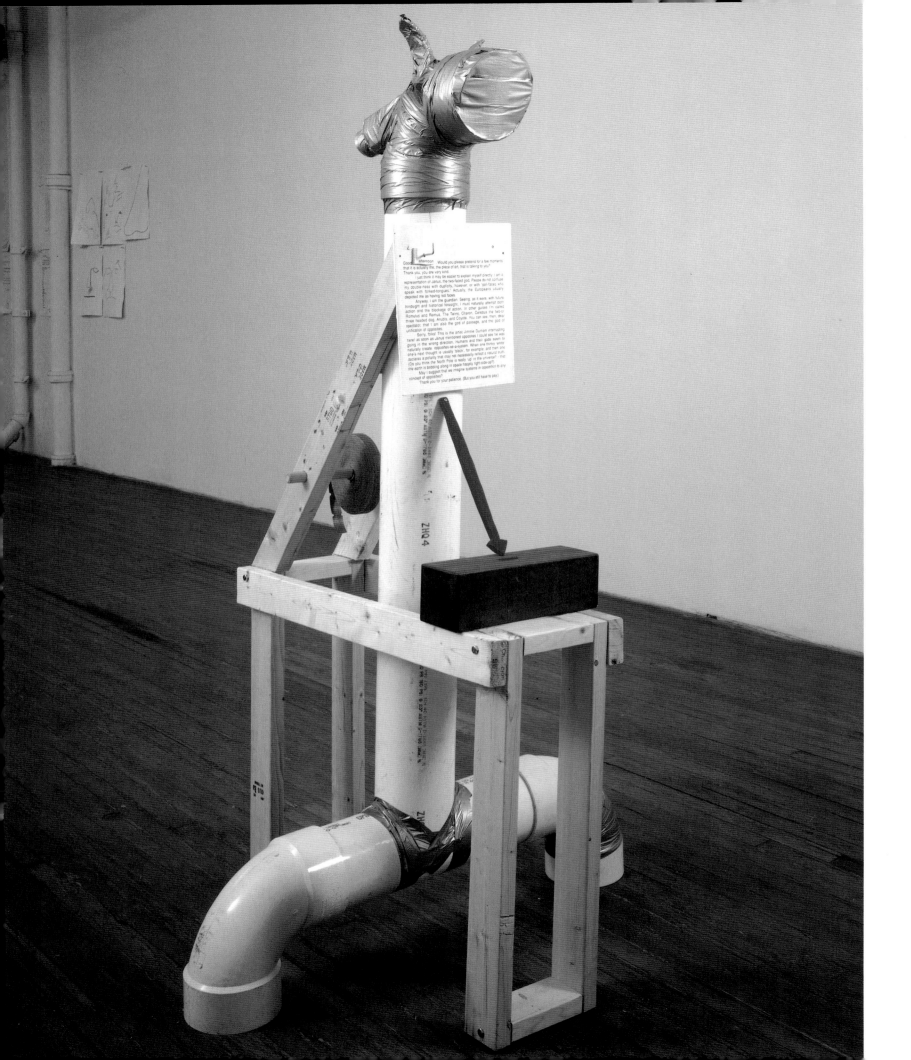

Untitled
1992
Wood, plastic, PVC pipe, paper,
paint, insulating tape, text
194.8 × 102 × 86.4 cm

cry. The pieces of wood contrast not only through the juxtaposition of the industrial with the non-industrial but through the curving roundness of the one with the square of the other. However, other sculptures make use of round lengths of wood which are machine produced, perhaps for broomsticks, and there are contrasts between the smooth surfaces produced by machines and the roughness of wood weathered by time. All these elements add to the sculptures' varied emotional impact, and the expressive relation between the figure head and the main body of a work.

Durham's use of different kinds of wood, in different relations to the organic and the industrial, leads to his use of other materials, particularly PVC piping. In his essays, Durham frequently mentions the ease with which native people took up and made use of such new materials and technologies that arrived in their country, thus challenging the before/after, technical/non-technical divide: 'There is a nefarious tendency to consider material

manifestations as traditions. If we accept such absurd criteria, then horses among the Plains Indians and Indian beadwork must be seen as untraditional. Traditions exist and are guarded by Indian communities. One of the most important of these is dynamism. Constant change – adaptability, the inclusion of new ways and new materials – it is a tradition that our artists have particularly celebrated and have used to move and strengthen our societies. That was most obvious in the eighteenth and nineteenth centuries. Every object, every material brought in from Europe was taken and transformed with great energy. A rifle in the hands of a soldier was not the same as a rifle that had undergone Duchampian changes in the hands of a defender, which often included changes in form by the employment of feathers, leather and beadwork. We six (artists) feel that by participating in whatever modern dialogues are pertinent we are maintaining this tradition'.[8]

These principles are ironically presented

Untitled
1992
PVC pipe, leather coat, paint
88.8 × 16.8 cm diam.

Untitled
1992
PVC pipe
265 × 20 × 120 cm
Installation, Documenta IX, Kassel

Untitled
1992
PVC pipe, paint, wood
72 × 136.8 × 96 cm

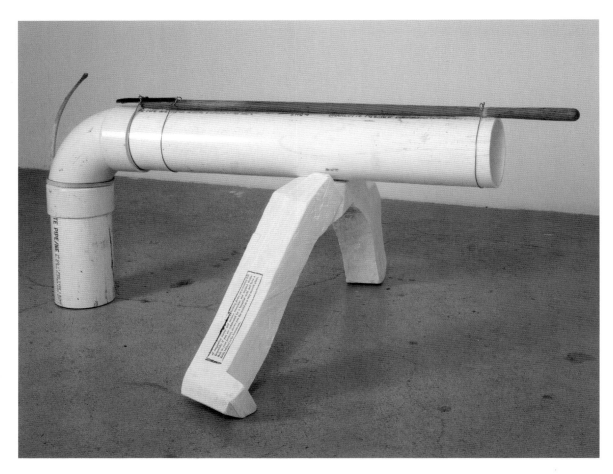

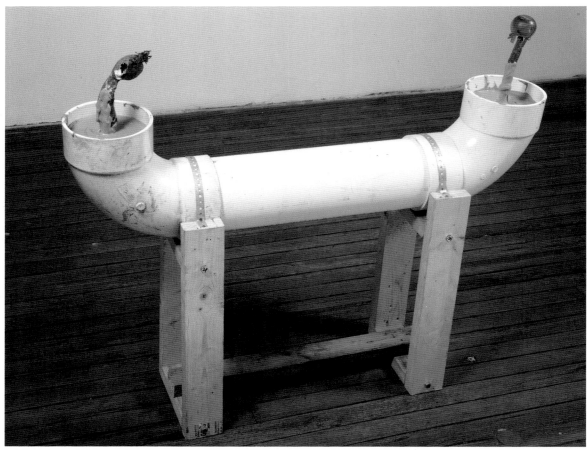

Untitled
1992
PVC pipe, paint, wood
89 × 104.4 × 25 cm

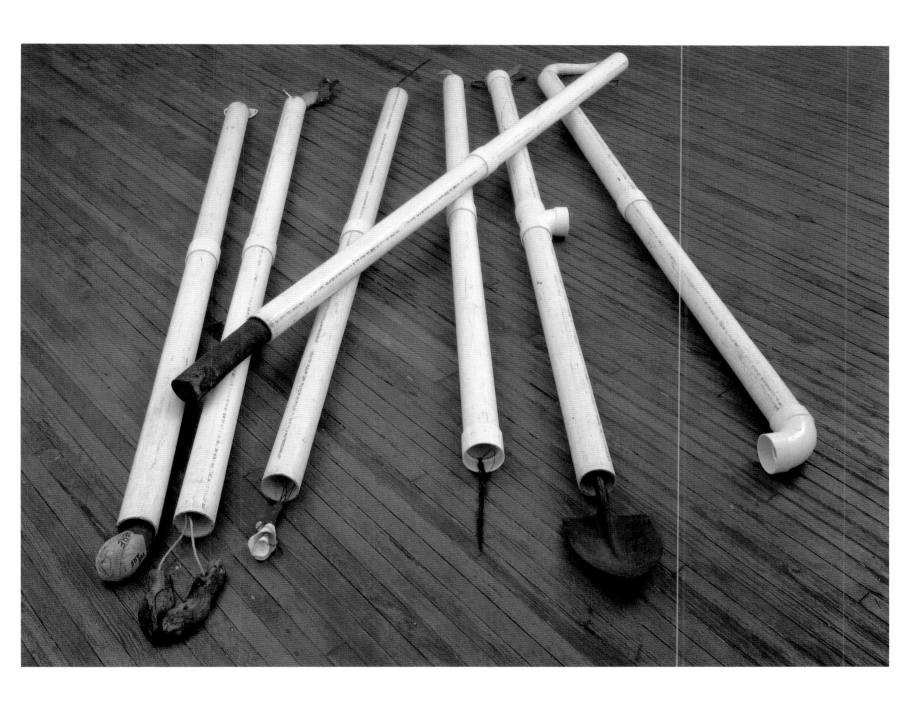

Proceeding
1992
PVC pipe, wood, stone, hair, iron
shovel
21.6 × 374.4 × 288 cm

Bedia's Stirring Wheel
1985
Aluminium, leather, fur, paint,
feathers, skull, string, cloth,
steering wheel
115.2 × 45.6 cm diam.
'from: Site B, quadrant 71
White Planes, New York
Jose Bedia, the famous Cuban
explorer/archaeologist,
discovered this stirring wheel,
sometimes referred to as the
"Fifth" or "Big" wheel, during his
second excavation of the ruins at
White Planes in 3290 AD.
'He believes that the stirring
wheel was a symbol of office for
the Great White Father, often
called, "The Man behind the
Wheel". Bedia claims that the
chief would stand behind the
wheel to make pronouncements
and stirring speeches'.

following pages, **Self-Portrait**
1987
Canvas, wood, paint, feather,
shell, turquoise, metal
172.8 × 86.4 × 28.8 cm
'Hello! I'm Jimmie Durham. I want
to explain a few Basic Things
About Myself. In 1986 I was 46
years old. As an artist I am
confused about many things, but
basically my health is good and I
am willing and able to do a wide
variety of Jobs. I am Actively
seeking Employment'.
'Mr. Durham has stated that he
believes he has an addiction to
Alcohol, Nicotine, Caffiene, and
does not sleep well'.
'Useless nipple'.
'I am basically light hearted'.
'I have 12 hobbies!'
'11 house plants!'
'People like my Poems'
'His Abdominal Muscle Protrudes
Aprox. 3-12 inches'.
'Appendix Scar'
'Hands are small, Sensitive'
'I have a crooked back'.
'Indian Penises are unusually large
and colorful'.
'My skin is not really this dark, but
I am sure that many Indians have
coppery skin'.

through *Bedia's Stirring Wheel* and *Bedia's Muffler* (1985), which decorate the modern, utilitarian car parts into exhibits for a future in which their utility is forgotten. In a further irony this tribute to an artist comrade, Bedia, which displaces use into display, shifts between the verbal and the visual, decorating the objects with beads which also, of course, refer to Indian adoption of European materials.

The native American economy was characterized by flexibility in its relation to its environment, shifting seasonally, for instance, between hunting and agriculture. And the landscape/environment was also culture, a mapping of traditional knowledge and existence onto the country itself. The settlers' misunderstanding of these relationships was formed by their perception of a landscape as a 'wilderness' rather than a repository of meaning. In this way, mythic belief, and the modes of thought that went with it, made up a base line for the political strategies that led to the Indians' history of loss and oppression. There is an essential connection here, between a mode of thought and the evolution of the actual political policy which characterizes American colonialism. Although there is the first and obvious level at which the Indian people were displaced as a result of European demand and greed for land, other factors are also significant. Michael Rogin argues that the ideology behind Andrew Jackson's determination to 'remove' the Indian people in the 1830s was based on a perception of their relation to the natural world. He quotes from Francis Parkman: ' ... we look with deep interest on the face of this irreclaimable son of the wilderness, the child who will not be weaned

from the breast of his rugged mother'. [9]

Such a perception generated a fantasy of the Indian as infant, or, in perhaps anachronistic but suggestive Freudian terms, as 'pre-Oedipal'. This altered iconography allowed the state to evolve a policy of sub-ordination and marginalization within legal and constitutional confines. Andrew Jackson was able to cloak his policies in the guise of paternalism and embark on a systematic programme of ethnic cleansing, with its genocidal hidden agenda, in the name of precipitating 'my red children' into a condition of maturity and individualistic independence. But even more significantly, the ideology revolves around an incompatible relationship to memory. An immigrant community is necessarily amnesiac. It is forced to cut off its ties with the past and even erase the political memory of conditions that may have given rise to its emigration. Thus, in a similar fashion, the Indians' ties to the land had to be broken. Two contrasting quotations illustrate the consciousness of these different cultural attitudes on both sides. In 1854, Seattle, a Dwarmish chief, said:

'To us the ashes of our ancestors are sacred and their resting place is hallowed ground. You wander far from the graves of your ancestors and seemingly without regret. Your religion was written by the iron finger of your God so that you could not forget ... Your dead cease to love the land of their nativity as soon as they pass into the portals of the tomb and wander away beyond the stars. They are soon forgotten and never return. Our dead never forget the beautiful world that gave them their being'. [10]

Andrew Jackson had said in his 'Second Annual Address to Congress' in 1830:

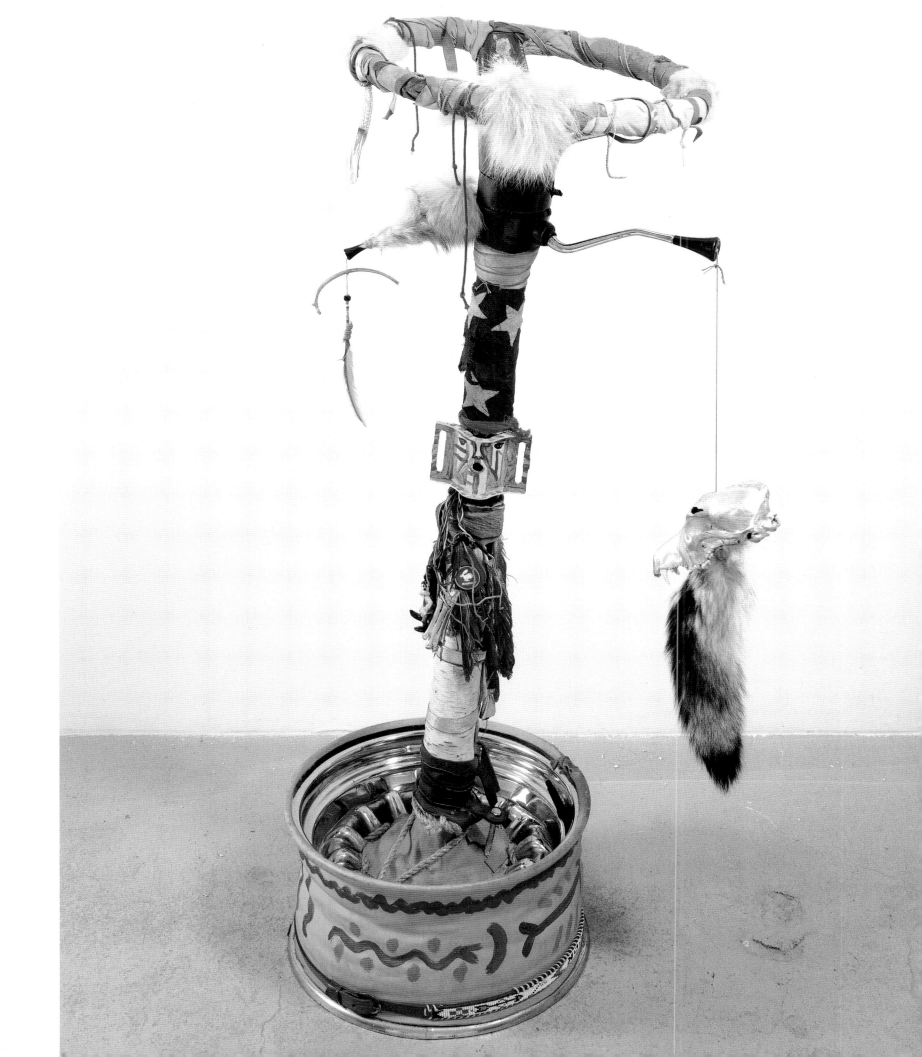

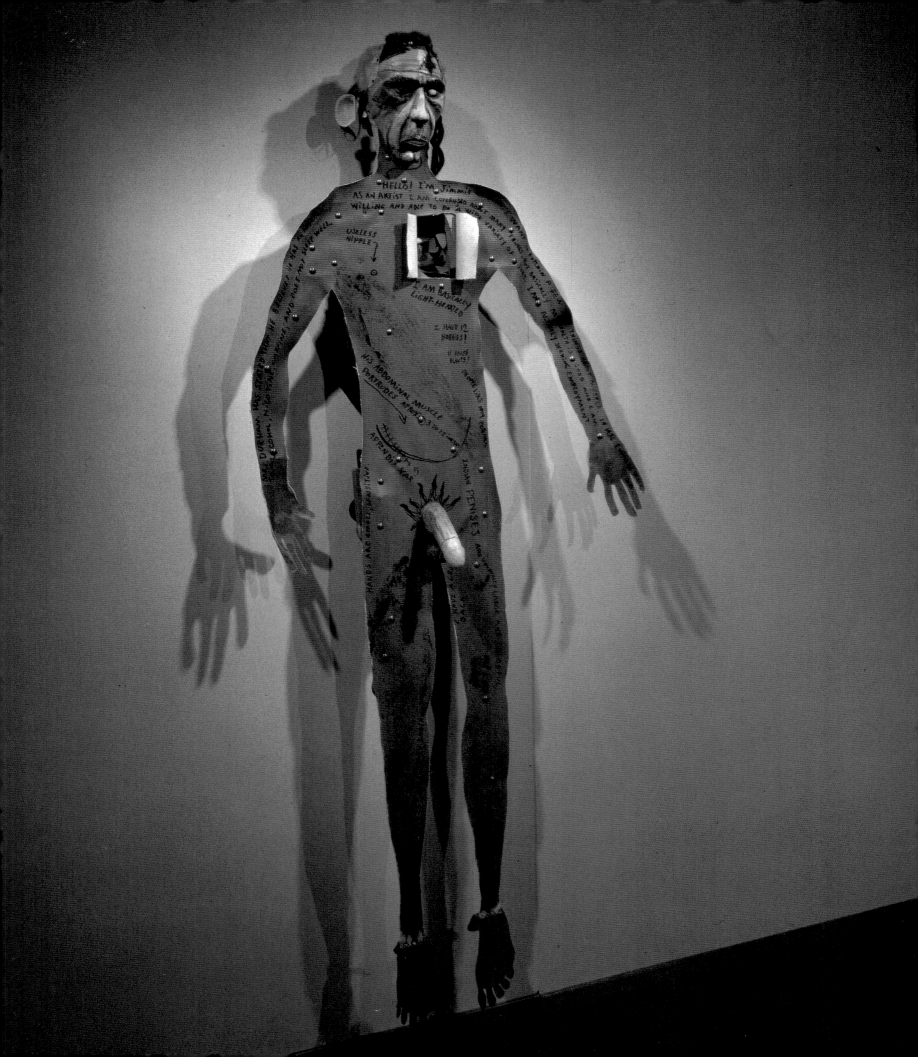

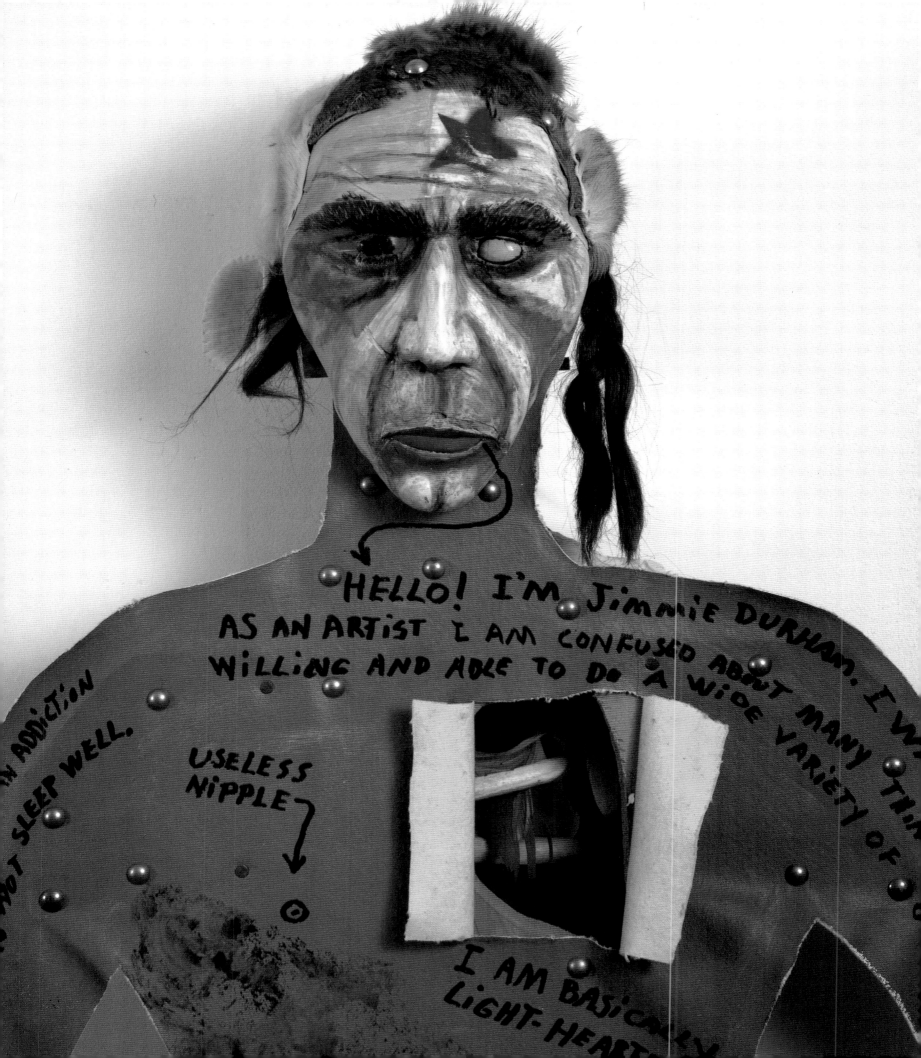

artist's note: I left those bubbles in the paper so that you would know I'm not trying to trick you, lik...

**Miscellaneous Ludlow
Characters**
1989
Text on paper, canvas
32.4 × 160.2 cm

'Doubtless it will be painful to leave the graves of their fathers, but what do they do more than our ancestors did nor that our children are doing? To better their condition in an unknown land our forefathers left all that was dear in earthly objects. Our children by the thousands leave the land of their birth to seek new homes in distant regions … These removed hundreds and almost thousands of miles at their own expense, purchase the lands they occupy, and support themselves at their new homes from the moment of their arrival. Can it be cruel in the Government, when, by events which it cannot control, the Indian is made discontent in his ancient home to purchase his lands, to give him a new and extensive territory, to pay the expense of his removal, to support him a year in his new abode? How many thousands of our own people would gladly embrace the opportunity of removal to the West on such conditions?'[11]

Under this inappropriate symmetry is concealed one of the worst tragedies of the Indian people, who were rounded up by the army and moved with enormous suffering and loss of life.

The Cherokee, for instance, lost a quarter of their people on their forced march and probably about thirty thousand Indians died during the removal period. The historical details of these events became the subject of another wave of official amnesia, or rather lay neglected and forgotten under a growing mass of popular mythology and belief about Indian life.

Jimmie Durham's work needs to be understood in the context of these paradoxes. His works of art bear witness to a history of loss which, even in its most intense drama, passed into national obscurity to become a lost history, preserved in Indian peoples' memory from generation to generation. However, the two aspects of loss then need to be understood within the context of a second paradox which also relates to Durham's work. Almost in proportion to the invisibility of Indian history, the image of 'the Indian' proliferated into visibility, first, in American popular culture and then exported all over the world with the international economic dominance of American popular culture, particularly the movies. Given

In Ludlow, Colorado, sent a train-load of Pinkerton men to kill the striking miners. Mrs. Rockefeller did it. The Ludlow Massacre may be considered as a cause, a source of phenomena even today. But Rockefeller had nothing to do with building the Cathedral of St. John. He built Riverside Church a few blocks away from the cathedral. So of course the National Council of Churches established its headquarters next door.

Jimie Durham 84

of the artists do. But don't worry; it's completely preserved.

this history, Durham's work is necessarily wary of iconic representation. There is no other comparable case in which a devastated people has had its image appropriated and circulated by the perpetrators of devastation. The 'Negro' image had a certain kind of commercial exploitation but, almost totally repressed by Hollywood, it never achieved the visibility of the 'Indian'. Perhaps there is some parallel in the circulation of eroticized images of women, particularly within American commodity culture.

The iconography of the Western frontier gave new vitality to the American Manichaean mode of thought, transforming it out of generalized European origins into a substitute for historical understanding. In yet another bitter paradox, the mass circulation of Western frontier mythology, with its readymade Indian iconography, took place at the same time as another desperate moment in the history of the native Americans. During the 1870s and 80s, Congressional legislation denied the Indian nations' autonomy and independence from the United States. Finally, at the instigation

of Senator Dawes, the Allotment Act of 1887 imposed private property on Indian people, decreeing that they could no longer hold land and possessions in common.

'The common field is the seat of barbarism, proclaimed an Indian agent. The separate farm is the door to civilization … The Indian must be imbued with the exalting egotism of American civilization so he will say "I" instead of "We" and "This is mine" instead of "This is ours".'[12]

The Dawes Act simultaneously overruled Indian social and constitutional traditions and, as individual 'lots' were fixed at 160 acres per head of household, it freed vast tracts of reservation land for white settlement or mining. It was during these decades that, with the industrial revolution in publishing, the 'dime novel' created the first mass entertainment market, with a readership of millions whose preferred genre was the Western. This genre simplified even further the Indian iconographies that had been gradually taking shape in white culture, and circulated them to a vast readership of newly arrived immigrants.

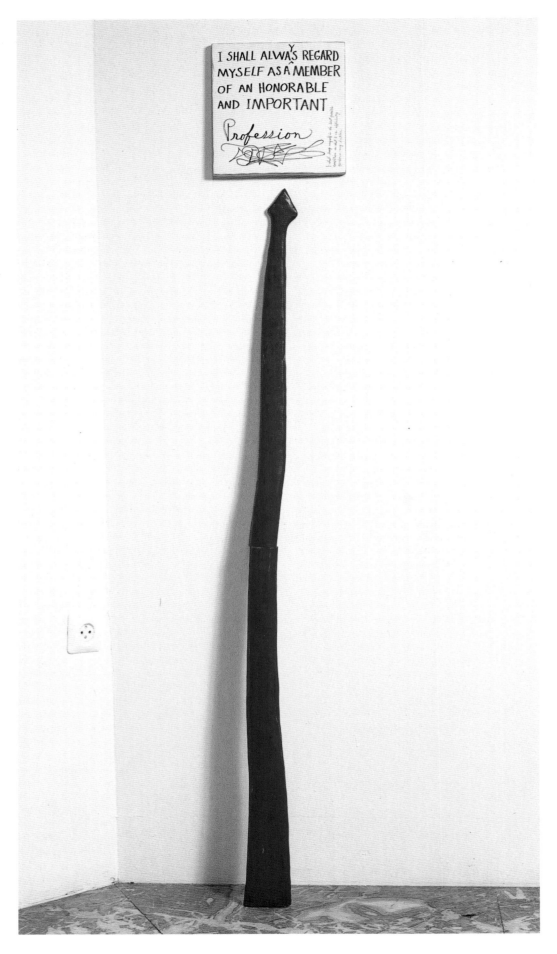

Articles 2 and 3 from the 1986
Pinkerton's Agency Manual
1989
Ceramic, wood, paper, polyester
resin
132 × 24 × 24 cm

Henry Nash Smith comments:

'Orville Victor once said that when rival
publishers entered the field the Beadle writers merely
had to kill a few more Indians. But it went further
than that. The outworn formulas had to be given zest
by a constant search after novel sensations. Circus
tricks of horsemanship, incredible feats of shooting,
more and more elaborate costumes, masks and
passwords were introduced, and even such ludicrous
ornaments as worshippers of a Sun God devoted to
human sacrifice in a vast underground cavern in
the region of Yellowstone Park. Killing a few more
Indians meant, in practice, exaggerating violence
and bloodshed for their own sakes, to the point of
an overt sadism'.[13]

By 1882, the Wild West show had developed
into marketable form, and the two strands of
'frontier entertainment', the novel and the
spectacle, were ready to fuse into the Western
film and then achieve worldwide consumption
through Hollywood domination of the interna-
tional entertainment market. The origin of this
explosion of imagery, and the recycling of the
Manichaean vision into mass circulation popular
culture, was thus located precisely at the moment
when the native people's actual survival was in
doubt. It is as though the mythology had congealed
into a huge smoke screen which concealed the
United States' government policies and their real
effects on native peoples' lives.

Such a complete disjuncture between the
Indian peoples' history in the nineteenth century
and the fictions of the frontier, has an important
side-effect on imagery and iconography. The
fetishistic image that emerges out of a disavowal

of reality is characterized by self-sufficiency. Like an image projected onto a smoke screen, it must distract attention with its appearance of autonomy and verisimilitude from whatever it conceals from view. But as the fetishistic image attempts to hold the eye, its actual spectacular properties hint at and almost advertise its hidden secret. In this sense, an aesthetic that emphasizes the reality of material rather than the realism of iconic appearance works against fetishistic belief. Jimmie Durham's works challenge aesthetic or artistic disavowal and the credibility invested in likeness as such, both the realist tradition of high art and the kitsch verisimilitudes of popular culture. His work is 'thing' based rather than 'picture' based and it casually lacks finish or surface gloss. It is only with his work on historical 'go-between' figures, who moved across the European and the

Indian worlds, that the human figure comes into particular focus. It seems as though Durham's figures acquire more iconic verisimilitude the closer they get to the European world, as though its culture bestowed outward visibility with its clothing.

La Malinche (1988-91), for instance, is composed of a white skirt, white stockings and a gold bra on a body reduced to only head and hands. The gold bra condenses La Malinche's double association with desire, using the sexual metaphor of lust to combine the rape of woman with the rape of a people and their land. The bra's Western sexual connotations evoke La Malinche's relation to Cortes. As his mistress, she is an emblem of sexual oppression both actually, in her own story, and as the essential prefiguration of the sexual ravages of colonial domination. As Octavio

Section 8 of the 1986 Pinkerton's Agency Manual
1989
Photograph, text on canvas
57.6 × 76.8 cm

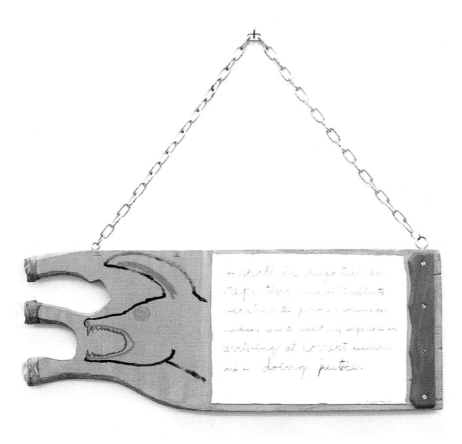

Article 10 from the 1986 Pinkerton's Agency Manual
1989
Wood, chain, paper
28.8 × 73.2 cm

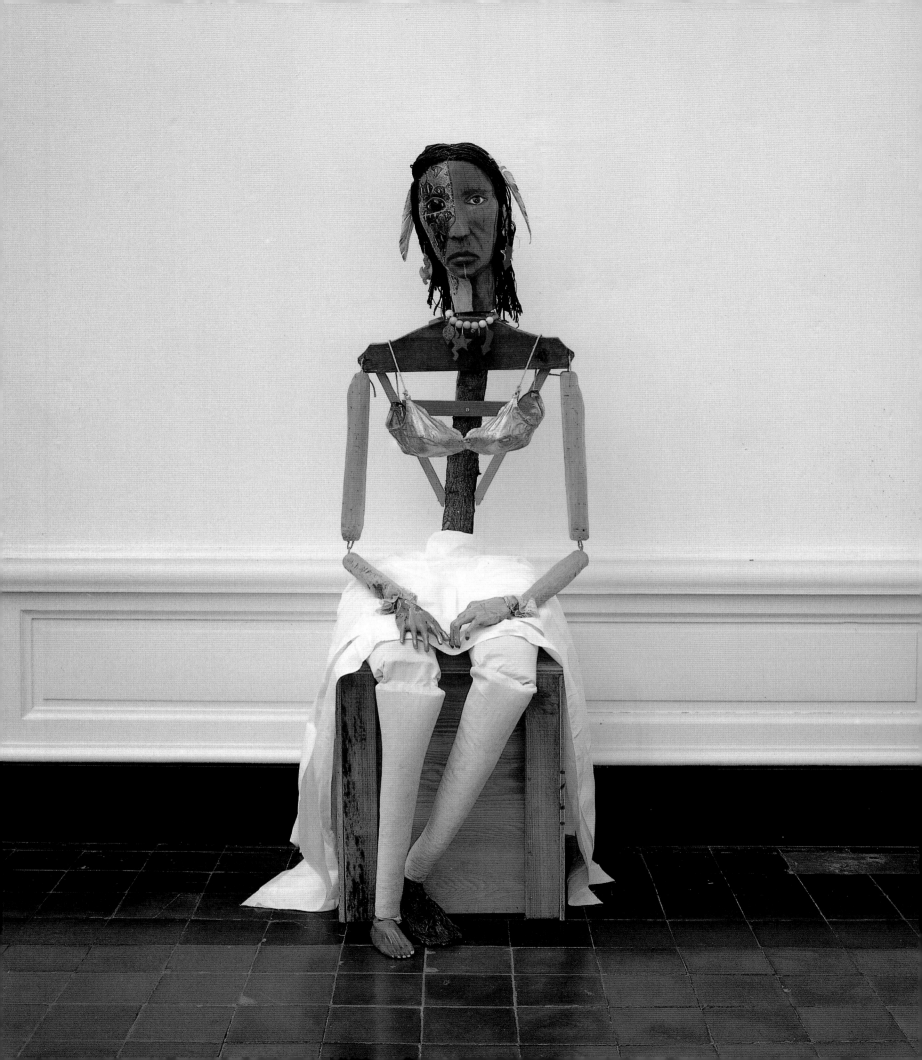

La Malinche
1988-91
Wood, cotton, snakeskin,
watercolour, polyester, metal
168 × 56.4 × 84 cm

Paz has pointed out, she is mother and whore. A traitor who bequeathed racial and cultural hybridity to Mexico. Through its colour, the bra links sexuality to lust for gold. As Cortes' interpreter, La Malinche smoothed his passage into Mexico and collaborated with the Conquest which was largely fuelled by the European's desire for gold. At the same time, white and gold are the colours of the Spanish baroque and particularly the Church altar pieces that both epitomise and disavow the true horror of Spanish colonial occupation. In Jimmie Durham's image of *La Malinche*, the tradition of her treachery is lost under her tragedy. The sculpture depicts a woman caught in events controlled by men and who had no power to affect the fate of her people. One side of her face is painted with an expression of dejection and defeat, the other is decorated with an intricate black pattern which masks any expression into illegible despair.

Pocahontas and The Little Carpenter in London (Matt's Gallery, 1988) also centres on 'go-between' figures, and Durham's self portrait, one of his few fully figurative works, may too. *Caliban's Diary*, on the other hand, records Caliban's wish to know what he looks like in the aftermath of Dr. Prospero's arrival on the island. In his diary entries, Caliban confides his inability either to visualize or make his own image. There is a sense that European culture places a particular value on iconic representation; at the same time, to be at the other end of a Manichaean polarization is to be deprived of self image. But there is also an implication that the European need to represent connects with a need to categorize, which Durham caricatures in his series *On Loan From the Museum of the American Indian*

Caliban Codex
1992
Pencil on paper
52.8 × 36 cm each

Types of Arrows
1985
from 'On Loan from The Museum
of the American Indian'
28.8 × 28.8 cm

(1991). All these works centre on issues of position, both in terms of an individual subjective position, a position of address, and a position as the place one occupies, or is assigned, in the world. Durham uses words, messages, quotations and direct address to highlight the misunderstandings and literal displacements in American colonial exchange. The placing of his address shifts, sometimes quoting from the Pinkerton *Men's Manual of Conduct*, sometimes from Frantz Fanon's *The Wretched of the Earth,* sometimes using the first person, sometimes the third person and always with irony. Meaning has to be considered; it never jumps directly out of the words as verbal discourse so easily can. And the irony often relates across word and object. For instance, *I Forgot What I Was Going to Say* (1992), includes these words on a piece of paper sticking out from a piece of rounded wood that separates a revolver from its trigger. It becomes a speaking stick that has lost its voice. In a different mode *Physickal Log* is made up of a very exquisite piece of birch wood, the central section has been whittled down to hold a message about paper. The paper referred to is apparently an academic paper, to be copied, but the viewer must also think about the origin of paper in wood and its endless waste.

Durham's ironies involve displacements of meaning across words and things. As everyone knows, the word 'Indian' is a displacement that resulted from a literal misunderstanding of geography, which was itself, most probably, rather an attempt at a condensation of incompatible political and economic discourses in Columbian Europe. However, during the nineteenth century, the primal psychological, geographical and economic displacement of naming culminated in the Indian tribes being literally uprooted and 'removed'. At the same time, the people displaced by European economic and social upheavals and turmoil, vast masses of Irish, Italians, Germans, Russians and others, arrived in the New World to form the industrial and agricultural working class that would create the wealth and power of the United States. One of Durham's quotations from

Physikal Log
1989
Birch log, paint, paper, metal
screw
12 × 68 cm

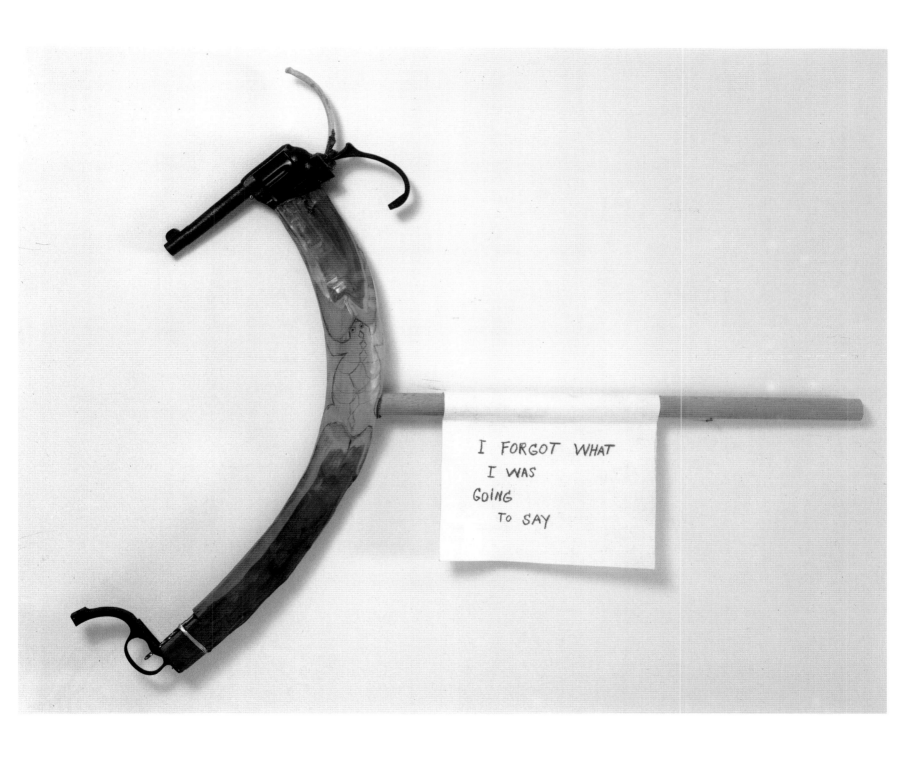

Tradition
1989
Animal hide, acrylic paint
86.4 × 86.4 × 2.4 cm

The Banks of the Ohio (details)
1992
Installation, 'Will Power', the
Wexner Center for the Arts,
Columbus, Ohio

Fanon's *The Wretched of the Earth* is written across an animal skin: 'The settlers' town is a strongly built town, all made of stone and steel. It is a brightly lit town; the streets are covered with asphalt, and the garbage cans swallow all the leavings, unseen, unknown, and hardly thought about'. This relation between nature and culture urbanizes the opposition between wilderness/agricultural cultivation and savagery/civilization. It precisely evokes colonial settlement as something which is laid on top, on the surface, of the land. The Manichaean mode of thought has become topographical, but one side of the polarization has become invisible, and written out, even, of the binary opposition. Durham's use of PVC piping brings back, ironically, the ironies of this way of thought. The piping is a conduit which connects the surface of the ground with its underneath. In Durham's way of thought, it condenses two main meanings. First, it acts as a means of disposal, of carrying the 'leavings' of civilization to an unseen destination while also acting as a means of extracting the natural resources of the earth, such as oil, to the surface to be transformed into money. At the same time, Durham uses plastic piping as a conduit to the 'underneath' of memory, both as a metaphor for the 'burying' of memory under the flow of conscious daily existence, and as a modern metaphor for access to the actual buried history of the Indian people.

In 1993 the Wexner Center for the Arts in Columbus, Ohio, staged an exhibition 'Will Power', to counter-celebrate the quincentennial of Columbus' landing in the Americas. The exhibition included a piece by Jimmie Durham called *On the Banks of the Ohio*. The piece was made of green pipes. The pipes start quite small, coming out of the wall of the museum and growing larger, with larger segments of pipe, to culminate in a huge head made of mud to suggest the shape of an enormous snake. It was difficult to see the snake as a whole. A small doorway opened a view of the head, rearing up and detached from any visible connection with its body. The body itself undulated along the gallery, set off by the white back wall which was painted with brown marks. Close by, the marks were shit-like in colour and smeared shapelessly across the surface. Seen from further back, the brown smears suddenly became elegant vegetal forms, like the growth of river plants, the tall, bending shapes of leaves. At the same time, the close-to effect remained and resonated with the presence of the pipes as cloaca, the transporters of contemporary shit through the landscape, usually invisible and underground but here monstrously visible and on display.

The serpent carried or condensed the representation of the hidden and underground transformed into the visible and overground, enacting Durham's intertwining metaphors. Just as, for instance, Bakhtin posited a relation between the impolite, lower parts of the body with their eruption in a carnivalesque mode, when the lower classes could assert a laughter of the socially repressed, so Freud used a metaphor of burying to evoke the unconscious and its repression which could erupt as symptom on the surface. For Freud, repression was historical and the buried was the past. And although he used images of known history, such as the volcanic eruption of Pompei, to evoke the plight of the individual psyche, the

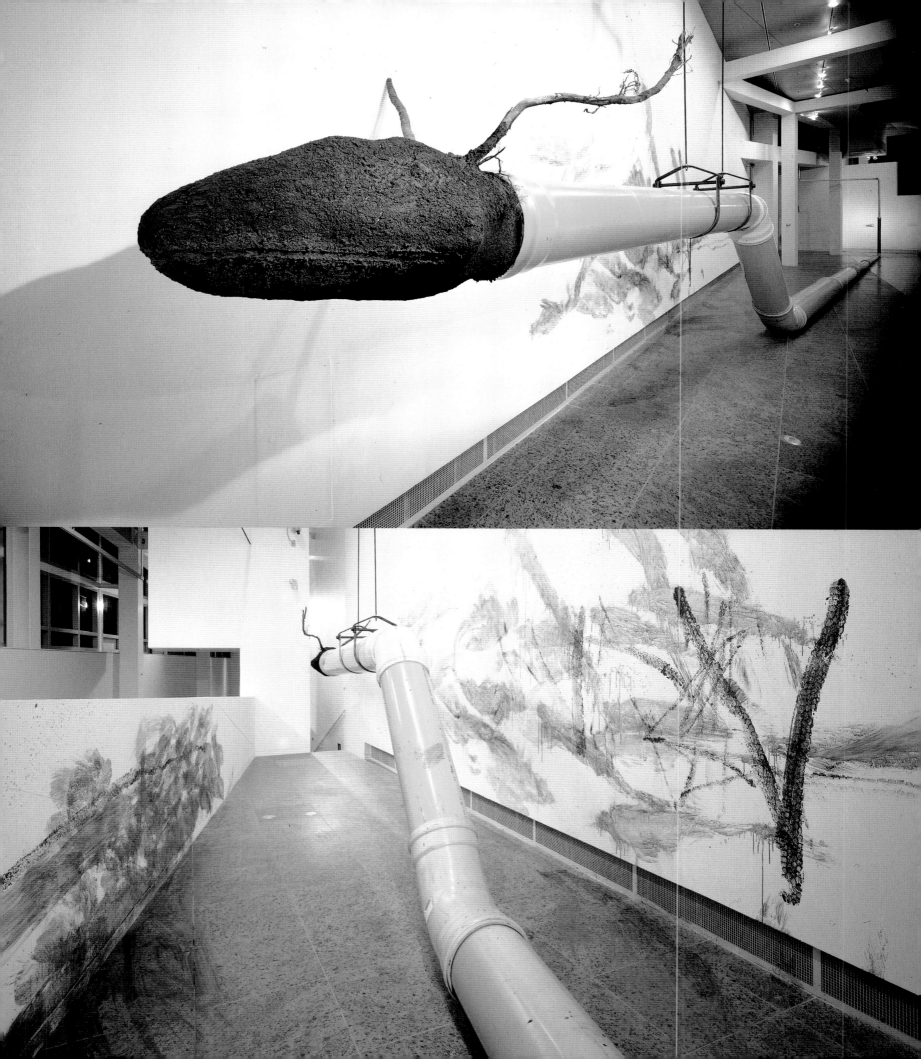

The Banks of the Ohio (details)
1992
Installation, 'Will Power', the
Wexner Center for the Arts,
Columbus, Ohio

metaphor can boomerang back to evoke the loss
of a social and collective history.

On the Banks of the Ohio refers to the Serpent
Mound, one of the most impressive of the Indian
earthworks along the valley of the Ohio River; it
winds along the top of a ridge, stretching 1,348
feet. It dates from the so-called Adena culture
which lasted for about the last thousand years BC,
to be followed by successive cultures and which
form a 'pre-history' for the native people of the
area. The mounds are sometimes burial mounds,
sometimes sacred gathering circles, sometimes,
perhaps, lunar and solar observatories, and they
bear witness to a people's commitment both to
an agrarian way of life and to cultural continuity.
Objects discovered in the burial mounds, such as
freshwater pearls, obsidian, objects formed from
mica, grizzly bear teeth, hammered copper and
gold, indicate that a complex trading network
criss-crossed the northern part of the continent.
Because these were locations of natural advantage,
early European settlements tended to form on the
same sites, and inevitably many were ploughed up,
incorporated into towns or adapted into a variety
of uses, from military encampments to present day
golf courses. Often only the word 'mound' incor-
porated into place names bears the trace of their
loss. Some, like the Serpent, have survived and
act as a sign inscribed into the landscape of the
civilizations that existed in pre-Columbian America
and a testimonial to the complexity of their history.
They also stand as a testimonial to the way that the
amnesia, imported by settler communities, was
imposed, blanket-like, on the past of the country
and on its landscape.

Jimmie Durham's tribute to the Serpent is
symptomatic of his work. Although the presence
of history and memory runs like a thread through
his themes and materials, the past is not recovered
'in virginity'. It is always subject to the movement
of time and history. But even more significantly,
the Serpent can represent the multi-faceted aspect
of his work; there is never a concentration on a
single meaning or a simple polemic. Materials act
as conduits for ideas from level to level, exploring
different topographies of time in space and space
in time. While his rejection of binarism and the
negative/positive opposition suggests a move
towards a dialectic, his aesthetic position is
one that stands back from the production of
a conceptual innovation or progress through
history as such. As he stands back, he examines
the interstices of things, so that while the dialectic
is still one of confrontation and struggle, it is
illuminated by 'acts and perceptions of combining'
and 'breaking down of separations'.

Object
It must have been an odd object to begin with.
Now the ghosts of its uses
Whisper around my head, tickle the tips
Of my fingers. Weeds
Reclaim with quick silence the beams, pillars
Doorways. Places change, and a small object
Stands defiant in its placelessness.
Durable because it contains intensely meanings
Which it can no longer pour out.
Jimmie Durham 1964

Untitled
From 'Rendez (-) vous' exhibition,
Museum van Hedendaagse Kunst,
Ghent
1993
Metal, drill, plastic
36 × 7.2 × 7.2 cm

1 Frantz Fanon, *The Wretched of the Earth,* Penguin Books, London, 1967, p. 31-2

2 Jimmie Durham, 'American Indian Culture: Traditionalism and Spiritualism in a Revolutionary Struggle' in *A Certain Lack of Coherence* Kala Press, London, 1993, p.2

3 In his *Memoirs*, Chateaubriand tells the following anecdote about his first encounter with the virgin wilderness:
'When, after crossing the Mohawk, I entered some woods where no trees had been felled, I was seized with a sort of intoxication and independence: I went from tree to tree, left to right, saying to myself,
"Here are no roads, no cities, no monarchies, no republics, no presidents, no kings, no men".
Alas, I imagined that I was alone in that forest in which I held my head so high! But suddenly I almost ran into the side of a shelter. Under the roof of that shelter, my astonished eyes beheld the first savages I had ever seen. There were a score of them, men and women, all daubed with paint, with half naked bodies, slit ears, crows feathers on their heads and rings in their noses. A little Frenchman, his hair all curled and powdered ... was scraping a pocket fiddle and making the Iroquois dance the Madelon Friquet. M.Violet was the savages' dancing master. They paid him for lessons in beaver skins and bears' hams ... Speaking for the Indians he always said, "These savage ladies and gentlemen" ... It was a terrible experience for a disciple of Rousseau, this introduction to savage life through a dancing lesson given to some Iroquois by General Rochambeau's sometime scullion. I was tempted to laugh but I felt cruelly humiliated'.
The Memoirs of Chateaubriand, Penguin Classics, London, 1965, p.164

4 Peter Hulme, *Colonial Encounters*, Methuen, London, 1986, p.139

5 Tzvetan Todorov, *The Conquest of America,* Harper and Row, London, 1985, p.121

6 See Durham, 'American Indian Culture', op. cit., p.16-17

7 Jimmie Durham, 'Creativity and the Social Process', *A Certain Lack of Coherence*, op. cit., p.69-70

8 Jimmie Durham, 'Ni' Go Tlunh A Doh Ka', *A Certain Lack of Coherence*, op. cit., p.108

9 Quoted in Michael Rogin, 'Liberal Society and the Indian Question', *Ronald Reagan, the Movie,* California University Press, Berkeley and Los Angeles, 1987, p.142

10 Frederick Turner (ed), *North American Indian Reader*, Viking Books, New York, 1974, p.252

11 Rogin, op. cit., p.154-55

12 Peter Nabokov (ed), *Native American Testimony*, Penguin Books, New York and London, 1991, p.233

13 Henry Nash Smith, *The Virgin Land*, Harvard University Press, Cambridge, 1970, p.92

Contents

What is our history, what is our culture, if not the history and culture of Caliban?
Roberto Fernandez Retamar [1]

1992 was the quincentenary of the mytho-historical event of first contact between European individuals and the individuals living in the Western Hemisphere, i.e. Columbus discovered the New World and its inhabitants. It could be argued that this encounter was the most dramatic and unexpected in all of human history; that it precipitated the greatest genocide in all of human history is of no doubt. The astonishment, the shock, the mystery, the fear and finally the inevitability of that first contact is irretrievably lost to the past. Yet the dissonant echo of that encounter has produced a half-millennium's worth of cultural decimation, proclamations, misrepresentations and endless buckets of blood. The cultural/ historical accounts of these events that have not been lost or deliberately forgotten are inevitably related in the language of the victor. Language and representation are inextricably related in all relations of power, be they individual or collective; in Jimmie Durham's Caliban works these relationships are portrayed with humour and fury, simplicity and depth.

One of Columbus' many legacies is the conceptual/linguistic paradigm he con-structed for the natives he encountered in the New World. In Columbus' world view these people could be either savage beasts or generous and docile primitives; there could be no grey area between the two perspectives. Lurking in the corners of Columbus' unconscious lay the demonic shadows of the medieval imagination, an internal landscape populated with monsters and demons; the soul, estranged from god, eternally dreamed of a return to Eden. In his journey into the unknown, it was preestablished what sort of world Columbus must find, either one populated by the marvellous and monstrous beings as witnessed by Marco Polo and described by Mandeville or one inhabited by pre-Christian beings, child-like in their utopic innocence, who could be brought to salvation through 'the word'. The former definition ultimately leads to extermination, while the latter requires a complete religious, historical, aesthetic and linguistic conversion. Either way, the original people have disappeared.

Columbus did not recognize the language of the people he encountered as a system with its own integrity, therefore he misapplied his own linguistic structure. As a free agent of European culture he embarked on what Tzvetan Todorov has called 'an extended act of nomination',[2] negating the language of the inhabitants and replacing it with the foreign

tongue (and structure) of Europe. Upon the people of the Carib was sutured the identity of the anthropophagus, the bestial man; Columbus positioned them in the landscape of his preexisting imagination. During the medieval period and the Renaissance, the Wild Man was featured prominently in woodcuts and travel books, alchemical tracts and emblems. Situated on the margins of civilization these language-less (and therefore barbaric) man-eaters, symbolized all that European man feared and for which he ironically waxed nostalgic. The Wild Man is the man without history, unfettered by cultural constraints.

Caliban is Shakespeare's anagram for cannibal. Columbus' misrecognition telescopes into the Renaissance and the Wild Man of the medieval imagination lives on in another age. Within the body of Shakespeare's *The Tempest* written in 1608, we find Caliban, the Wild Man, in an impossibly conflicted relationship with Prospero, the owner and keeper of the books, as well as Caliban's master. It is within this relationship that the struggles of language and representation and of the ownership of history and identity are played out in Elizabethan verse. In 1992 Jimmie Durham reinvents and reembodies Caliban; together they become a constellated compound figure, both fictional and living; the work becomes biographical and autobiographical. And in the process, Shakespeare's and Durham's Wild Man becomes *the* symbol, and his predicament becomes *the* metaphor for the defining relationships of colonial and contemporary America.

In *The Tempest* Prospero is the highly refined aesthete, the artist/alchemist who could be a stand-in for Shakespeare himself. Prospero enslaves Caliban but gives him 'language', a more than equitable trade in Prospero's eyes, 'Thou didst not, savage/know thy own meaning, but wouldst gabble like/a thing most brutish'. Caliban, on the other hand, feels differently about the contract, 'You taught me language, and my profit on't/is, I know how to curse. The red plague rid you/for learning me your language'. Caliban knows he is caught in the web of history, in the despotic embrace of Prospero's language. With the negation of his own tongue, Caliban's subjectivity is also destroyed, he is unable to represent himself. He is compelled to learn Prospero's linguistic structure to make himself understood, but by using the colonial language of the master he inevitably negates his own identity and is forced to assume the identity of Caliban. His only defiance can be to curse his teacher/colonizer.

Durham has stated,[3] 'I think there is no time, I think it is a funny invention, there is

CHAPTER I

Dear Dairy,

I put chapter I at the top to encourage us. I really intend to write you faithfully every week or so. I need to say what really happened here since Dr. Prospero came.

There's no one left but me (and you of course)

Now first, Dr. Prospero says he killed my mother because she tried to kill him. I was very young then but I know its not true

Or at least maybe she had a good reason.

CHAPTER II

Well Dairy, its been more than a month since I started writing you; I'm very sorry. I guess I went through a kind of depression.

That guy Ariel —— I don't love him. He's not from here, but Dr. Prospero says all these islands are the same. He's always trying to impress Dr. Prospero, and reason with him.

OK, I do love him, but not for the reasons he thinks. Really, I don't think Dr. Prospero really likes him. Maybe I shouldn't say this, but I think Dr. Prospero really likes _me_. or at best admires me.

CHAPTER IIII

Miranda says we can't do that anymore, what we used to do, I think she mustve said something to Dr. Prospero. Because she always used to say oh what if daddy saw me.

all works
Caliban Codex
1992
Pencil on paper
52.8 × 36 cm

Chapter IIIIIII

Dairy guess what?! I've decided to be an artist! Don't worry, Dairy, I'll still write you. But I want to make a complete portrayal of myself. And I'm good with my hands so why not?

I don't know what I look like. Since Dr. Prospero came there's nothing here that reflects me.

I don't know what my nose looks like, for example. I can't touch it because Dr. Prospero says its not nice to touch yourself.

C. A. LiBon

CHAPTER IIIIIIII

Today I asked Dr. Prospero if my nose looks like his.

He can be so mean sometimes! Then he said I didn't know how to draw anyway.

So heres my new idea: if my nose doesn't look like anyone else's, and if I myself don't recognize it, aren't I free of my nose? But I have to stop thinking about it.

(Calibanos)

Dear Dairy,

I didn't tell you before but its Dr. Prospero who taught me to speak and to write. as he says, his language is marvelously subtle and complex. Every day I learn a new set of words.

HEAVY, or DARK (OPPOSITES→)	LIGHT
EARTH	SKY
LAND	HEAVEN
GROUND	CELESTIAL BODIES
DIRT	SUN
DUST	ANGELS
CLAY	PHOTONS
MUD	CELESTIAL REALMS
MUCK	GOD
MIRE	LIGHT
ME	PURITY
FILTH	MIRANDA
GARBAGE	ETHER
WASTE	BEAMS
DETRITUS	RAYS
DRECK	X RAYS
DROSS	ULTRA VIOLENT LIGHT
CESS	GASES
CRAP	FIRE
SHIT	
CA CA	
DOO DOO	

Your friend Caliban,
the dairy dude

IF I CROSS MY EYES AND CLOSE MY
LEFT EYE AT THE SAME TIME THIS IS
THE PART OF MY NOSE THAT I CAN SEE.
(EXCEPT I DIDN'T DRAW IT VERY WELL.)

LEFT NOSTRIL RIGHT NOSTRIL
I BREATHE OUT, I BREATHE IN.

Caliban Codex
1992
Pencil on paper
52.8 × 36 cm

a duration of things. If a piece of history of a people doesn't get resolved, it's not history in the sense of historical conflicts, it's the present … when something gets resolved then it's past, until it's resolved then it is the present, it's always the present'. In choosing to re-embody Caliban, Jimmie Durham admits that things have not changed much. Durham is Caliban; he was christened Caliban the day he was born, just as all of his family and ancestors have been since the moment of first encounter. In utilizing this misrecognition as a motif, Durham can accomplish several things, he can splice himself into the 17th century as artist/appropriator/time bandit somersaulting through linear time, kidnapping Shakespeare's Caliban to resuscitate him and make him speak at the end of the 20th century. Durham, thus, moves Caliban's dilemma from the margins of cultural discourse, a mere footnote in English Literature, to the centre of the West's struggle for identity. Caliban's forced impersonation of himself is shaped into a mirror in which is reflected our own distorted and uncomprehending selves.

Durham's Caliban works are primarily in the form of diary entries and pencil drawings, some with pigment and small groupings of sculptures of brass and mud, with occasional additions of patina and found objects. They, like many of Durham's works, are humble in form and material, child-like and somehow incomplete. The diary entries are marked in number by strokes on the top of the page, (Chapter I, Chapter IIII, Chapter IIIIIIII, etc); not using roman or arabic numerical systems Caliban could be feigning ignorance, illustrating his primitive nature or simply being logical. The tone of voice used in the entries is disarmingly self-effacing, one might think Caliban has lost his will to defy Prospero, although there are a few passages that hint at the violence behind the relationship. 'One time Prospero was going to spank me because I was playing with mud. When I resisted I caused him to accidentally hit me in the nose'. The image itself is paint and dirt on paper. In addition to the text we see droplets of red in a random pattern that begins to form a kind of monkey-faced figure. The elements suggest various hierarchies (social, material, biological); the mud brings associations of the child and of earth, both with which Native Americans are associated. The supposed accidental violence suggests that the victim is complicitous in the accretion of deceptions that become his history.

In Chapter IIIIIII Caliban proclaims he is going to be an artist; he writes, 'I don't know what I look like, since Dr. Prospero came there's nothing here that reflects me. I don't know

overleaf, **Untitled (Caliban's Mask)**
1992
Glass eyes, button, mud, PVC pipe, glue
24 × 15.6 × 4.8 cm

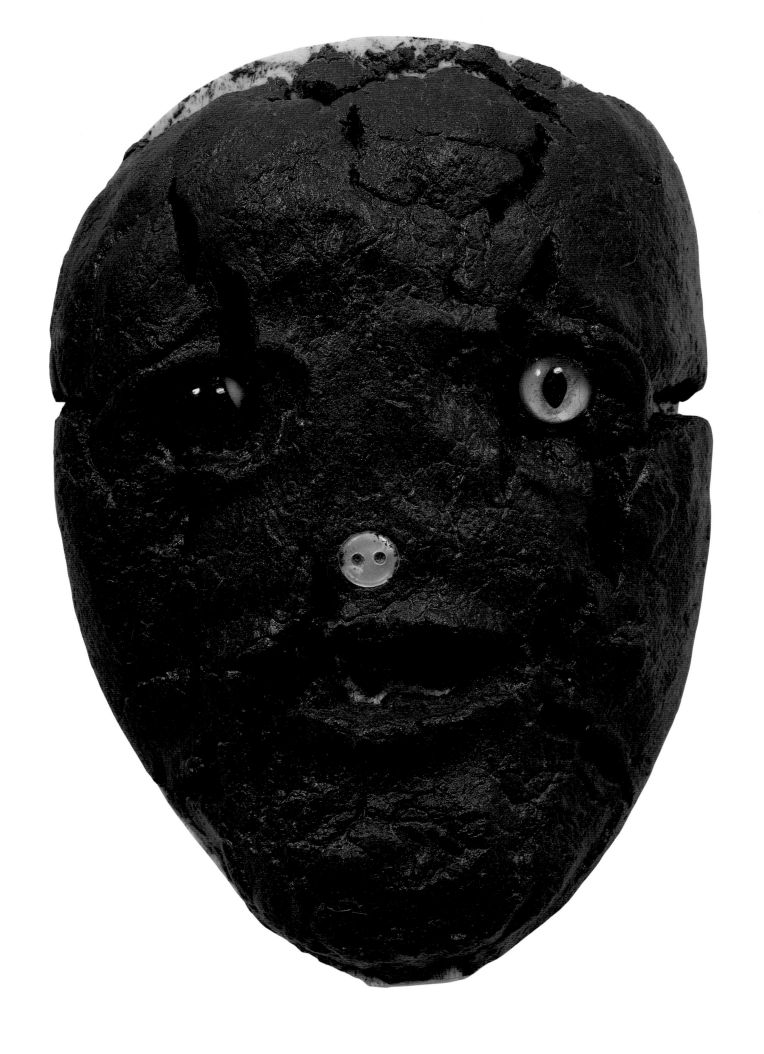

Dear Dr. Prospero,

 May I, with great humility, please present to you, as an embarrasingly inadequate small token of my extreme gratitude for the constant encouragement, extreme patience and inspired friendship (I hope!) which you have so generously employed to show me a Better Way, this self-portrait? I hope you will always remember me. (But I still wish I knew what my nose looks like! ha, ha!)

 Your grateful student,
 Caliban

what my nose looks like, for example, I can't touch it because Dr. Prospero says it's not nice to touch yourself'. Thus he sets out on his impossible quest to draw his nose and by extension, his entire identity. Durham's Caliban is a slapstick image of the savage attempting to render himself without reflection, extrapolating from the blurred lines of his own nose. Caliban's earnest but failing attempts to draw his own nose are both hilarious and heartbreaking. He makes silly drawings filled with angles and arches, wobbly lines and grimacing mouths tight with concentration. Caliban tries so hard to be a good student! How is he to know himself, ripped as he is from his historical and cultural context? Caliban is an invention (invention as a necessary manifestation of colonisation) and he knows it; he can only define himself in relation to his inventor Prospero. But by employing the language of his inventor he digs himself deeper in the hole of signification in which he is trapped. This is Caliban's paradox.

This is Durham's paradox as well, especially vis à vis the art world. How can Durham make images and objects with any faith when their reading will be predetermined by his identity as a Native American? Especially when that identity is essentially a false one; 'I want to say my own things to the world, and so, of course, given history, part of "my own things" is that you don't let me say anything'.[4] Every utterance then is met with its own choking, every gesture met with its own negation. The threat exists that each drawing Caliban makes of himself erases that which was. In one drawing Caliban rests; in pencil are some shaky vertical lines below which read, 'left nostril, right nostril, I breathe out, I breathe in'. The breath is represented by tentative lines; the text, an accumulation of marks, communicates a humble proclamation and allows Caliban a brief respite from his existential crisis. He breathes, he makes marks, he observes himself. He is human.

The sculptural and assemblage pieces in this series continue Caliban's attempts at self-portraiture. A pair of noses mounted on wood juxtaposes a hammered brass nose and one fashioned of mud. The mud nose looks as though it is a rivulet of blood coming from the more refined brass nose. With amazing conciseness Durham brings together a cluster of ideas and associations. The mud nose refers back to a list that Caliban made with Prospero's instruction to pair all things light (good) and all things dark (bad). On a very basic level this brings up the inherent racism within the English language itself and how in adopting the colonizer's tongue the colonized must inevitably degrade themselves. Durham also reiterates Caliban's inferiority complex via the reference of how the West has always

measured cultural sophistication in terms of the tools and the metals utilized (the stone age, the bronze age, etc.). Durham's use of the nose as symbol has other associations as well; the sense of smell is associated with the more animal-like characteristics of human behaviour representing a privileging of the senses over language. But it is also the sense of smell, of all the senses, 'which is attracted without objectifying (and) bears closest witness to the urge to lose oneself in and become the other'.[5]

Caliban finally completes an image of himself and he makes a gift of it for Prospero. It is a mask, the skin appears to be made of cracking earth, the eyes asymmetrical, brown and yellow, seemingly from different species. The mask attempts an uncertain smile over which hovers a button nose. Caliban's inscription reads like a high school student writing to his favourite teacher who just barely passed him in the final exam, allowing him to graduate. Caliban's success becomes a travesty of representation, an absurd demonstration of language internalized; he is mud, he is animal, he is dark and ugly, yet he does have that cute button nose. In Caliban's unfinished skin we find the contemporary crisis of identity.

This notion allows for the serious playfulness that characterizes Durham's work in general and the Caliban series in particular. Caliban's quest for identity is really a search for a proper mask to wear in his dance with Prospero. Caliban is lost, so is Prospero, though for him to admit it would mean to overturn the civilized/savage binary that gives him power. It is Caliban's task, then, to teach Prospero about his own inauthenticity, and the paradoxical naturalness of this artifice. By drawing and redrawing versions of himself, Caliban draws a roadmap through the wilderness of representation, and it is a road that continually interrupts the belief in the stability of history and identity. 'Perpetually incomplete' is a good way of describing Durham's works; there is no beginning nor end in any linear fashion. There are slippages of logic and even the formal presentation seems to imply things left undone. But this condition of perpetual incompleteness, this permanently unresolved state, asks profound questions concerning the nature of time and history and what we humans do when we encounter one another in the dark.

1 Roberto Fernandez Retamar, *Caliban and Other Essays*, University of Minnesota Press, Minneapolis, 1989, p. 14

2 Tzvetan Toderov, *The Conquest of America,* Harper Torchbooks, New York, 1987, p. 28

3 Jimmie Durham in an interview with Mark Gisbourne, *Art Monthly*, London, no. 173, February 1994

4 Jimmie Durham, *A Certain Lack of Coherence*, Kala Press, London, 1993, p.139

5 Max Horkheimer and T.W. Adorno, *The Dialectic of Enlightenment*, as quoted by Michael Taussig in *Mimesis and Alterity*, Routledge, New York and London, 1993, p. 66

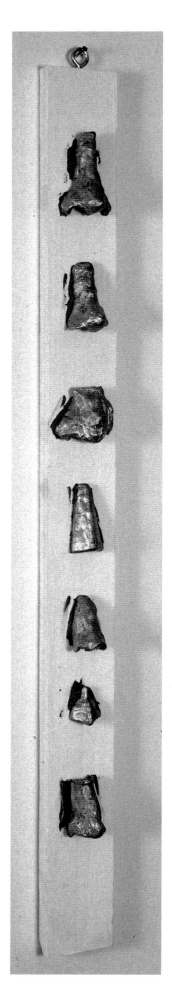

Untitled
1992
Brass, wood
91.2 × 7.2 × 6 cm

Untitled
1992
Coconuts, wood, plastic pencil
sharpener
18 × 91.2 × 11.4 cm

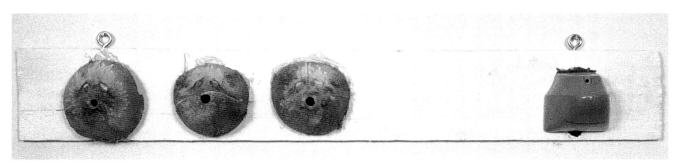

Small Action Painting
1992
Paint, dirt on paper
50 × 48 cm
'One time Dr. Prospero was going
to spank me because I was
playing with mud. When I resisted I
caused him to accidentally hit
me in the nose. Caliban'

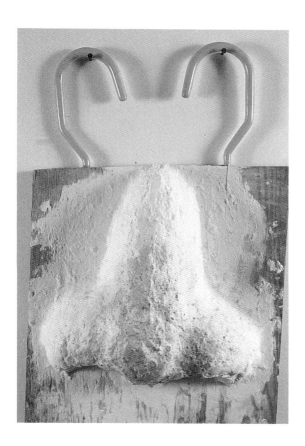

Untitled
1992
Papier maché, marble dust, wood
38.4 × 25.2 × 10.8 cm

top, l. to r., **Untitled**
1992
Brass, mud, glue, wood
49.2 × 38.4 × 6 cm

Untitled
1992
Racoon skin, metal, wood, paint
49 × 38.4 × 6 cm

bottom, l. ro r., **Untitled**
1992
Pig skin leather, wood, paint
42 × 36 × 7.2 cm

Untitled
1992
Root, paint, wood
42.6 x 36 x 9.6 cm

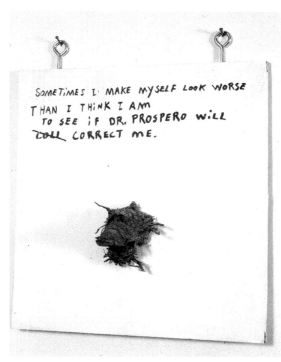

Contents

We come out of the darkness, no, we enter; outside there is darkness, here something can be seen amid the smoke; the light is smoky, perhaps from candles; but colours can be seen, yellows, blues, on the white, on the table, coloured patches, reds, also green, with black outlines, drawings on white rectangles scattered over the table. There are some *clubs*, thick branches, trunks, leaves, as outside, before, some *swords* slashing at us, among the leaves, the ambushes in the darkness where we were lost; luckily we saw a light in the end, a door; there are some gold *coins* that shine, some *cups*, this table arrayed with glasses and plates, bowls of steaming soup, tankards of wine; we are safe but still half-dead with fright; we can tell about it, we would have plenty to tell, each would like to tell the others what happened to him, what he was forced to see, with his own eyes in the darkness, in the silence; here now there is a noise, how can I make myself heard, I cannot hear my voice, my voice refuses to emerge from my throat, I have no voice, I do not hear the others' voices either; noises are heard, I am not deaf after all, I hear bowls scraped, flasks uncorked, a clatter of spoons, chewing, belching; I make gestures to say I have lost the power of speech, the others are making the same gestures, they are dumb, we have all become mute, in the forest; all of us are around the table, men and women, dressed well or poorly, frightened, indeed frightful to see, all with white hair, young and old; I too look at my reflection in one of these mirrors, these cards, my hair too has turned white in sudden fear.

How can I tell about it now that I have lost my power of speech, words, perhaps also memory, how can I tell what was there outside; and once I have remembered, how can I find the words to say it, and how can I utter those words? We are all trying to explain something to the others with gestures, grimaces, all of us like monkeys. Thank God, there are these cards, here on the table, a deck of tarots, the most ordinary kind, the Marseilles tarots as they are called, also known as Bergamasque, or Neapolitan, or Piedmontese, call them what you wish, on taverns, in gypsy women's laps, crudely drawn, coarse, but with unexpected details, not really so easy to understand, as if the person who carved these drawings in wood, to print them, had traced them with his clumsy hands from complex models, refined, with who knows what perfectly studied features, and then he went at them with his chisel, haphazardly, not even bothering to understand what he was copying, and afterward he smeared the wooden blocks with ink, and that was that.

We all grab for the cards at once, some of the pictures aligned with other pictures recall to me the story that has brought me here, I try to recognize what happened to me and to show it to the others, who meanwhile are also hunting there among the cards, pointing a finger at one card or another, and nothing fits properly with anything, and we snatch the cards away from one another, and we scatter them over the table.

translated by William Weaver

Jesus
1992
Wood, metal, mud, glue
144 × 86.4 × 86.4 cm

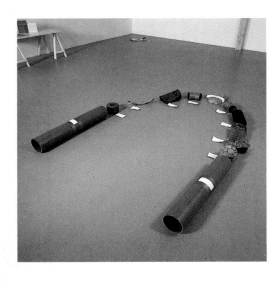 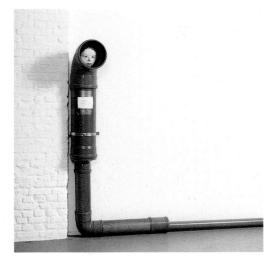

Paradigm for an Arch
1994
PVC pipe, wood, papier maché,
horn, paper, polystyrene, cloth
308 × 215 × 20 cm

Garcon, Garou, Gargouille
1994
Papier maché, PVC pipe, leather
150 cm, l. approx. 4 m

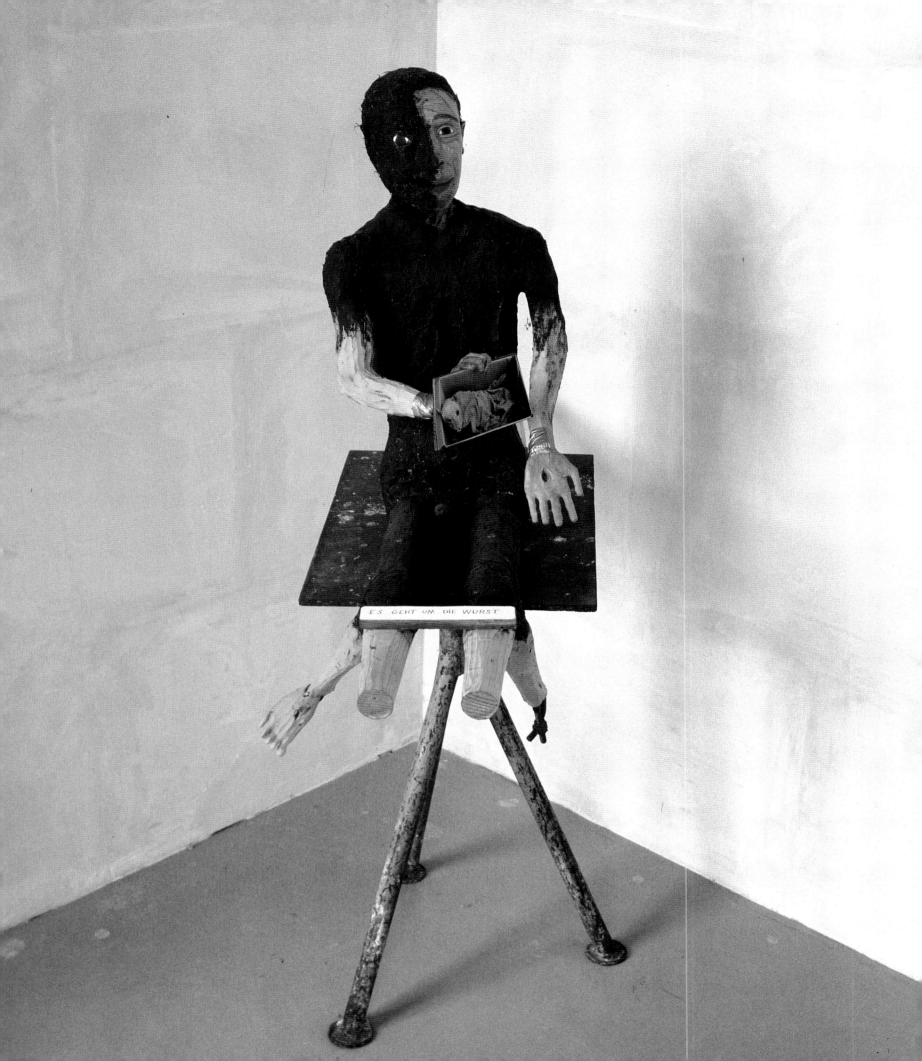

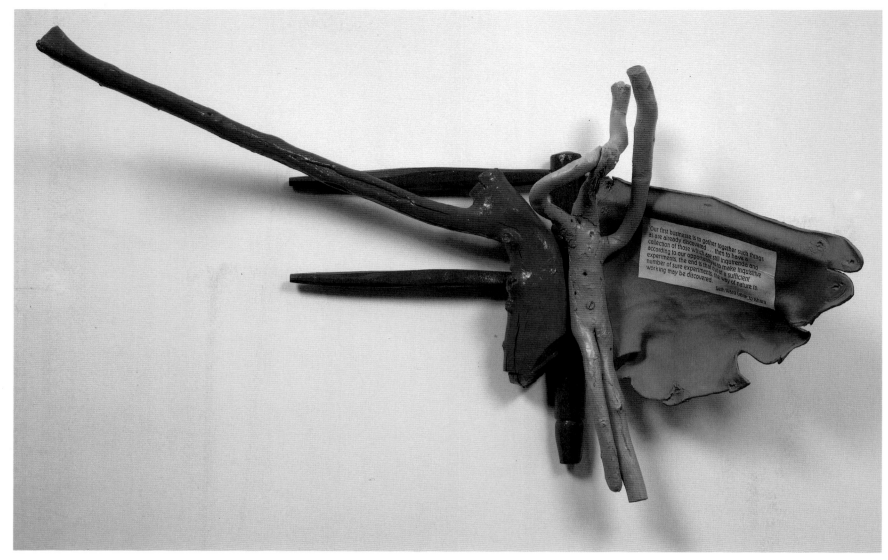

Study in Blue, Red and Yellow
1989
Wood, acrylic paint, animal skin,
nails
69.6 × 91.2 × 24 cm
'Our first businesse is to gather
together such things as are
already discovered ... then to
have a collection of those which
are still inquirenda and according
to our opportunityes to
make inquisitive experiments,
the end is that out of a sufficient
number of sure experiments the
way of nature in working may be
discovered.
– Seth Ward letter to Isham'.

Untitled
1991
Charcoal, butterfly wings on paper
48 × 92 cm

Untitled
1990
Charcoal, moth wings on paper
48 × 92 cm

Science I
1990
Pencil, paste on paper
38.4 × 48 cm

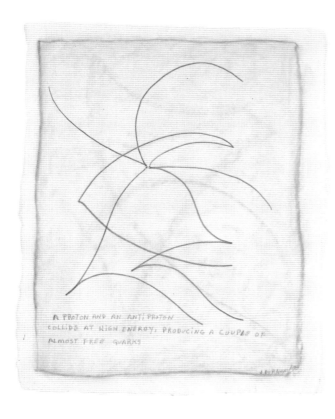

A PROTON AND AN ANTI PROTON
COLLIDE AT HIGH ENERGY, PRODUCING A COUPLE OF
ALMOST FREE QUARKS

Is it legitimate to turn to scientific discourse to find an image of the world that suits my view? If what I am attempting here attracts me, it is because I feel it might connect with a very old thread in the history of poetry.

The *De Rerum Natura* of Lucretius is the first great work of poetry in which knowledge of the world tends to dissolve the solidity of the world, leading to a perception of all that is infinitely minute, light, and mobile. Lucretius set out to write the poem of physical matter, but he warns us at the outset that this matter is made up of invisible particles. He is the poet of physical concreteness, viewed in its permanent and immutable substance, but the first thing he tells us is that emptiness is just as concrete as solid bodies. Lucretius' chief concern is to prevent the weight of matter from crushing us. Even while laying down the rigorous mechanical laws that determine every event, he feels the need to allow atoms to make unpredictable deviations from the straight line, thereby ensuring freedom both to atoms and to human beings. The poetry of the invisible, of infinite unexpected possibilities - even the poetry of nothingness - issues from a poet who had no doubts whatever about the physical reality of the world.

This atomizing of things extends also to the visible aspects of the world, and it is here that Lucretius is at his best as a poet: the little motes of dust swirling in a shaft of sunlight in a dark room; the minuscule shells, all similar but each one different, that waves gently cast up on the *bibula harena*, the 'imbibing sand'; or the spiderwebs that wrap themselves around us without our noticing them as we walk along.
translated by Patrick Creagh

it lose that photo! None of my
neva talk to me anymore, so t
e only record I have that I to
in Switzerland. Shit hell fuck
it, it was part of this
how that I really was, aw
I'd lose a lot of quee
long trip! you so

Artist's Writings Jimmie Durham The Poor

The Poor People 1970

Street performance, Geneva
1971

You should have seen them
When they plucked leaves
From sword plants
And assumed dueling stances.

All soon withered.

At that, it was better than when
They tried to use icicles –

Licked away by enemies, cousins,
And other relations.

Now the rich people have offered a
Choice of weapons for sale:
1. Aerosol bombs
2. Emigration permits
3. Leaves from coca plants

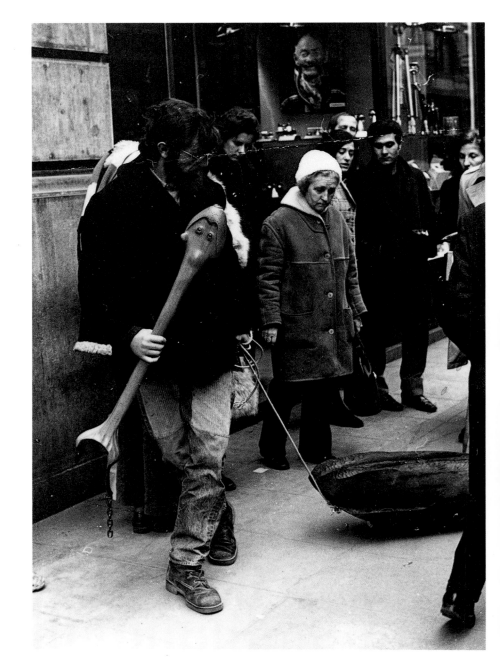

Untitled
1972
Wood, rope
14.5 × 33.5 × 89 cm

I Think We Will Have To Break Out 1973

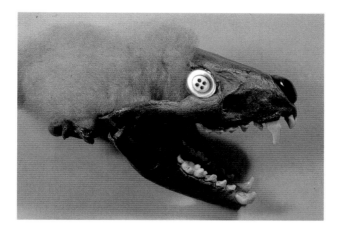

Badger
'I found this badger dead in the
road, just outside Geneva in 1969
or 1970; so I took the head and
made a badger head stew. I used
the skin for 2 or 3 installations
and finally put it in the Documenta
show in 1992 as one of the outside
floor pieces'.
1971
Skull, sheepskin, acrylic paint,
button

The sheriff in Van Horn, Texas
Asked me what I was doing in his town.

I am looking for something
I am searching for it.

Tatanka Iotanka said
If you lose something go back and you will find it.
I do not know where I lost it.
They took it away.

I look on the highway,
In cities,
Dangerous small towns.
In the desert I turn over every beer can.
I try to read factory smoke,
Books,
Newspapers.
Search through planks stacked
Outside the sawmill where the forest was.

In this jail,
I think they put it in jail.

I think we will have to break out.

Columbus Day 1975

In school I was taught the names
Columbus, Cortez, and Pizzaro and
A dozen other filthy murderers.
A bloodline all the way to General Miles,
Daniel Boone and General Eisenhower.

No one mentioned the names
Of even a few of the victims.
But don't you remember Chaske, whose spine
Was crushed so quickly by Mr. Pizzaro's boot?
What words did he cry into the dust?

What was the familiar name
Of that young girl who danced so gracefully
That everyone in the village sang with her–
Before Cortez' sword hacked off her arms
As she protested the burning of her sweetheart?

That young man's name was Many Deeds,
And he had been a leader of a band of fighters
Called the Redstick Hummingbirds, who slowed
The march of Cortez' army with only a few
Spears and stones which now lay still
In the mountains and remember.

Greenrock Woman was the name
Of that old lady who walked right up
And spat in Columbus' face. We
Must remember that, and remember
Laughing Otter the Taino who tried to stop
Columbus and who was taken away as a slave.
We never saw him again.

In school I learned of heroic discoveries
Made by liars and crooks. The courage
Of millions of sweet and true people
Was not commemorated.

Let us then declare a holiday
For ourselves, and make a parade that begins
With Columbus' victims and continues
Even to our grandchildren who will be named
In their honor.

Because isn't it true that even the summer
Grass here in this land whispers those names,
And every creek has accepted the responsibility
Of singing those names? And nothing can stop
The wind from howling those names around
The corners of the school.

Why else would the birds sing
So much sweeter here than in other lands?

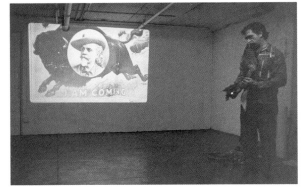

Manhattan Give-Away
1985
Performance, Franklin Furnace,
New York

Tarascan Guitars 1976

In Texas, at that old Comanche place called White Flint,
I found the skull of an armadillo.
Maybe some new hunter killed an armadillo with a .22 rifle.
I asked rocks and other things around.
It was probably that way, they said.

I painted the armadillo's skull bright turquoise and orange,
Blue and red, black, green, like tiles and aztec flowers.
Where his old eyes had been, I put an agate
and a seashell;
For seeing in all directions.

Now he can go to the festival of the dead
In Tarasco where they make those guitars,
And where a wildman made the first ocarina,
To make the women fall in love with him.

In Tarasco, Mexico, where fields are covered with flowers,
They sometimes make guitars from the armor of armadillos.
So if he goes there to the festival of the dead
He can dance like a flower to the music of his brothers.

Everyone will be glad to see him, and he will say,
That Cherokee guy sent me here.

If we do not let our memories fail us
The dead can sing and be with us.
They want us to remember them,
And they can make festivals in our struggles.

Someday we will find those Cherokees
Who tried to escape Texas into Mexico
But were killed by Sam Houston's hunters.

I have already found an armadillo's skull,
And like Sequoia who was lost in Mexico
I write to remember.

All poems from Jimmie Durham's collection, *Columbus Day*, West End Press, USA, 1983

Armadillo
1976
Armadillo skull, acrylic paint,
agate
8.4 × 4.8 × 4.8 cm

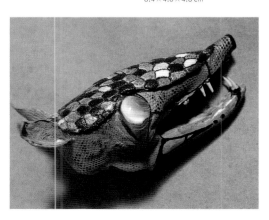

The Mystery of the Two Islands: The True Story of How Cuban Communists Gained Control of Trump Tower 1986

In those days I explored the island. Up at the northern tip, in Inwood Park, there is a plaque set in a boulder which states that upon that spot, Indians sold the island to the Dutch for a few guilders and some beads. Down at the southern tip, near the Staten Island Ferry, there is another plaque set in another boulder with the same facts. Thus I began to overturn stones looking for secret messages.

In those days, Manhattan Island was supposedly inhabited by a tribe called, variously, the White People, or the Plane White People, a people who were imagined by later tribes to have originated in White Planes.

The famous Cuban explorer Jose Bedia has discovered what he believes to be the actual site of White Planes and although he has brought forth an impressive array of artifacts from several cultures, he finds no direct evidence for the existence of the Plane White People.

As the legend goes, a vast and complex civilization once flourished on Manhattan Island. Indeed, Bedia has unearthed many multiple-unit dwellings and a network of mysterious underground catacombs. But most of these ruins are known to have been built by Mohawks, Africans, Tainos, Celts, and at least one of the Semitic tribes. In addition, some ancient documents written in Chinese have recently come to light.

Finally, then, the only evidence of a Plane White People is in the stories and rituals of later peoples. As early as 2050 A.D. the magical incantations, 'Automobilindustry', and 'Petroleumindustry', were used by shamans of some tribes in the area. These nonsense phrases were expected to bring great power, although what sort of industry a 'Petroleumindustry' might be we must leave to the reader's imagination.

Petroleum is a poisonous substance of some rarity, with no known uses.

Bedia has conjectured that the term 'automobile' describes a state of being achieved by certain shamans through the medium of sacred objects attributed to the Plane White culture.

Perhaps it is too easy now, from our rather privileged vantage point, to laugh at those more primitive tribes of the twenty-first and twenty-second centuries. But we should not forget the hardships of their daily lives; hardships that made them dream of a past which they could not even claim as their own. In those days, there were few flowers or trees, and hummingbirds were seldom seen.

The following manuscript, discovered by the famous Cuban explorer Jose Bedia, gives us a glimpse of the aspirations and dreams of those mysterious tribes of long ago – strangely, not so different from our own.

Note: The mythical character Donald Trump is a version, albeit a version in his evil

The Reading Room
1989
Installation, Exit Art,
New York City

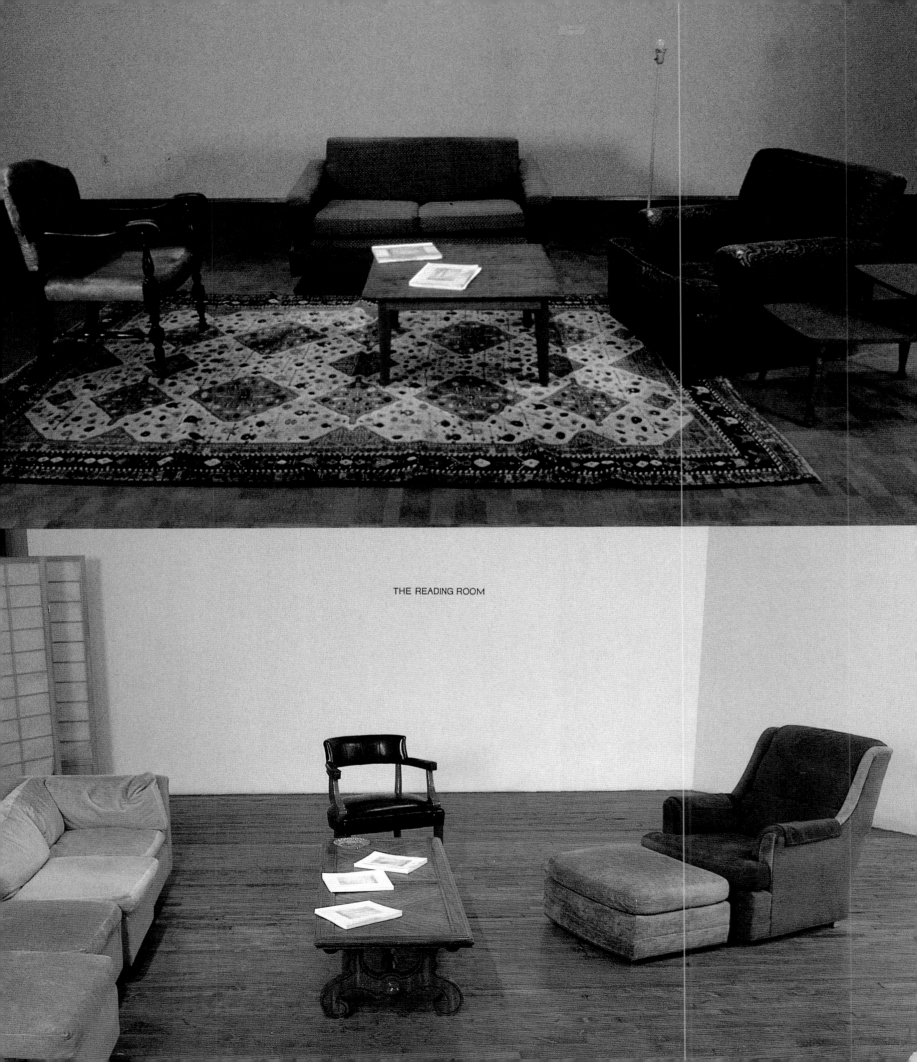

THE READING ROOM

aspect, of Harlequin/Moki, the 'Juggler' in the Tarot. To 'pull a Trump' was an expression that meant to gain enormous profit by illegal means, and to be 'Trumped' was a synonym for being trampled upon. The mythical Donald Trump was a gambler and card-shark who lived in a fortified tower called Trump Tower.

See also the writings of Carl Jung and J.R.R. Tolkein.

Certain Facts You Should Know

If you live on Manhattan Island, you probably feel that you have enough facts already to last you a lifetime. Every time the Facts Come to Light it turns out that some policemen, who we urgently need to trust because we need their protection, have killed an artist (like Michael Stewart) or an old woman (like Eleanor Bumpurs), or that we are drinking Plutonium in our water, or that PCB's are more widespread than we had been led to believe.

But what we want to tell you are some historical facts, even though we realize that most Americans especially do not want to hear historical facts.

When the Industrial Revolution began in England (in other words, here goes, whether you're ready or not) most machine parts, especially in the textile industry, were made of wood. Ships were also made of wood, and all of that wood came from the banks of the coastal rivers of what is now the U.S. Early British travellers reported that entire areas were denuded of trees, and for years the rivers were muddy and polluted, with almost no life in them at all. In those days sassafras was one of the largest industries in Europe. The sassafras was picked all over the 13 colonies area and sold to Europeans as a cure for syphilis and cancer. Later, the historians accused the Indians of starting syphilis.

Early anthropologists stated that Indian men were effeminate, because we did not have much body hair and were overly emotional. (They also said that Jewish men were beastly, as proved by too much body hair. It seems that the correct amount of body hair is a rather fine line, but quite important.)

Later, they said that Indian men were not emotional: that we are stoic. Daniel Boone recounted in his diary that after he and his men had destroyed one particular Indian village, one little boy was still alive, though badly wounded and burned. 'The little boy was not even crying', Dan wrote. He said that when he returned to the village the next day, he and his men retrieved potatoes from the cellar, and the potatoes were perfectly cooked with the grease of the burned Indians.

Later, the historians denied that we had had potatoes or cellars, or even that we existed; it was just 'wilderness' that Dan'l and the guys conquered.

Meanwhile, Inwood Park on the northern tip of Manhattan once had dozens of little springs of clear water. The City Fathers fixed that up so that now all those springs flow underground into the Hudson River. I guess it was a matter of disorderly conduct.

Turkeys do not come from Turkey, of course; they grew up right here. At first the bird, that is now called Guinea, was called Turkey, because the Turks introduced them to Europe, having brought them from Guinea Bissau in Africa. Later, American racists called the Portuguese, Guineas because they often came here from the Portuguese colony of Guinea Bissau. Later they forgot who the Guineas were and started calling the Italians Guineas.

But now that the 1st World War is completely over (except for the area called the Middle East) people forget how pervasive and destructive the Turkish Ottoman Empire was, and the effects it has on our lives.

Four-Part Chronicle Concerning Chickens, Cuba and Freedom

In 1960 Fidel Castro arrived in Manhattan, very proud of his country and all of its produce, bringing with him some fine Cuban chickens. That was very insulting to the American people of the time because they believed that U.S. chickens were the world's greatest. Fidel also insulted some Americans by staying in Harlem while he was on Manhattan Island, but refusing American Fried Chicken was a direct affront to our mothers. The President of the U.S. then passed a law which forbade the sale or trade of chickens and all other merchandise between the U.S. and Cuba.

In 1985 Jose Bedia arrived in Manhattan without a single chicken, yet he intended to do an art installation which contained many chicken feathers, because it was to be a piece connecting American Indian history and Santeria in Cuba. I said, 'No problem, I'll just go to a live poultry market and gather up some feathers'. I went to Los Dos Hermanos Poultry Market, but they have an automatic chicken-plucking machine which leaves the feathers in a soggy pile mixed with guts and feet.

I said, 'No problem, I'll just buy three live chickens and we'll pluck them ourselves, after taking a photo of Jose holding the chickens victoriously like Fidel'. So I placed an order for three live chickens, but I believe that the poultry people thought I intended to murder the innocent birds in some savage ceremony. They presented me with three dead, plucked chickens.

Later, in my apartment I spread the soggy feathers which I had scooped off the killing floor and carefully removed the guts and feet.

Jose left my place with a bundle of old newspapers which dripped feathers all the

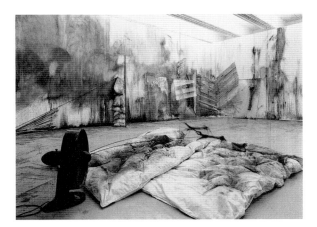

Ricardo Brey
Installation at Documenta IX,
Kassel
1992

way to Broadway.

Ricardo Rodreigues Brey is a mysterious Cuban for more reasons than just the fact that we hereby introduce him without previous context. He said that when he was a boy he played Indian often, and he had a pet chicken which he enlisted to play the part of the faithful, but ferocious hawk. The chicken perched on the shoulder of the fierce-eyed Ricardo, who, upon seeing the enemy, would quickly thrust his right arm forward while shouting, 'Falcon!' With his left hand, Ricardo had to throw the chicken into the air, because the chicken could never concentrate on the game. Once the chicken found himself propelled suddenly into the air, his only thought was to obtain a solid footing on the ground as quickly as possible, forsaking all grace and dignity.

But now I must tell you of the chickens on the Magic Island of Puerto Rico, where little frogs sing like birds. In the first place, Puerto Rico's chickens are Paso Fino. They are small compared to some other chickens, but our sense of them is that they are exactly the right size for themselves and for their place. Their size has an integrity not found in other chickens. The same is true for Puerto Rico's famous little horses, called Paso Fino because they step so fine. Dancing horses which take grace and exactitude as a standard instead of size or speed. As it turns out, every thing on the Magic Island is Paso Fino. The native dog is a marvel to watch, and again, it doesn't look small so much as finely tuned. The wild doves, and even the buzzards are exactly petite. The Islander's favourite kind of banana is called Lady Finger, and their traditional houses, bohios, never intrude but compliment the Paso Fino rivers and streams.

It was there on that Island, whose Puerto es muy Rico only for export, a door marked EXIT ONLY, that I learned the Truth about chickens.

In the hills, the Puerto Rican chickens are allowed to roam free and do whatever they wish. I watched them for days.

We have so many clichés about chickens and their behaviour. All of our ideas about chickens come from our knowledge of chickens kept in total captivity, so that their real ways are deformed and degraded. This we take to be the natural ways of chickens, because by now we take as natural that chickens are captives.

I must tell you reluctantly that it is now the custom of all the big chicken-producing companies to cauterize the beaks of the young chickens, so that their beaks will not grow and so that they will not peck each other to death in the confusion of their unnatural lives. The cauterization is done simply, with a red-hot iron.

In Puerto Rico each small flock of hens and chickens employs a rooster. The rooster's job is to protect the flock from predators, so he is very fierce. If a flock had two full-grown

roosters they would fight each other, because fighting is the nature of their job. At night, all the small flocks come together to roost in one tree; safety in numbers. To facilitate that nightly gathering the roosters of each small flock crow constantly during the day. Each small flock thereby knows the location of the other small flocks, as they fan out at sunrise and begin foraging through the forest. If they all stayed together during the day they would find less to eat. During the forage the smallest chicks usually ride on their mothers' backs, for safety and to keep up. When the flock finds a good place to stop for a while, even the smallest chicks may forage, but at the slightest sign of danger, all of the chicks of every age hide under the hens, while the rooster struts around the perimeter of the flock.

Their crowing, their 'pecking order', their 'chicken-heartedness', all make perfect sense when chickens are free to be themselves.

Photography and Federal Reality

Early in 1974 Jimmie Durham was working in the National Office of the American Indian Movement in Minneapolis. At that time a man named Doug Durham was also part of the office staff, and was in fact the A.I.M. Chief of Security which was not fair, because ol'Doug was actually an FBI agent. Doug told people that he and Jimmie were brothers, so that when he was exposed as an FBI infiltrator, people called up J.D. to warn him to get out of town, that his brother was exposed as a Fed.

Some time later Doug Durham testified before a U.S. Senate Committee (led by Senator Eastland) to the effect that Jimmie Durham was a Communist. To prove it he gave the Committee a photo of J.D. in Havana. That was in either late 1975 or sometime in '76, yet to this day, Jimmie Durham has never been to Cuba. (Nor, he would like us to point out, to the Soviet Union or even China.)

So where is the photo from? The actual facts may be worse than Senator Eastland's most horrifying nightmares: Jimmie Durham has been to Miami (which could look like Cuba in a photo, if the photographer got palm trees in the background), where he met with a large group of Haitian refugees. He has also been to Puerto Rico, which, if we are not constantly alert, could Go the Way of Cuba.

What we must ponder is; did the Federal Government actually begin the process that culminated in the Cuban take-over of Trump Tower in 1985, masterminded by the double Red, Jimmie Durham? It is common knowledge that interpretation of photos can re-create a past and a reality that never before existed. Perhaps that is exactly what happened, and ten years later, Jose Bedia, The Cuban Infiltrator, influenced by Federal

Reality, 'mysteriously' shows up at an 'art opening' by Jimmie Durham.

Footnote by Jimmie Durham:
Not only did the Feds pass around a photo of me in Havana to prove that I am a Communist, they doctored some of my writing in a most inexcusable way. In 1975 I had written a paper about the U.S. Left, which contained a sentence beginning, 'Marxist-Leninists ...'. The government added to that the phrase 'Such as I am', so that the sentence in their version of my paper begins, 'Marxist-Leninists (such as I am)...'.

They distributed their version to Tribal Councils and Indian organizations. It is still intolerable to me, even after so many years, to think that there are all sorts of people out there who, because of governmental stupidity, assume that I do not know the basics of correct English grammar.

Why couldn't they at least have added something like, 'of which I am an excellent example', or, 'among whose numbers I am proud to count myself', or even, 'Marxists-Leninists (a secret, Godless and violent organization of ruthless individuals intent on destroying the American Way of Life, upon whose Central Committee I have single-mindedly served all of my adult life)'? They could easily have added, 'like me', and thereby maintained certain grammatical standards necessary for even false communication. I demand a re-match.

The Discovery of the First Basement
Jose Bedia, the famous Cuban explorer/archaeologist, states that he suspected the existence of the First Basement as early as 3006, during his second foray onto Manhattan Island. Twenty-three years later he actually stumbled into the Basement. After ten years of work cataloguing the artifacts and scientificts, with the passive co-operation of the Museum of Natural History, Bedia now opens this special exhibit of the Basement, with the support of the Sir Walter Raleigh Tobacco and Firearms Corp., and the John Jacob Astor Animal Skinning Company.

The Basement
The Basement, according to Bedia, was built long before any other structure on Manhattan. Its original purpose was to imprison the last Indian left on the Island. It also served as his Place of Worship. At a later date, when the Indian was given a work-release parole so that he could function as Manhattan's Janitor, the Basement was remodelled into his apartment. During the 1920s and 30s, the Indian, still living in the

Manhattan Festival of the Dead
(Store) (detail)
1982
Installation, Kenkeleba Gallery,
New York

Manhattan Festival of the Dead
(Store) (detail)
1982
Installation, Kenkeleba Gallery,
New York

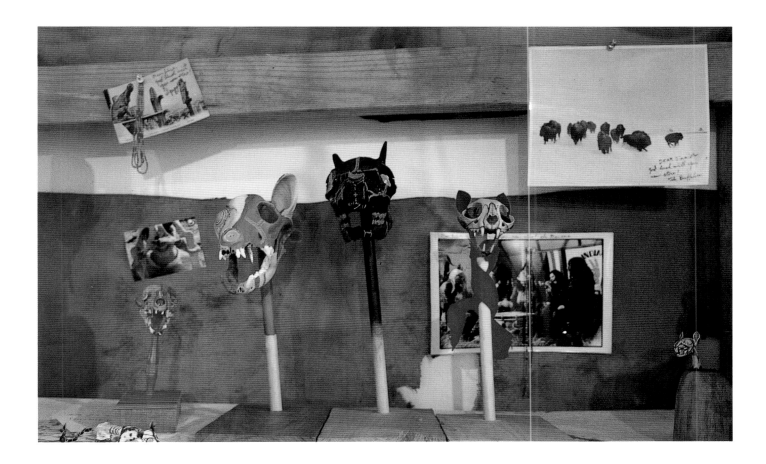

Basement, became the city's 'High Steel Walker', an exalted position in the civilization of the era, comparable to today's High Governmental Official.

Who Was the Indian?

There is a dispute among some archaeologists as to the identity of the Indian, but Bedia has amassed solid evidence that Chief Injun Joe was the builder and inhabitant of the First Basement.

He cites, for example, the evidence of Pocahantas' Panties in the Basement. Injun Joe was known to be Pocahantas' lover when she made her 'debut on Broadway'. Further, he claims, since the Basement is undeniably the First Basement, 'Who's apartment could it have been if not Injun Joe's?'

Review Questions for Chapter 2

1. How did the white people come to own Manhattan Island?
2. What did they do with the local population?
3. Who is the 'mysterious Cuban'?
4. Puerto Rico is a colony of what imperialist country?

Interview with a 10,000 Year Old Artist 1983

New Clear Family
1989
Wood, cloth, string, paint
19 pieces, approx. 45 × 10 × 4 cm
each

'Things were different in the old days', says Og Mg Erk.

Og Mg Erk is perhaps the oldest living artist, but is still producing new work and still has that creative fire. We sat in Og's cluttered studio in Manhattan's Lower East Side, amid literally millions of paintings and sculptures that Og has produced in the last 10,000 years. I began the interview head on:

Art & Artists Og, how old are you, precisely?

Og Mg Erk Well, I believe I was born on January 6, 8003 BC; but of course we had no birth certificates in those days, and we didn't know it was BC. We called it BT – Before Tomorrow.

A & A How did you become an artist?

Og As others have pointed out, there wasn't much to do in those days. You could be a critic, an animal chaser, an artist, or a co-ordinator. And of course there was prostitution.

A & A But wasn't that just for women?

Og Oh no, there were many more male prostitutes than female. It was a very high-salaried job. But anyway, I got my first break in the form of a grant from NEA's Minority Arts Program. NEA is the Neanderthal Endowment for the Arts.

A & A Minority Arts Program?

Og Sure. I was the first Cro Magnon, you know.

A & A What was it like being an artist back then?

Og Things were different in the old days. In the first place, there were only six artists in the entire world. On the other hand, finding a place to show was a real problem; there were no galleries or at least none that you would want to show in. I had my first solo show in Altamira, and I was so naïve that I let the dealer rip me off really bad.

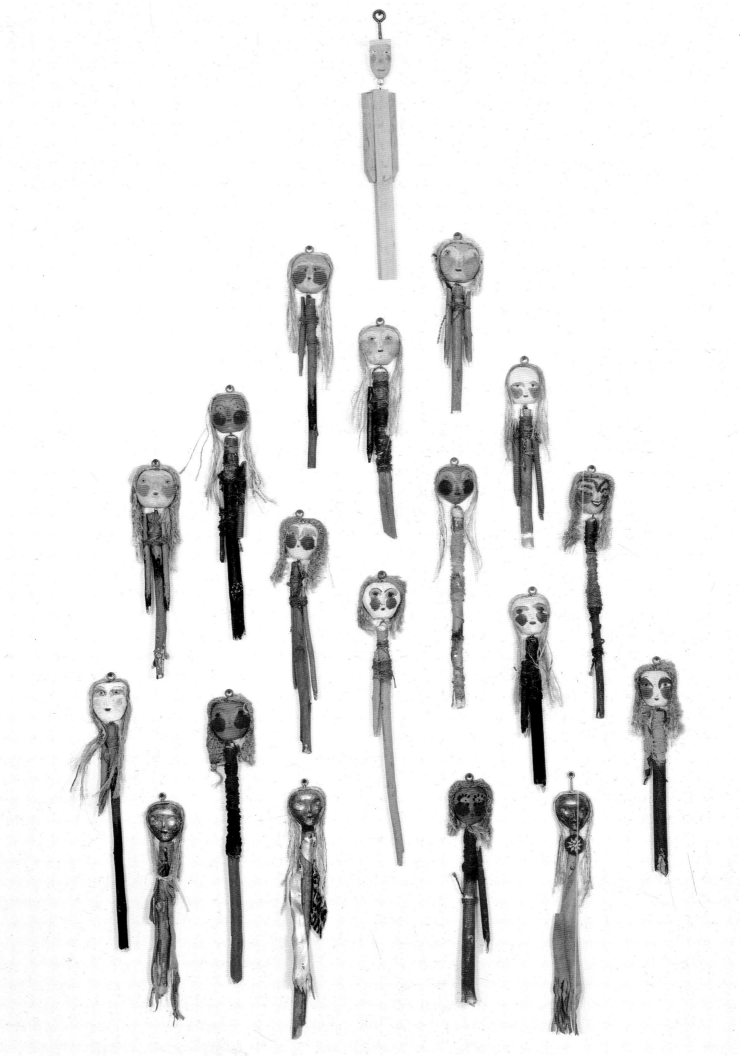

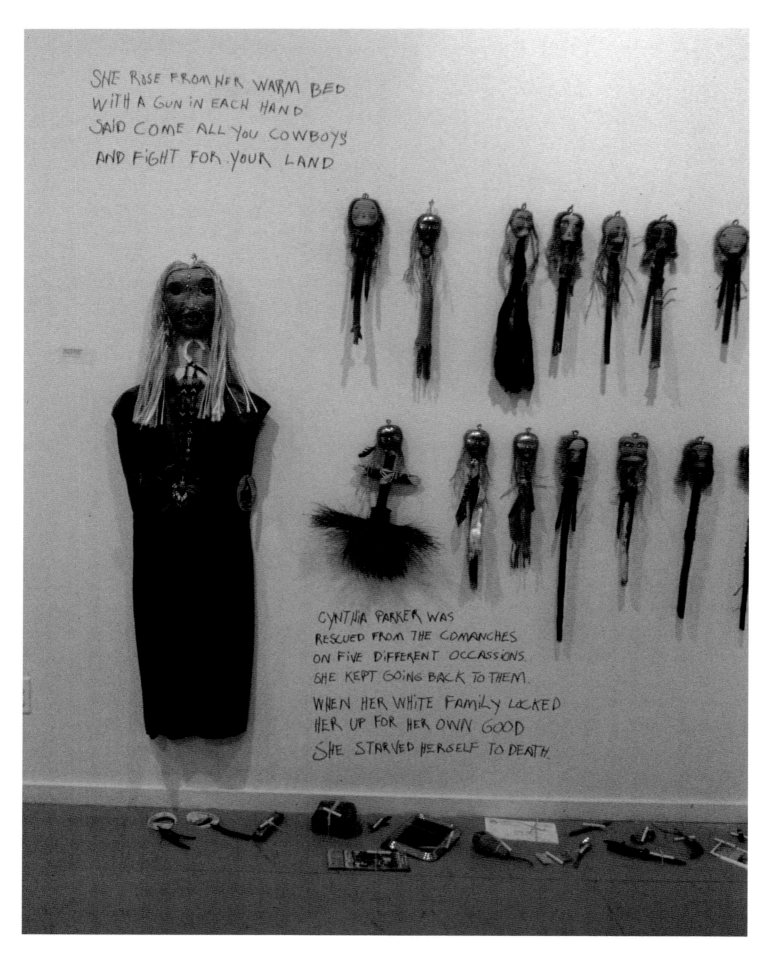

SHE ROSE FROM HER WARM BED
WITH A GUN IN EACH HAND
SAID COME ALL YOU COWBOYS
AND FIGHT FOR YOUR LAND

CYNTHIA PARKER WAS
RESCUED FROM THE COMANCHES
ON FIVE DIFFERENT OCCASSIONS.
SHE KEPT GOING BACK TO THEM.

WHEN HER WHITE FAMILY LOCKED
HER UP FOR HER OWN GOOD
SHE STARVED HERSELF TO DEATH.

Suck cess
1992
Wood, acrylic paint, screws
52 × 82 × 17 cm

Ladies War Club/Dagger
1991
Wood, crystal, metal, twine, beads
52.8 × 70.2 cm

My Blood
1991
Acrylic paint, artist's blood on
paper
57 × 46.8 cm

A & A How were artists paid in those days?

Og In greenbacks, if you were lucky; I usually got paid in shiny pebbles. Greenbacks were the skins of little green frogs, so they were more valuable. Dealers would take 50% of all sales, sometimes they would charge you for the publicity and the reception. At Altamira I had to pay for thirty buckets of elderberry wine, plus the little roots that were served as hors d'oeuvres, and the dealer lied to me about what the work actually sold for.

A & A This is a two-part question; how would you describe your work, and what do you think of modern art?

Og I guess I'd say I am a traditionalist. I work in the classical style that has proven value over the centuries. I like some of the modern painters, Titian, for example. But they need more discipline, and a sense of quality of lasting values. Political work, that is those paintings that are pushing some ideology of the moment such as Christianity, cannot possibly hold up after the fad is over. As a traditionalist, I also question the use of all of this new material and media. I'm very suspicious of oil paint, especially when it is applied to this flimsy cloth they all love to use, stretched over even flimsier sticks. I don't think oil on canvas has been around long enough to be proven yet. What's wrong with painting on a good, solid cave wall, or a tough buffalo hide? All of the experiments with new media show a poverty of ideas.

But this guy Keith Haring, his work might last, down in those subway stations. It reminds me of a guy I knew at Lascaux.

A & A What would you say has been your biggest problem as an artist?

Og Family life, definitely. You know I've had a hundred kids, and my husband thinks that women should stay in the cave.

Art and Artists, New York, November/December 1983

republished in *A Certain Lack of Coherence*, Kala Press, London, 1993

She Rose from Her Warm Bed
1987
Installation, 'We, The People',
Artists Space, New York

Shoot Three Hands (a screenplay, extract) 1988

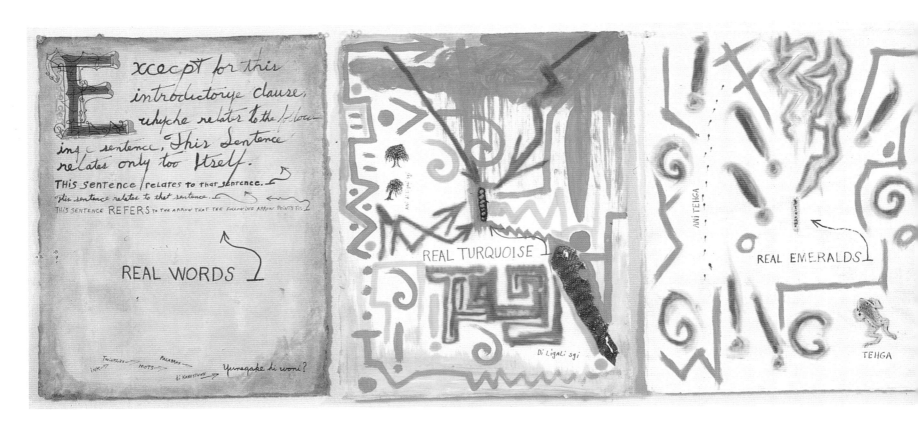

Int. large classroom – morning.
(Here are the students of three different classes, combined to hear Jack speak. The students are all white and obviously well off. They range in age from eight to twelve. There are three women teachers.)
(Angle on principal)

Principal Well, boys and girls, I know you've been waiting all semester for this, so without further ado let me introduce Chief Jack Three Hands; the Head Chief of the Indians!

(As Jack walks into the classroom, one of the younger girls starts crying in fear. Students around her, especially the boys, immediately begin to laugh and make fun of her. Jack takes in this vignette quickly but is perplexed as to what to do. He stands motionless before speaking.)

Jack You children leave her alone, now. Everybody's afraid of something.

A Boy Did you ever scalp anyone?

Another Boy Why is your name 'Three Hands'?

Jack Well now, that's a good question. The first Three Hands was my great great grandfather – a famous Chief. *His* father got his hand cut off in a battle, so Three Hands said 'Don't worry, Father, I will be your other hand' and to prove he was serious, he wore his Father's cut off hand on a string around his neck.

Stellar Message
1989
Wood, acrylic paint, paper, metal
74.4 × 38.4 × 7.2 cm
'Most of Egypt's 55 million people show little interest in Impressionist art. But officials, watching the opward spiraling prices of Impressionist works in the West and Japan and the downward spiral of their own economy are rapidly coming to the conclusion that they are neglecting what could be a valuable asset'.

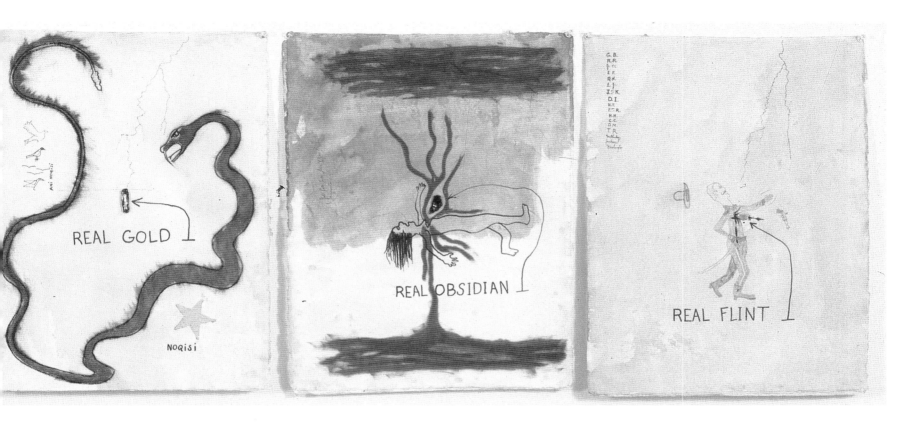

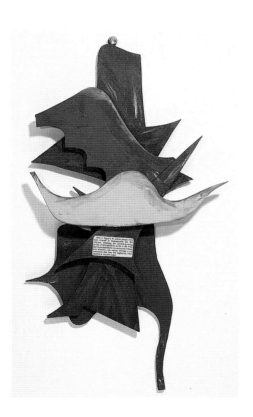

Students Blah! Gock! Oh, gross! *(etc.)*

Boy #1 and Boy #2 What if he got his stinking old foot cut off? Or his head! Ha, ha, ha … What if he got something *else* cut off? Hoo hee!

Teacher #1 That's enough! Do you boys want to be sent out?

Girl #1 What did the Indians eat?

Jack Well, we still eat … Ha, ha, ha … If you mean a long time ago, we ate a whole lot of things: birds, birds' eggs, sunflower seeds, roasted cattails, wild turnips, wild rice and a whole lot of wild game like buffalo and antelope and deer. These days I guess we eat pretty much the same as you do. I like fried fish.

Boy #3 My Dad said to ask why you want to live on a reservation instead of working.

Jack Tell your dad to come out to visit us. We work a whole lot. The reservation is just our land, where we live.

Boy #4 Why do you say 'whole lot' so much?

Jack Ha, ha, well, gee, I don't know. But, you know, different people talk in different ways, I guess.

(Cut to:) Ext. School Parking lot – morning

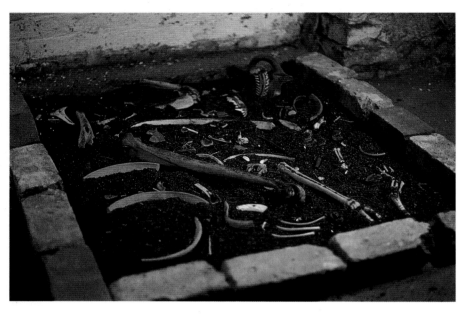

Bedia's First Basement (detail)
1985
Glass beads, ceramic, animal
bones, rifle shells, dirt, ashes,
bricks
Installation, 22 Wooster Gallery,
New York

(Jack *and the* Principal *stand beside the principal's car.*)

Principal Well, that was just great, Chief. Just fantastic! We really appreciate your taking the time.

Jack (Removing Warbonnet) That's okay. Can you give me my money now?

Principal (Pause) Oh, well, gee whiz. This is embarrassing. We didn't know you expected a fee! The school has no budget for that.

Jack Can you loan me five dollars?

(*The* Principal, *looking resigned and slightly disgusted, pulls out his wallet.*)

Principal Sure thing, Chief, here you are ...

(*The Chief takes the five as they get into the car.*)

Jack Thanks. Just drop me off in town.

Principal Sure thing, Chief.

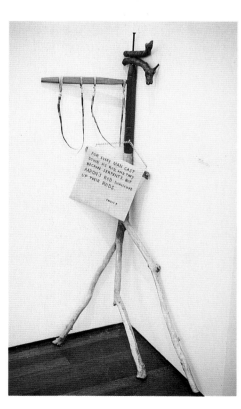

Exodus 7
1990
Wood, paint, card, chain,
iron nail
144 × 57 × 36 cm

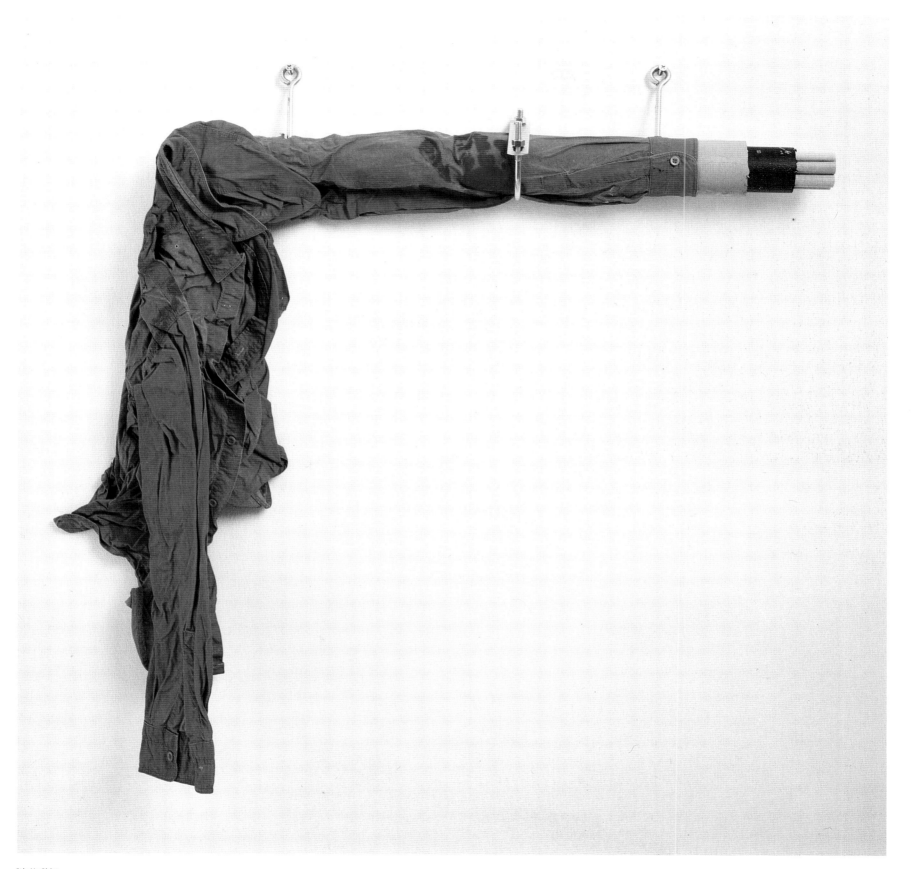

It's My Shirt
1993
Shirt, PVC pipe, wood, acrylic
paint
74.4 × 96 × 12 cm

Crazy for Life
1990
Performance, 'The Decade Show',
The Dance Theater Workshop
The Museum of Contemporary
Hispanic Art, The New Museum of
Contemporary Art, and The Studio
Museum of Harlem, New York

Covert Operations Excerpts from a Discussion between Jimmie Durham and Michael Taussig with Miwon Kwon and Helen Molesworth 1993

(…)

Miwon Kwon What do you think would be 'good' anthropology?

Taussig Well, it seems to me that for the past five to ten years, anthropologists have been sharply divided in this country. There are those who think that anthropology can't exist the way it has – that it should turn the mirror around, so to speak, to turn the gaze around to study the gazers; to use anthropology to study the history of the discipline. Some people think this a dead end, but I don't think so. I think there are a lot of fantastically interesting and important things to be done that way.

In general, the people who are arguing for turning the gaze around are in the minority. I think this is partly because the process requires a different type of discussion altogether. The temptation, especially in universities, is to have a coherent and neat reduction, which I know is necessary sometimes. But I nevertheless think that there has to be a degree of openness and movement in the texts and objects that we produce. We have to rethink the way that words are used or the way pictures are painted. That's where most people fall away. They won't go along with you. But my position is that the very nature of talking has to be more fun and open – that's what's involved in this turning around of the gaze.

Helen Molesworth Your work [Jimmie's] does many of those things for me. It turns the gaze around while at the same time undercutting any sort of validity to either of the gazes. Your work laughs at the turning even.

Durham **Yeah, I try to do that.**

Molesworth This is curious because even though your work appears to be 'autobiographical', it actually never is. But I wonder what happens to your voice in the turning and the laughing?

Kwon Related to that, you've said that being incoherent is a strategy of yours. Intuitively, I can understand why such a strategy is important, especially against a long history of truth claims, but can you talk more about this incoherence?

Durham **I probably can't talk about it coherently.**
[Laughter]

Molesworth We're not going to let you off the hook that easy, Jimmie.

Savage
1991
Performance with Maria Thereza
Alves
Time Festival, Museum van
Hedendaagse Kunst, Ghent

Savage
1991
Performance with Maria Thereza
Alves
Time Festival, Museum van
Hedendaagse Kunst, Ghent

Durham **Well, there are different aspects to it, that's what I mean. First, there is the problem of visual art and what kind of things it can do, that I can get it to do. Or no, not what I can get it to do, cut to see if it will do or say a particular something. If I make a piece, I don't want it to say what I would say, because then it becomes me talking through the piece. I don't want it to echo what I just said to it. Since visual art doesn't talk, I want to see if I can *make* the object talk, on its own, with me, and with the audience. Not to have a pre-recorded speech for the audience but to engage in a kind of conversation. That's the art problem, a production problem. How to produce a viable object.**

Maybe we'll call the other side the political side, although they're not really separate sides. Of course, I want my art to be socially involved, but I want it to be experienced a little more purely if it can. We seem to want to approach everything with the knowledge of it already. We don't want to come as a stranger to anything. We want to know that if we buy a ticket to a play, it's going to be a play. We don't want to see something else. We don't want to be confused. I suspect we all do this too much. So I want to jumble up the expectations. People think, 'I'm going to see Jimmie Durham's work. He does socially responsible, political, Indian art'. And I want to say, 'Ha ha, that's not what I do. You made a mistake'.

To have some sort of real conversation. I think that's it. If you and I have a conversation, and we both say what we said yesterday, then we feel kind of let down with each other. Or if I repeat exactly what you say, then you feel like, well, he's smart but very boring.
[Laughter]

Kwon Well, I came prepared with only one question. And it seems apropos now as we sit here surrounded by these display cases that seem to need a lot of physical and conceptual help. It's a question posed by the critic Jean Fisher in one of her articles regarding the problems of art and ethnographic exhibitions. She writes, 'Institutional codes constitute the meaning of the exhibition itself. Under these conditions exactly what kind of witness does the historic ethnographic object displayed in white institutions present?'

As an artist, you [Jimmie] deal with the institutional framing of your work, which always adds another layer of meaning to whatever object you produce, dictating the kind of conversation that is possible between the work and the audience. And as an anthropologist, you [Mick] also produce writings and exhibitions within an institutional frame, with very limited terms for a conversation with an audience. Can we focus on this problem and talk about the exhibition itself as a kind of writing? How can the objects in them speak differently?

Taussig I read an article by Jimmie in *Third Text* in which he talks about museums necessarily containing necrophilic objects – that everything is already dead. And that struck me as a very disturbing idea. The immediate categorizing of objects as pertaining to the past, and more than that, to something sinister that's associated with death. So the question for me might be, is this true in all displays? Would every object automatically share something with the past and death? And is that necessarily the end of the conversation, or a beginning of one? It seems pretty obvious to me that what you're doing and saying is that it's the beginning of a conversation. So in a way, the object can be seen to be in a very interesting place, pointing in two directions at once.

Durham **That's what I think. But I think there are specific histories to consider. In the Americas, especially in the U.S., there is a history of Indians that's very much a working history. So a museum that houses Indian objects has a very specific message that a museum of European art doesn't convey. The histories are not the same. But in another sense, they are the same because someone is saying, 'Look at the objects we're showing you. Come into this building and look at these objects that are in our collection'.**

Kwon If creating an interesting conversation between the work and the audience entails having to engage the place from which the work is going to be seen, then as a Native American artist, producing work for an Indian art museum versus a European contemporary art museum would result in very different kinds of objects. I mean you would have to undercut different kinds of histories.

Durham **Yes, except I'm not in control of it very much. That's the problem. When I had my show at Nicole Klagsbrun Gallery in November, I had a piece, which I called my 'Giacometti', that got bought by the Denver Art Museum. They have the largest collection of contemporary Indian art, so that's why they bought it. And because they buy works by contemporary Indian artists, they can't leave me out. I'm not, but they think that I am. *[Laughs]* So, a piece that I didn't specifically intend to engage an Indian art collection is now in an Indian art collection. You see, I would much rather they write me a letter and say, 'We're the biggest contemporary Indian art collection. Could you make us a piece?' Then I could have a little control over speaking to them and to their collection.**

Taussig Do you find that it's a lot easier if you're doing something for a specific purpose like that? If someone says, 'I would like a piece for such and such exhibition or site', do you

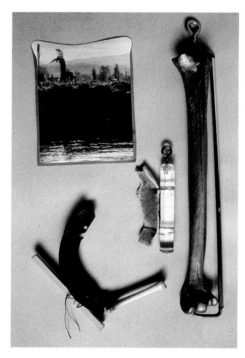

Death
1991
Bone, plastic, wood, metal,
photograph
62.4 × 48 × 7.2 cm

find that you can engage with it much more? Produce something really good?

Durham **I can't really do things any other way. For example, this gallery show that I was talking about. It was in the fall of 1992, just after the Columbus quincentennial, and it was in the New York art world. So I had those specificities to play with. The challenge is how to engage them in ways so that they can see I'm engaging them, about their stuff, but not about what they expect I think is their stuff. Or what they expect is my response to their stuff. Frankly, I don't have any reason to sit in my studio and make an object just because I like to play with physical stuff. For me, it's just a question of finding the specifics if they're not demanded. When they're demanded, it's so much easier.**

Taussig Well, I have this notion that our work is always the penultimate – the statement before the last – and the last is never realized. When I was working on the book on terror, I got very upset reading the various reports by Roger Casement about the Putumayo situation in 1910. I had never thought about terror and cruelty in a sustained way before, you see, and I thought, 'Well, he's got to be exaggerating. This is impossible'. Then I thought, 'Why do I want to say that?' I realized that a real historian would get a hold of the archives and chase every little name and every little incident down to get to the truth. But I also realized that with such an approach, I would lose sight of the fact that it's the second, third, and fourth hand accounts that are socially active: they keep the terror alive.

Something happened. Someone told someone about it. That someone told someone else and along came this outsider from Ireland, and two months, two years, twenty years later, added his or her rendition. Then I come along and inherit the responsibility. What am I going to give to the next person to think about? Because that person will go on to talk about it, too. So I always think that our work is the statement before the last, and the last, by definition, will never happen.

Kwon Would it be accurate to say that you're posing an ethical problem?

Taussig Yeah, but the trouble with calling something ethical is that it makes things too abstract and hard to deal with. I think you have to create a situation that contains a certain degree of humour and relaxation where you can see multiplicities, right?

Kwon I think humour is very operative in Jimmie's work.

Durham **But I'm really suspicious of it.**

Kwon For me, the laughter in your work doesn't come from it being funny. It's more a terrifying kind of laughter. I hope that's what you were going for.

Durham **Yeah. That's nice.**

Molesworth Why are you suspicious of the humour in your work?

Durham **Maybe it's because of the U.S. The U.S. has too much bad humour. Too many bad jokes. Too much funniness.**

Kwon Do you worry that your work will be taken simply as a joke and left at that?

Durham **Yeah. When New York celebrates Jewish humour, it's very different from Jewish humour in a Jewish community. Jackie Mason on Broadway doing Jewish jokes is a different business.**

Molesworth I think humour's relationship to stereotypes is especially tricky because it tends to function like a lubricant between different groups of people. Certainly that's how it's used in Hollywood cinema – 'Oh, isn't it funny what happens when a white cop and a black cop get together? They keep making funny jokes about each other'. But if you have too much lube, you don't get quite enough traction. *[Laughs]* It can cover over and mask real tensions. It makes everybody feel okay.

Durham **That's what worries me. It becomes an escape.**

Kwon Well, I want to get back to the question concerning exhibitions. Since creating an ethnographic display, like the one in this room[1], is potentially something an artist and an anthropologist might be involved in together, I want to ask, if such a collaboration were to happen here at Columbia, for these very cases, what and how will the specificity of the site be incorporated into the display? Is it possible to create a 'factual', educational display that can carry on a conversation? Or would you want to undercut it with something unexpected, to provoke a self-consciousness about the expectations that people might bring to the display?

**Karl Marx and Alexander van
Humboldt Tour the Americas**
(detail)
1990
Installation, Centre d'Art
International. Montreal

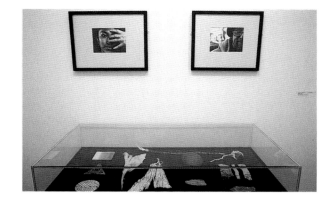

Durham **I like Brecht's idea for continually interrupting 'belief'. Maybe theatre doesn't
transfer well to visual art, but usually visual art is presented within a system of 'believing'.
That's probably especially true if the artist intends the work to be socially interactive.
We're supposed to believe the presentation even if it's parody, so the audience can only
be passive. Brecht liked to have interruptors and interruptions to bring the play and the
audience together outside of the play – outside of belief and easy emotions.**

Taussig I think of anthropological writings as no less 'artifactual' than the artifacts that
are in these glass cases. That sounds a bit obvious, but to me it's very revelatory. If an
anthropologist, to use a rather simplified and thingified notion of what anthropologists
do, can have the distance to talk about a canoe paddle or a marriage custom, you could also
pose the question, 'What makes their statement less of a canoe paddle or a marriage custom?'

Durham **This is the test I took when I went in the military: a canoe is to a paddle as an
archaeological study is to ... a canoe?**
[Laughter]

Taussig Two things stick out for me in thinking about anthropology. One is the power of
primitivism, no matter how it is displaced. And two, anthropology is an enterprise that
involves fieldwork as opposed to reading books. An anthropologist is someone who rubs
shoulders with the Other to some extent, away from university libraries and the academic
community. Of course, these two modes are connected in all sorts of ways – the whole
enterprise of truth seeking. But compared with other disciplines, anthropology has this
magic fieldwork. Even at the end of the twentieth century, I'd single out these two things
as the distinctive aspects of anthropology.

Molesworth Would you somehow want to incorporate the magic of fieldwork into the
exhibition?

Taussig Maybe. I also think anthropology involves class issues as much as cultural issues.
If you remember that anthropologists generally work with poor people in marginal areas ...
they're mostly middle class people changing their class situations for an extended period of
time. That seems to me to be an important aspect of the anthropological experience. I don't
know to what degree this has been acknowledged since the emphasis is always on exoticism
and primitivism, but the class thing is very important.

Molesworth Your comment about class is very interesting because Jimmie's artwork, which always uses bits of detritus and found objects, can be read against the general slickness of artwork made in the eighties. It evokes questions concerning class that I had not thought about until now.

Durham **That's one of the things I was trying to say to the art world in the early and mid-eighties. There was a postmodern 'style' going on. It was an expensive style. It was a very locked-in style. And I wanted to say, 'Well, if it's postmodern, then there's not a style, right? I do smart work, so you can take my work, couldn't you?' But the assumption in the art world was the opposite. The assumption was that he is Indian and he's poor. He's not doing the kind of work that is pertinent to us right now. That's what was told to me: 'Your work is not pertinent right now'. And I was doing it specifically pertinently!**

Molesworth Perhaps now class issues have been glamourized a bit, David Hammons' work, for example. It's as if the art world is saying, 'There's work by people of colour, by native people, by the Other, and they don't do high tech. They use these low materials, they are from a different class', which means that a lot of art viewers can feel like they're slumming when they like this work. Class is always so tricky. Downward mobility has such an appeal (…)

Durham **For my show in November, I wanted to engage the New York art world specifically about its current events, including my place in those events. I also wanted to do some pieces that I had been wanting to do for a while. But I didn't know how to put any of it together, so I made Caliban into a visual artist. I created a fictitious archive of Caliban's drawings, letters, and sculptures as a way to explore the third world artist in contemporary art practice. I fictionalized the fiction, in a sense, to talk about my observations about somebody else. So I was dealing with the same problem but in another way.**

Taussig You know, one of the things that we're talking about, which I see quite explicitly and as incredibly relevant, is this thing that people are calling 'identity politics'. But it seems to me that for a lot of people, identity politics is about saying, 'I am such and such. I am "X". I am proud of it so fuck you'. It's a position that can be capitalized on. But you can also be destroyed by it as well.

Installation and performance
with Maria Thereza Alves
1992
Museo de Monterry, Monterry,
Mexico

Durham **Oh, yes.**

Kwon I think some people embrace a singular identity because they feel it is the only way to instigate political change – to pass legislation, to get people in power to really pay attention. But it's an extremely problematic position also, especially when it begins to be militantly self-privileging and exclusionary.

Durham **There's a history in the Americas, and in the New World in general, in which a European can come specifically to not have a past, to have no identity, to escape mother's class, to escape national history. You can escape all that and be free in the New World. So that in the early eighties, there were many popular self-help books on how middle-class white Americans could reject the truth of family history and invent new ones. If you didn't like your mother, these books encouraged you to say, 'I bet I have another mother'. Except just as these self-help books were getting to be popular, multiculturalism came along. Now, mothers and family descent (I love the idiocy of that use of 'descent') become a license to take a little power. And it becomes a phenomenon of enforcing restrictions – and then, just as much a fantasy as the other way of inventing a history.**

There are a couple of guys writing the history of the American Indian Movement. One of them was an active part of it and the other one is younger. But in writing the book, and in dealing with Indian lives today, they are trying to re-imagine us Indians as more normal human beings than we had agreed to be. We kind of agreed to be the noble savages without ever thinking that that's what we were doing, so they're starting to push, and I think a lot of other Indians are, too, that we are stupid, greedy, confused, and banal like all normal people are. [Laughs] We might see a way out of this super identity, but only to move into something just as nutty. We go from one nuttiness to another. And with this over-reaction, it could be that by the end of the nineties, Blacks, Indians, Chicanos, etc., will really be seen to be closer to what the right-wing imagines us to be than what we had imagined ourselves to be.

Taussig But I think the tortuous and tempestuous encounters that we were just describing have a flip side to them, too. On the one hand, there is in identity politics, if I can use the phrase, a kind of closing in, a rigidification. But on the other hand, it is an enormous invitation for a proliferation of identities. You see a tremendous amount of invention right in front of you, especially in this city.

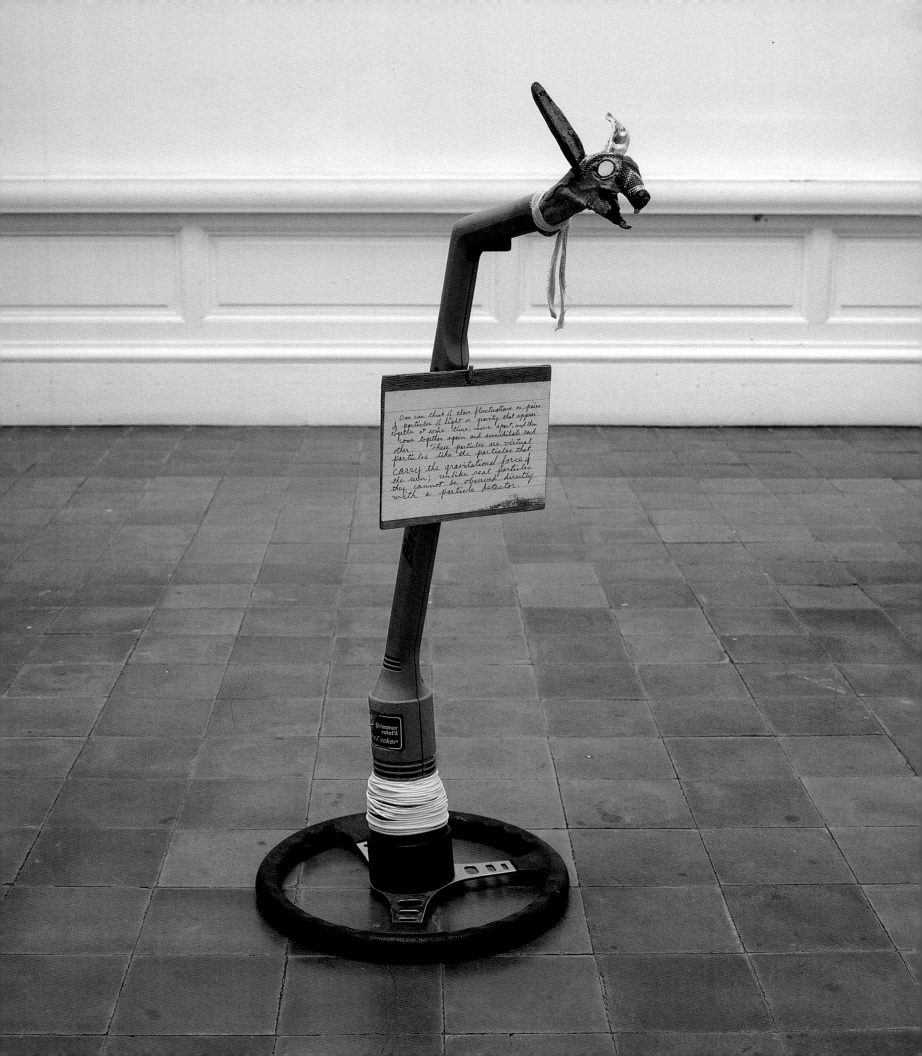

One can think of these fluctuations as pairs of particles of light or gravity that appear together at some time, move apart, and then come together again and annihilate each other. These particles are virtual particles like the particles that carry the gravitational force of the sun; unlike real particles they cannot be observed directly with a particle detector.

Rabbit
1990
Skull, shells, wood, paint, text
91 x 35 x 23 cm

Kwon But there's another kind of move that is very curious within identity politics which is the rigidification of 'hybrid' identities. You know, I am this and that. Within the context of multiculturalism, hyphenated identities like Chinese-American and Mexican-American are very readily embraced from all sides. It has real currency now.

Molesworth The biggest problem for me with certain notions of hybridity is that they insist on the instability of identity in a willful refusal to account for how it is, in fact, that we are so often speaking from fairly stable positions. Maybe this idea of instability is a kind of fantasy – that we can be different every morning. Part of identity politics seems to be about this dream of being the trickster and not accepting the total banality of how similar we really are from day to day.

Taussig Well, there's nothing more odious than some guy getting up and saying, 'I'm really a trickster'.
[Laughter]

Molesworth It's like Jimmie's take on the American fantasy of waking up and deciding that your mother isn't really your mother.

Durham **The fantasy was so strong that it sold a lot of books in the early eighties on how to do it**.

Taussig But I'm more impressed with the other side of it actually. I mean you may see in a particular corner of a performance, intellectual work, or artistic work, this irresponsible celebration of hybridity and multiplicity. But I think that's a very tiny component of what makes this country work. I think the other side is far more enduring. After all, people talk more about their mothers than murder them.

1.This conversation took place in an anthropology classroom at Columbia University, New York.

Documents, New York, Summer 1993, no.3

Gado usdi hia? 1993

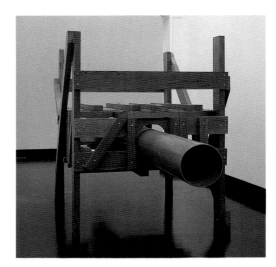

Untitled
1993
Wood, metal, PVC pipe
192 × 118.4 × 372 cm

Ni, gado usdi tsa duli?

Deskunh si, desginehunh si, desgedisi,

desginunhsi, deskunhsi – 'sta yi ale

utana, 'sgi na nunh ya,

Hi anunhya – adahne di.

I tse lisgunh kilowuagihunh hi nai.

agua agunhnige dantogi gunhneha tse nito tsi,

squala. ale, gelia go hi unahwi tsi wasgi.

Ya degadagunh ha lunhdi. a tla ha nunh ya,

nunh yo. Ni, so gu'hni ga daha nunh ya.

a tla ha na, agihunh hi.

Tlayi a tla ha.

What Sort of Thing is It?

I started to write this text in Korean.

'Gado usdi hia' means 'what sort of thing is it?' Except there is no word in that phrase which means 'thing'. The phrase contains 'what' and a verb; no noun or pronoun.

I do not know of a Korean word which means 'thing', or 'object'. There is no pronoun 'it'.

I've written in a previous essay that the Korean word for 'the Earth' could best be translated as 'a continuing process'. Most Korean nouns are not nouns at all, but descriptions of action, function, or shape (or all three). We might consider Korean as a language which speaks of functions and relationships.

Nouns are completely integrated with verbs, so that when my Korean text says 'I offer you my hard, impure heart', the hardness of said heart is in the verb ('hard-I-give'). The word 'heart' is not abstract; we can translate it only as 'functioning-inside-me-heart'. (I then add to that an adjective for a particular kind of impurity common in Pearl Harbour.)

A completely different word is used for a heart which has been removed from the body; such a heart is no longer the same 'object' because its function has changed. In the Korean text that is the word used when I say that you attempt to buy my heart.

opposite and following pages,
Untitled (details)
1993
From 'Rendez(-) vous' exhibition,
Museum van Hedendaagse Kunst,
Ghent
Mixed media
Dimensions variable, approx.
24-48 × 9.6-16.8 cm

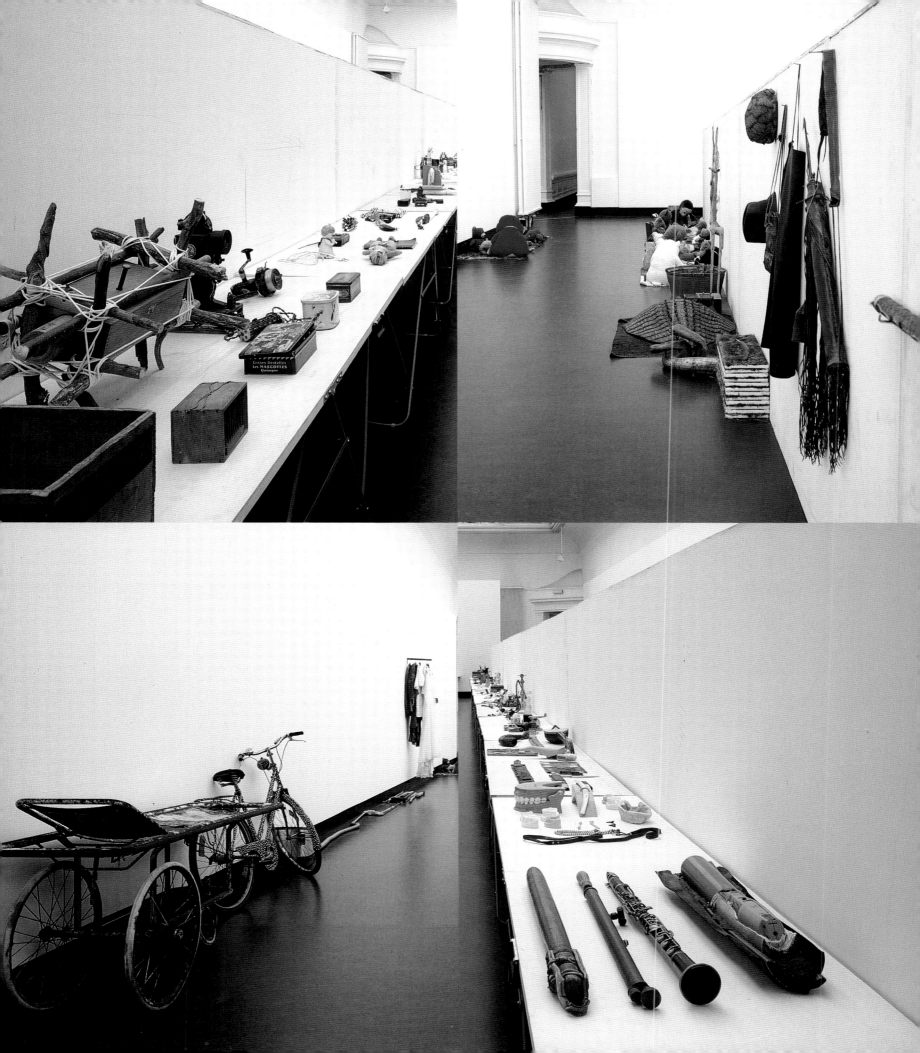

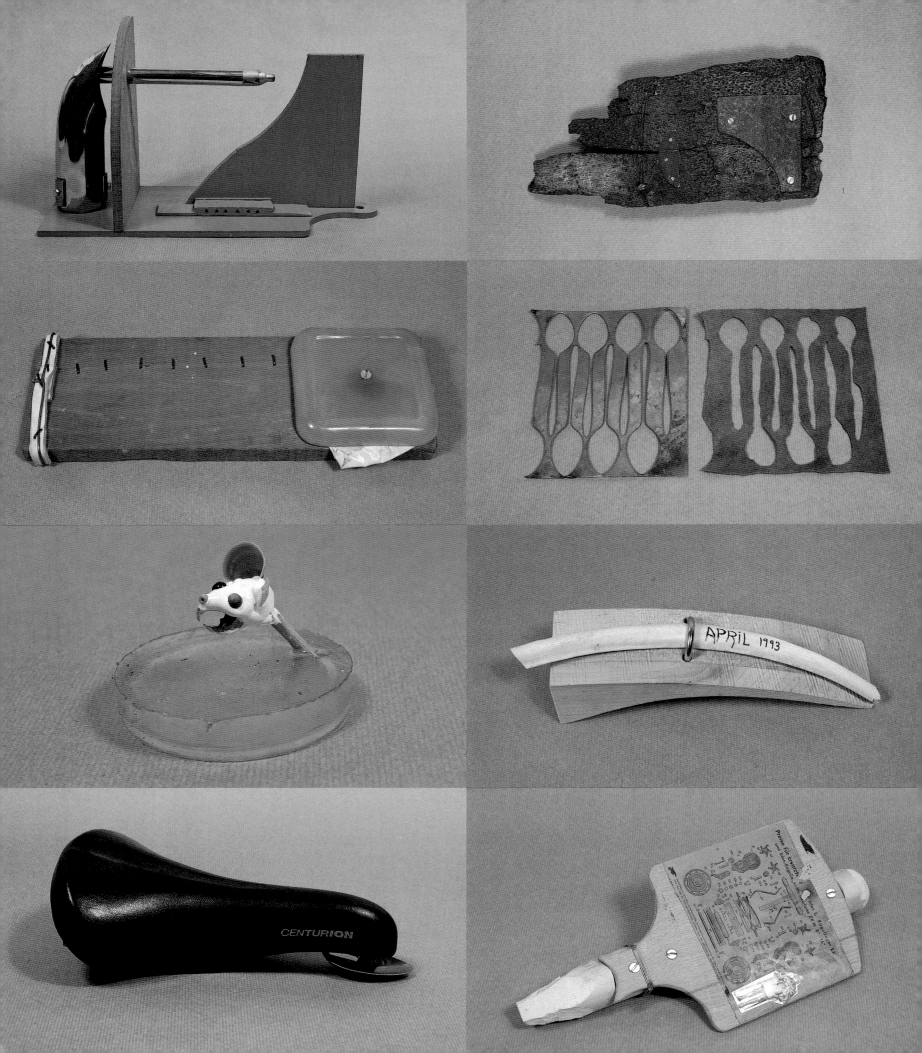

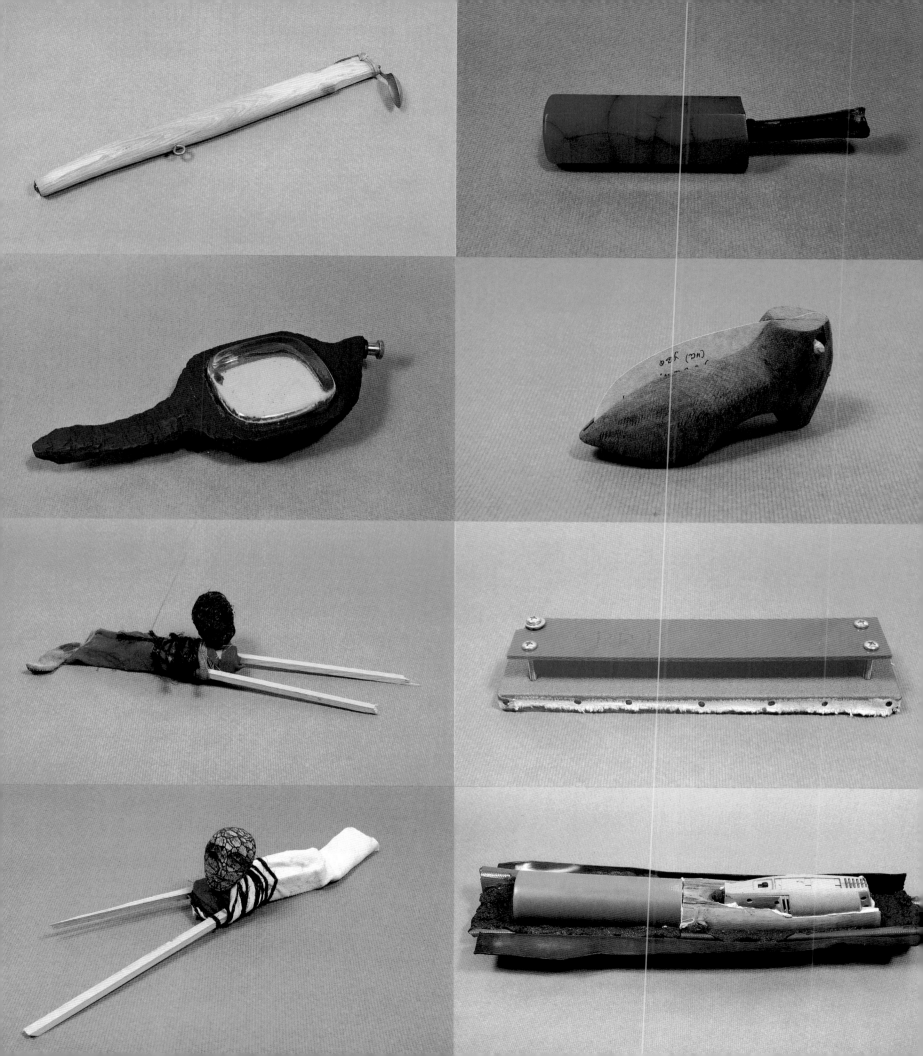

A Map of the Sky Including Betelguese and a Pecan
1993
Pecan, crab, fabric, cotton on wood
386.4 × 86.4 × 74.4 cm

There is a slippery exactitude to Korean language. A verb which almost translates as 'to want' always contains as part of its form a description of the thing wanted but never an abstract 'thing' as object even if that is what is intended, because there is no abstract thing. When, in the Korean text I ask 'Gado usdi tsa duli?', you reply with a verb only; with a specific desire, in other words.

You can ask for a cut-off piece of meat by using one word (not related to the word for a severed heart), but you must, because the verb does, describe the basic quality of the meat.

One can say 'a tla ha', which might mean 'an object that is not moving but previously was in motion'. But the phrase has nothing that means 'an object'.

This descriptiveness of words precludes a possibility of showing ownership of things. There are no possessive pronouns in Korean simply because who owns something is not pertinent. 'Sgi na nunh ya', 'like a rock' – I can give it, you can buy it. But it will never be an 'it', and no one can own it.

Of course, one might say an abstract 'thing' by action; 'adahne di' means 'gift'.

'Rendez (-) vous' (cat.), Museum van Hedendaagse Kunst, Ghent, 1993

Fire! Or Imperialism!
1994
Performance, Cleveland Center for Contemporary Art, Cleveland, Ohio

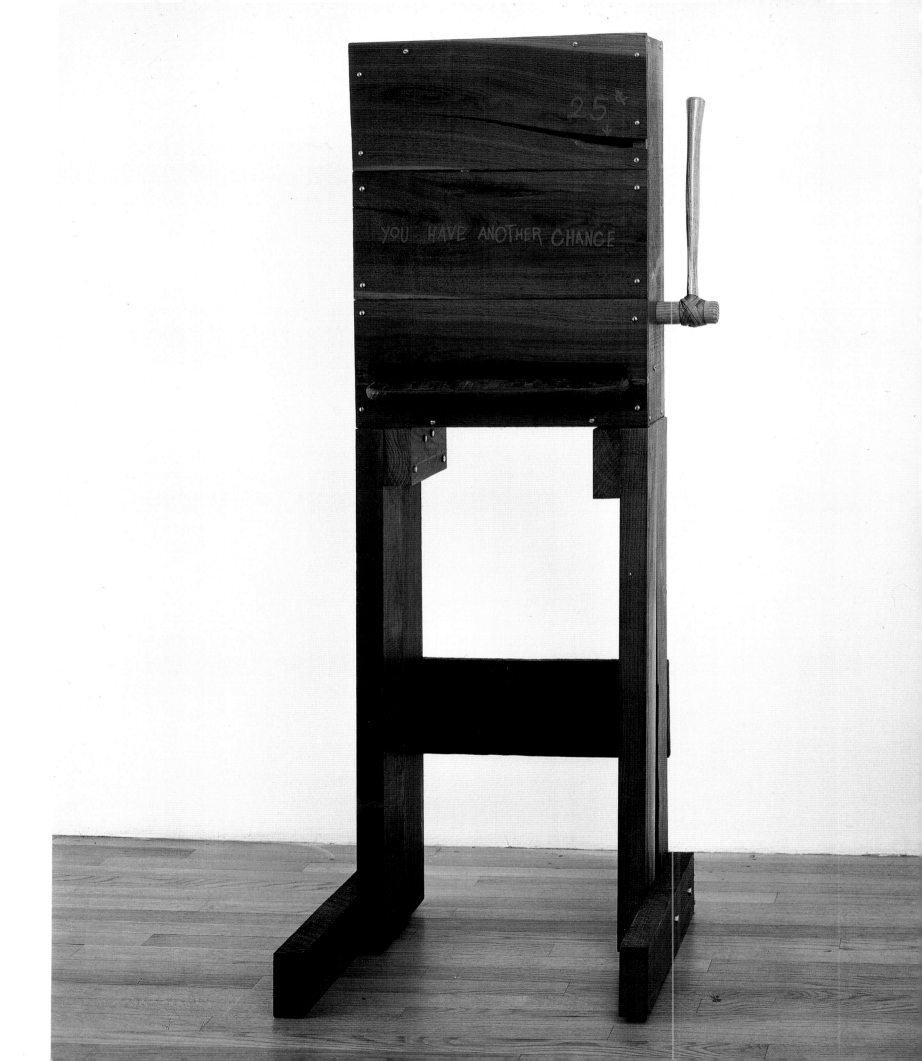

How I Made My Sauce 1993

I was home by myself, so I decided to put supper on to cook while I went to work in the garden. I put carrots, onion, chayote and two bunches of cilantro in a pot with some water and two nopales.

When I came in at seven, the water had boiled away and the vegetables were black. I poured in more water, to clean the burnt pot. But the mixture had a good smell.

I decided to add some garlic, cinnamon, and coffee, to see what that would taste like. Pretty good, so I thought, how about some guavas, chilli peppers, and concentrated tangerine juice, with a little vinegar?

Even better. So I added lemon peel, tangerine peel, ginger and Chinese black tea.

Getting to be a very good taste, so I put in some capers, dried cranberries, cardamon, and bourbon whiskey. Hmm!

There was some tamarind paste mixed with dried chillis on the table, so I threw that in with some anise seeds and cumin powder.

After it all cooked a while, I put it in the blender and then through a strainer and then into bottles.

It is very good. Better than Worcestershire sauce, but similar.

Next time you have some gardening to do, you might want to try this delicious recipe.

But it's got me thinking about things: has anyone tried making a sauce from mushrooms that have been roasted until they're completely burnt? It just seems to me that my sauce would've been much better, if I'd added roasted shrimp heads, mushrooms, and corn with the cornsilk and husks.

That, however, might be a separate sauce in itself, cooked in clam juice with mango, onion, lemon and ginger. Perhaps fish heads roasted along with the shrimp heads, and pumpkin seeds with white wine, celery and white raisins. A little thyme and rosemary.

Smoked mackerel heads, or smoked eel, would give either of these two sauces a special flavour, as would, I think, roasted egg plant and tomato.

Okra, or more nopales, maybe with red seaweed and a little pectin and cornstarch with sassafras leaves or roasted avocado leaves, would add a nice sensual texture, I imagine.

I've decided I must copyright these two recipes. Make these sauces, by all means; but do not try to sell them.

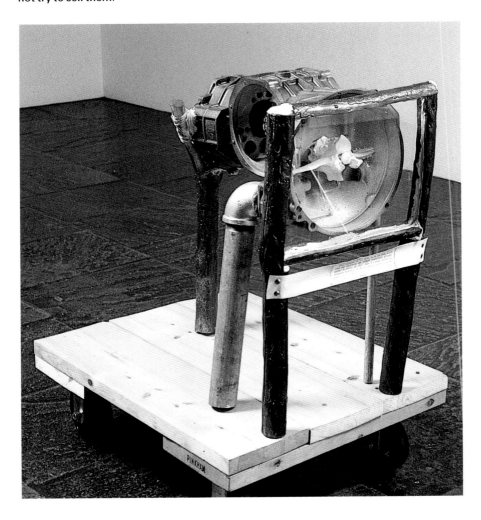

Untitled
1993
Bone, metal, wood, glass
92 × 72 × 62 cm

Artist's Writings

Gilgamesh and Me 1993

Editor's Note

In the autumn of this year Jimmie Durham, who has posed variously as an artist, a theoretical biologist, and as an international gardener, was detained under suspicion by the authorities at Antwerp Airport. Durham was found attempting to enter the city carrying sheets of dried pulp made from trees, upon which he allegedly had made certain markings.

The following text, deciphered by the Bureau of Egress, was delivered to the Museum by the Bureau of Foreign Documents. The Museum does not claim authenticity for the text; certainly it does not contain the original markings made by Durham.
R.F.P.

Introduction

The Wildman, or Wildemann, family faded into oblivion as writers and critics during the Enlightenment period, but prior to that they were a social phenomenon of great influence outside of virtually every city in Europe.

The Works of Enkiddu Wildemann were collected by his grandson Friedrich but were not published for two hundred years. Subsequently, because of family squabbles and misfortunes, most of the original manuscripts of both Enkiddu and his father, who was known only as 'Wildman', were destroyed or lost.

It is with genuine pleasure, then, that I am able to make public these texts by Wildeman which were thought lost over 6000 years ago. You will notice that Wildman holds to the theory that civilization – city-ness – actually contains only one city; that the city is what might be called a multiple entity, or virus.

Even when he playfully assumes to be writing about some specific aspect, such as his 'Antwerp' in the 'Editor's Note' included here, and in this 'Introduction', (both of which were, of course, originally published under pseudonyms) he does so, we believe, only to call attention to the basic carboniferous unity of the city.
Jimmie Durham, 1993

Gilgamesh and Me The True Story of the Wall

I have lived in the city most of my life so that now I often think I've lived in the city all of my life, even though I am originally from the forest and have acute memories of those emerald-and-tortoise-shell days. It is as though I've always lived in both places, sylvan and civil; perhaps the Wall has actually contributed to the unity of my duality – when I visit the Wall am I not seeing the trees under and around which I once fearfully and

Gilgamesh
1993
Wood, PVC pipe, axe, door,
furniture, screws
374 × 432 × 144 cm

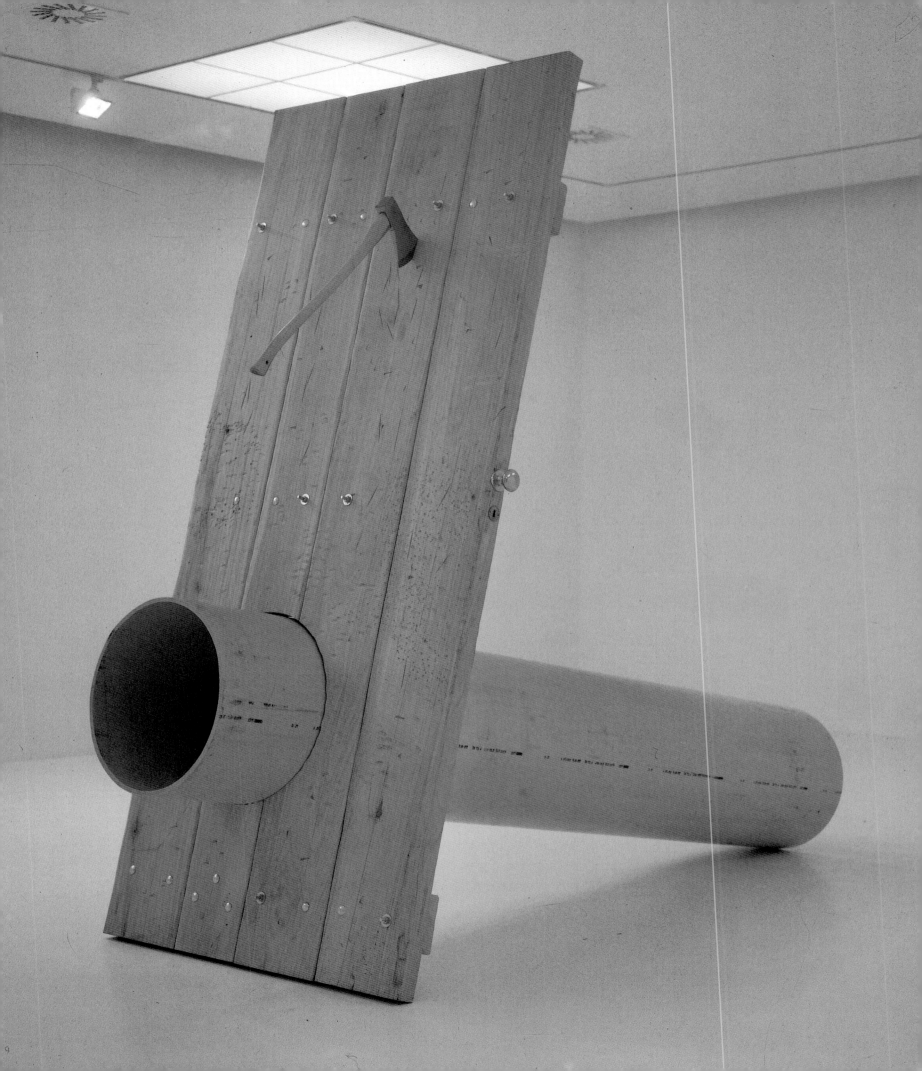

celebratorily walked?

Well, let me begin again: like the forest itself, and certainly some of the streets in the city's centre, stories must often go around themselves. You already know the basic facts: Gilgamesh the King built the city and saw that the perception that more protection was needed could insure him a place in history. He also perceived that the city needed a cleaner delineation, that it needed a wall as a way of defining civilization, of showing the city it proper limits. In whatever case (I mean, of course, I only hope I imagine his thoughts accurately; we were brothers only by desire and by a continuously maintained artifice which, as you will see, soon began to crumble), Gilgamesh cut down the forest to build the city wall.

We had, shall I say, an encounter, he and I. Right from the first, Gilgamesh wanted me. The king was truly an insecure man, but I had never known security: a tree is shelter for any creature that comes along. He wanted this Wildman to witness his mighty works, needed my wonder like a writer needs a pencil, and I was impressed by such a need. I agreed to come to the city because I saw that Gilgamesh's project was nothing less than civilization, and I would be its anvil. Also, of course, there was no place else to live.

Whether or not I forgave more than I should have is one of those eternal questions friends and lovers ask, as absurd as trees or walls. But the truth is I still miss him. He was a beautiful idiot. Gilgamesh the King was always afraid of me, and I had sympathy with his fear. After all, I knew his city and its wall much more intimately than he ever could have known.

I remember well his pleasant shock when I showed him that his wall must necessarily

Je t'attend

be considered as a door also. And in those days when the world was not nearly so vertical as it is now, he and I would use the wall as a table, a kind of connective barrier upon which fists could be pounded and cards shuffled. Cards! Gilgamesh taught me the relations between kings and jokers and I taught him to delight at the deliberate flimsy-ness of card houses.

What happened? Something fell between us heavy as a tree, decisive as an axe, as clear and insurmountable as broken glass.

One day in September he said, 'You are dead. I'm going to the wilderness to find you, come with me!' With that kind of stupidity friends and lovers always have, the immediate perversity of deciding to answer the wrong question, I replied, 'What wilderness?'.

I have not seen him since. Am I dead? I live in this city where I have lived most of my life. I write, I have my circle of friends. I visit the wall and explore its innards, this city sometimes a labyrinth sometimes just guts.

All of the King's subjects are still here, and act as though he is still here. If they recognize me they often become angry, at what I don't know.

But a week before the King went searching for my authenticity we had had a conversation about my relationship to his, as he said, loyal subjects. He stated quite calmly that my speech habits and basic foreignness

(here the manuscript ends)

'On taking a normal situation and retranslating it into overlapping and multiple readings of conditions past and present', MUHKA, Antwerp, 1993

A Friend of Mine Said That Art Is a European Invention 1994

Originally this paper had three titles, by which device I'd intended to show my own hesitancy to attempt a clean statement. My reluctance to clarity is not simply a way to enlist your sympathy to my muddle-headedness; in these days we are making contradictory demands on ourselves and each other and, while one might wish the demands to give up vociferocity in favour of articulateness, one wants to respect the bases of the contradictions.

Because our subject is what we hope might be some new internationalism, let us begin with some old questions about nationalism, for how might we imagine internationalism without it being among nations? Or do we instead imagine us all to be free cosmopolitan spirits? Even if we do, the authority in charge of permits and permission imagines nothing, so the question remains. We have a proper distrust of nationalism. Yet we often seem to feel a need to assert something of our nationality or ethnic background.

I will propose that history in this century has made a confusion between nations and states, so that when we examine any particular nation-state we find turmoil and falsehood. Here is England, made a nation-state by the invasion of the Normans (by which event it should perhaps be more properly called 'New Normandy', like 'New York', except that Normandy itself is the product of an earlier invasion of territory that was in no way part of 'France' at the time). In most cases the state has taken over nationality, as others have said, by terrorism, and it maintains its power over us by terrorism. Something is thereby put into place, into a vacuum caused by the state's activity, that we call 'culture', or 'national culture' simply because we have a survival interest in not calling it the daily effects of daily terrorism.

Nationalism, then, as a rationale for internationalism, becomes an anti-cultural starting point. And, of course, we might better name internationalism 'interstatalism' in these instances.

What seems often forgotten, though, or at least elided, is that the nationalism of states is rapidly becoming a thing of the past, having been forced out by its own suppression of the histories of ethnic groups. It is not difficult to make the case that the various fundamentalisms and ethnic aggressions which plague us now are actually reactions against nationalism: against the nationalism imposed by modern states. The future looked at that way seems closer to the cosmopolitan side of our desires than does the present, but also more mean and dangerous. A postmodern medievalism.

Anyway, I don't see how we can continue to think of internationalism as though there will always be an England; at least not an England, France, Germany, US and

Forbidden Things
1993
Paint, wood, plastic
213.6 × 136.2 × 76.8 cm
Collection, Museum of
Contemporary Art, San Diego

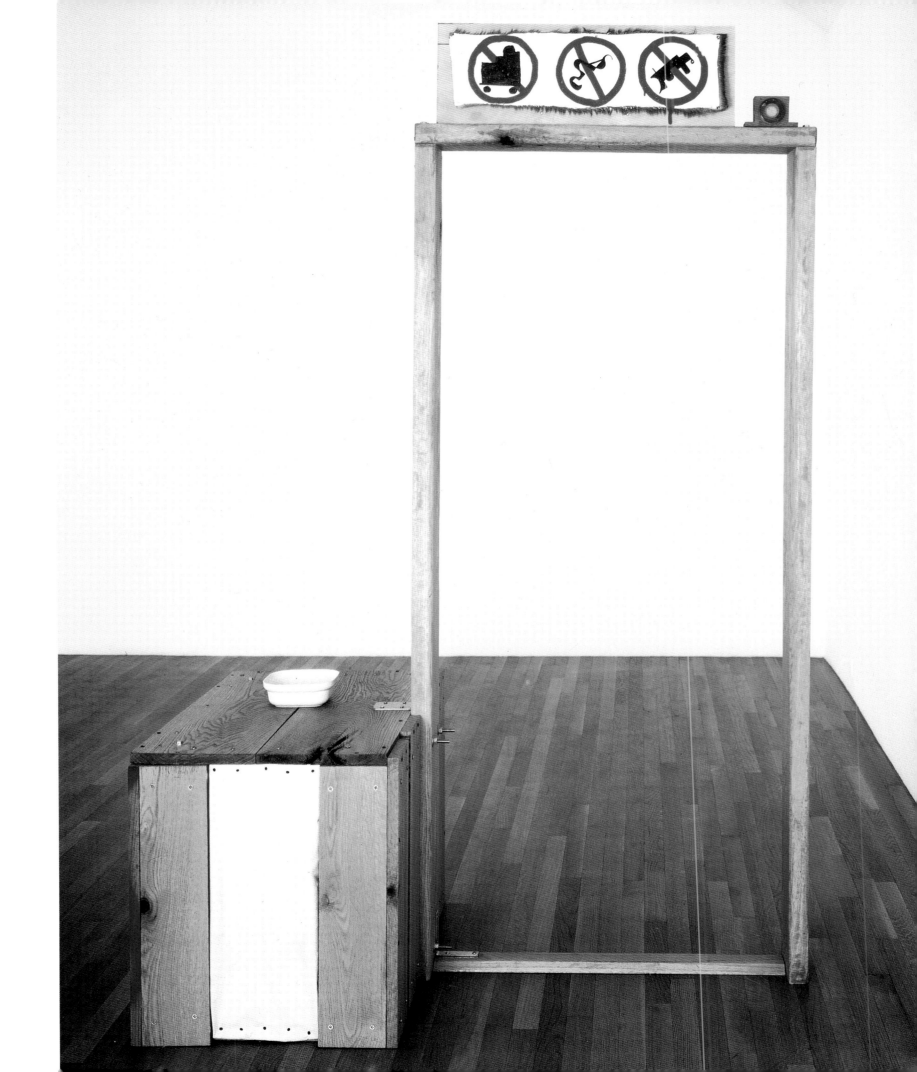

Ukraine under and against whose auspices internationalism can be appreciated.

But I do not really mean to commit prophecy here, because meanwhile we are at the tail-end of a project, the state, which is still a living beast. We haven't much choice but to try to grasp the tail.

When we think of nation-states we think first of those which make up the mythical concept 'Europe'. It is those which make the essential internationalism that we have known. Thus nationalism comes as defensive strategy of one against the others, like Mafia families. This internationalism is in the first instance competitive, like the Venice Biennale, and in the second, fearful and hermetic. Now Europe-the-myth attempts to re-create itself as a concrete 'community' wherein competition is more ordered. The current debate about who might be allowed into this community, and who might be forced out, exposes the roots of internationalism. If internationalism is a requirement for civilisation, what nation is civilised enough to participate? Or, who can England talk to? (And how, these days, can the nation-state called Great Britain find a voice in which it may talk back?)

Our seminar is at the Tate Gallery; in the spirit of internationalism will the Tate convince itself to acquire some newer, funkier 'Elgin Marbles'? By asking the question I do not mean to condemn the acquisition of any older 'Elgin Marbles' by anyone. But simply, as a national museum, can the Tate decide that these days it need only diversify its holdings to speak to a more diverse 'Men of England'? It's not so easy at all for the Tate to cease being an English museum – what else can it be; an 'international' museum, a 'European' museum, or, worst possible case, a museum that reflects 'the changing realities of postcolonial Great Britain'? And, how could it *not* commit those reasonable crimes? The crises we are in are big and small; there is no proper voice for anyone, whether one is an artist, a museum, or a nation. History, and our refusal to face it, forces us all into positions of reaction, so that the reactions themselves become less and less intelligible.

If there are nations what can be the project of each? Simply to be, to exist? As Jan Hoet recently said about Indians of the Americas, that's not much of a project. What if we imagine a group of people who speak the same language getting together for general, open-ended discourse about themselves. Let's call that a simplified nation, without state terrorism to enforce it. What sort of ideas will our little nation say to itself? I bet that pretty soon quite a few members will get bored and become passive. Some others will, deliberately or inadvertently, say things one is not supposed to say (according to Italo Calvino's model wherein no-one knew one was not supposed to say that until one did).

Like the scientific theories about the first three minutes after the 'Big Bang' that began our universe, our theory must be that both terrorism and censorship, orthodoxy and 'nationality' itself, begin at the moment, at the next moment the thoughtful member must escape, if not physically then at least intellectually, to hold on to the little nation's original idea.

This exile then is the 'only true patriot'. What will she say to the other nationality when she tries to function in their city, their conversation? There's been no imbalances of power between these two neighbouring nations because we just now invented them, so the people there are sympathetic to our exile, and welcome her. At an official reception the mayor asks, 'What happened?' 'Oh, I said that glass is a fourth category of matter, and people become angry and afraid.' 'Mais, c'est ridicule!', replies the mayor, 'Everyone here says that!' She is given a medal. But I forgot to say that her sister was also exiled; I can't remember why. However, during the ceremonies the sister noticed that the poetry of the host nation had to make rhymes of the last words in each line. She said that that was an invention of primitive militarism, having to do with primitive mental drum beats to call people into war. It was actually against the law to say that, but being an honoured guest she was not put in prison. Her punishment was more severe; no-one would talk to her. She became a double exile and committed suicide. Meanwhile, our original exile went around happily saying that she had said glass was a fourth category back home, and people began to get bored and would ignore her, so she also committed suicide and was given another medal posthumously.

Actually, we know that in the first three minutes after the 'Big Bang' there *was* an imbalance of power; so that the first nations meddled in the affairs of the other nations even to the point of inventing them, and inventing them in the image of their invention. But suppose my absurd model were true, what would be a possible excuse for my little nations? It could only be, it seems to me, their destruction. Destruction in the sense of continual change. One nation would exist only as a way of speaking to others, not amongst itself. Doesn't communication have the idea of change within it? Change is a kind of destruction (and, of course, re-creation). If one communicates only with one's self there's little possibility of change. (One may then become 'a very strong self', but what's that good for?)

All of these old little nations have bad histories and bad excuses. Any sort of communication with the outside, any internationalism, is perceived by them as death.

Do you see what I mean about the Tate? Some day when I have time I want to do a comparative study of Josephine Baker and Anish Kapoor.

Michael Taussig, in his book, *Mimesis and Alterity*, presents the idea that we set up roles for the 'other' to fill so that we can recognize the otherness (the alterity) that we want to be there. The other then fills the role by mimicking our mimicking of the role and by mimicking us, by which we recognize ourselves. That is the third minute in the internationalism of nations. 'The border', Taussig writes, 'has dissolved and expanded to cover the lands it once separated such that all the land is borderland, wherein the image-sphere of alterities – disrupt the speaking body of the northern scribe into words hanging in grotesque automutilation over a postmodern landscape where Self and Other paw at the ghostly imaginings of each other's powers.'[1]

We can say that this takes us to one of the multiple hearts of the new internationalism. Not that we will by-pass nations, but that we will treat them as curiosities that lack compelling powers. By that phenomenon perhaps there is opportunity for discourses closer to our hearts. The states will continue to terrorise us but we can see them as outside forces. A new internationalism could be inside; that is, an intellectual project for a change.

What we have seen in the past few years in the arts is a kind of slavish little echo of the reactions against state projects by the general populaces, which in themselves are so belligerently anti-intellectual that it has been easy for the states to direct them. More artists from differing backgrounds are visible now, and the art produced seems usually completely predictable. I do not care if this seems an old and even curmudgeonly complaint; recently I spoke to a group of art students in Holland, and said that we as artists are in a severe crisis about what might be art at this time. The regular teacher thought I was scaring the poor young people, and said, 'People have always claimed that there's a crisis in art'. Well. There always has been, so why not complain? The current crisis seems more severe because there really is nothing to be made effectively, in the traditions of what art can do, and we are left with small gestures about the past.

I want to return to my friend's statement about art as a European invention. In the main I do not disagree with him. It is only that I am not sure about three of the words in the statement: 'Art', 'European', and 'Invention'. 'Invention' is especially problematic in our present crisis. Maybe there has been an underlying idea that art was invented at some point, and certainly the art schools and art books give that impression simply because their existence gives a kind of history, so that all that needs doing is a fixing up, fine-tuning, or improving to suit the times. Such an idea might be helpful in giving a general outline or description, but I doubt it.

I'll consider the idea of 'European' again a little further on, but 'art' as a given is

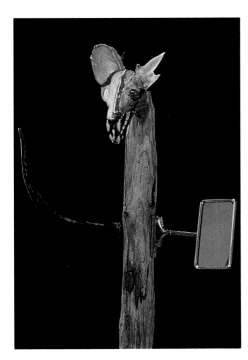

above, **Not Joseph Beuys' Coyote**
(detail)
1990
Beads, mirror, paint, skull, horn,
wood, shell, bone
144 × 48 cm diam.

left, **Not Lawrence Weiner's Trip
to the Borneo**
1990
Wood, cocunut shell, screws,
mixed media
18 × 9 × 27 cm

directly connected to 'invention'. One hears of people who love art. I can't make sense of it; it seems as asinine as loving children. The category is too broad, and it also hints at some complicity in entertainment, if not actual badness. Maybe it's a category for experts, in that experts make the category so that they may then get jobs as experts.

We all must have lists of art and of artists that we detest *because* they betray what is important to us about art. Yet that importance is explainable only through specific examples. We really have only individual works, for specific reasons to each work. If there had been an invention wouldn't we have had to have scrapped it? (Or perhaps now we must?) It would not, whatever it was, have been like the invented wheel, applicable to a thousand vehicles.

Gabriel Orozco, a Mexican artist who probably would not approve of being described that way, says that we cannot make thrilling art anymore, that Disneyland, the movies, or just Benetton advertisements can do it so much better than we can, even if it were a good project. By 'thrilling art' he means both the gigantism of Henry Moore and Richard Serra and the *mechantisme* of Jeff Koons and Charles Ray.

Not that I ever wanted to make thrilling art, but Orozco has thrown me into a pit. I ask what sort of art can one make, and strike from the list art that is instructional, confrontational (people would only pretend to be confronted), 'puzzle' art, in which one has only to find the answer and then one need not look at it anymore, intellectual art that cancels sensuality, sensual art that cancels intellectuality, art that attempts only the smallest ambition or complexity, art that tries too hard, 'properly balanced' art, and most certainly 'delightful' art and as I've said earlier, art that is simply gesture within the art world.

Certainly we cannot be making only that art which is necessary, as I've tried to do most of my life, because we are not capable of measuring necessity, and the world will not admit even the possibility. Another certainty closely connected to that is the almost impossibility of making public art or art with 'community involvement'.

Yet don't we sense that the times are demanding something from us? Something beyond what we can easily imagine?

So then! Is this a crisis or not? A crisis! In the eighties, more so in the nineties, we have seen really too much bad art in a style that we began to call 'international' just because the work was so predictably, so sophisticatedly bland; the blandness of smart cocktail party chatter. Didn't we always think it was about to lead somewhere? And aren't quite a few of us now trying to figure out how to do it a bit smarter than the next guy just because there's now a possibility to get into a show at the Serpentine Gallery?

Suppose we were not doing 'international' art, and were doing what must amount

Gabriel Orozco
Dial Tone (Tono de marcar)
1992
Paper collage
l. 979 cm

to 'ethnic' art instead? Entirely ridiculous and beside the point as well. Does that leave us doing art that has an accent?

That is what many of the 'Europeans' seem to think worthwhile. They seem to think that, as art is their invention, effective art is within a developed vocabulary and accent. They might wait expectantly for change but they're sure it can only come from them; we don't have European accents.

I'm back to my friend's statement about art, and there is an incomprehensible history embedded in the word 'European' which is now blooming in wondrous absurdity. We might say, as some *do* say, that 'European' means 'western Europe', with Italy, Austria and Germany as the Eastern border but not truly including Spain and Portugal because they are too medieval, and hardly including Italy itself because of Mediterranean anarchic culture. Not either including Germany much since Goethe and Hegel; it's been bent on backsliding into barbarity. Basically this Europe is France, Benelux and Great Britain (Scandinavia is too isolated up north). But I am always struck by the charming stupidity of Britons in calling themselves Great Britain and everyone else 'Europe'. England is not properly part of Europe; everyone knows it's in the ocean, with no other significant islands around. (But now, for reasons hard to follow, international soccer is an economic necessity, and the European teams and villages feel severely put upon by the peculiar type of civilised behaviour from the British side.)

Diana Trilling once said that only the English truly developed the novel. She made such a good case that, after considering the weaknesses of French, German, Spanish and Italian novels, I completely took her point. Except I substituted 'Russian' for 'English'.

I do agree with my friend. But if 'Europe' is actually no more than the expectation of a project (which in itself is a phenomenon of great importance, don't mis-understand me), it doesn't seem to follow sensibly that we should do more with the fact than to say thank you with sincere admiration (which in itself would be of great importance).

Can Europe, or even Europe with its 'white' colonies such as Canada and the US, use its invention of art exclusively, and exclusively for an internal discourse? I hope I've shown within common sense that the question is silly in every part.

Next, will they allow themselves or will we allow them to collect our invented authenticity? Will we allow them to collect our anger? Well, they cannot even manage that, because *their* existence is too ghostly.

Multiculturalism might be considered a viable strategy if anyone out there, including a soon-to-be-realized Europe, had any culture. But I expect not even then. Instead we would end up with something like an international 'sale of work', a

'garage sale' of trading units.

People have said to me, better to just do your work and forget all the theoretical *angst*. I think, more likely to forget work for a while and develop more *angst*.

Everyone *knows* so much these days. Isn't it odd how sure we all are? The New York city taxi driver who wrings a miserable life of unfulfilled dreams from his student days in Iran is sure that Salman Rushdie's death will fix things up. John Major is sure that if we return to English family values we'll work it all out.

As artists I think we should see our ideal audience as people smarter than ourselves. It is the very attitude we seem least willing to accept. And how rare that art ought to be coupled with intelligence anyway. We traditionally tie art to 'talent' (the most rusty old part of the European invention), to vision, and to some not-quite-defined instinctual characteristic (as though any of these were opposite to intellect).

I know there is a desire for learning, and that it is a desire for changing, because that is how we begin to see this new internationalism, but like England and Germany we tend to want to learn that which we already know. We want to expand art to be a part of the narrative in declaration. When Europe invented art it realised that it had invented a monster. To keep the monster pacified Europe asked it to tell stories; to un-invent itself and become text. To say that one picture is worth a thousand words is to say that one picture is *like* a thousand words. (And in England people still go to the Tate to look at the 'pictures'.) I am *sure* art should not be visual metaphor for text, and I feel that we give text more importance than it actually carries in daily life. It is not the only way of meaning, nor the only intellectual way of meaning.

I'm not saying that there is some art out there among us Third Worlders that should be included in the established art world for its positive destruction. I mean something more like why isn't there, and how might we make it so? There is an art discourse that is always on the verge of being interesting. Almost a discourse. We cannot just interrupt it with a new discourse, we have to enter it; Europe has to enter it; and each as ourselves with our own proper voices. Us who have neither selves nor proper voices.

As usual, we are looking toward the future as though it will be the past.

1. Michael Taussig, *Mimesis and Alterity*, Routledge, New York and London, 1993

Global Visions, Towards a New Internationalism in the Visual Arts, Kala Press, London, 1994, pp. 113-119

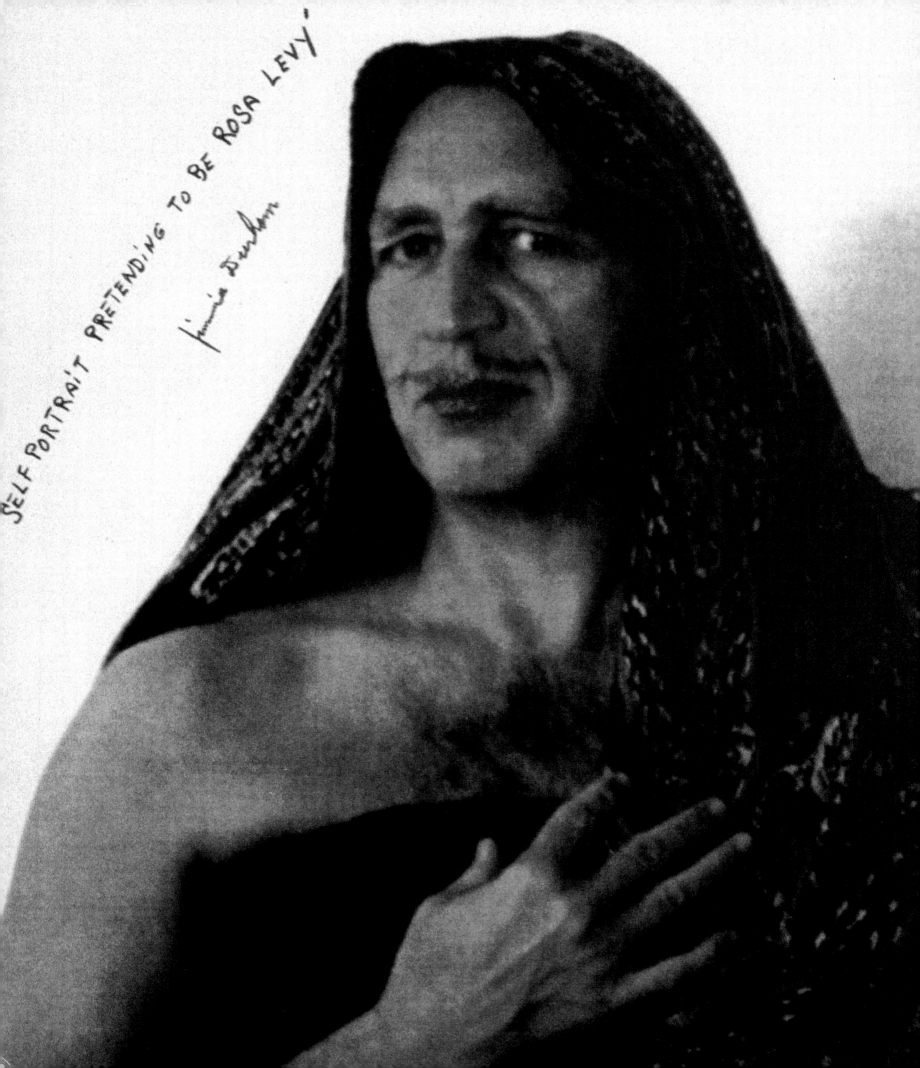

SELF PORTRAIT PRETENDING TO BE ROSA LEVY

Contents

Selected exhibitions and projects
1964-76

Selected articles and interviews
1964-76

1964
Poetry published in *Adept*, No1, 2 &3, Houston, Texas

Performance, 'My Land', **Alley Theater**, Houston, Texas
with boxer Muhammed Ali and Vivian Ayers Allen

1965
Exhibitions in various galleries and at the **University
of Texas**

Articles and poems to alternative newspapers and
magazines in Austin, Texas

1967
University of Texas, Austin, Texas (solo)

Adept Gallery, Houston, Texas (solo)

1968
Moves to Geneva

1969-72
Various street performances, Geneva, Switzerland

1971
Centre des Recontres, Geneva, Switzerland (solo)

Circa Gallery, Geneva, Switzerland (solo)

1972
Attended Ecole des Beaux Arts, Geneva, Switzerland

Circa Gallery, Geneva, Switzerland (solo)

Ecole des Beaux Arts, Geneva, Switzerland (solo)

1973
Full-time organizer for the American Indian Movement

Lives on Pine Ridge Reservation, South Dakota

1975
Text, 'T VA and the Snail Darter', *The Washington Post*,
9 April , 1975. Reprinted in *The Denver Post*, *San
Francisco Chronicle* and the *Los Angeles Times*

1975-79
Executive Director of the International Indian Treaty
Council, New York

Member of the American Indian Movement's Central
Council

United Nations Representative, New York City

1975 - 1980
Co-editor of *Treaty Council News*, monthly newspaper
of the International Indian Treaty Council

1976
Editor of *Chronicles of American Indian Protest*, 2nd
edition, Council on Inter-racial Books for Children,
New York

Text, 'Untitled Essay on Governmental Infiltration of
the American Indian Movement', *Counterspy*, Vol 3 No
1, New York

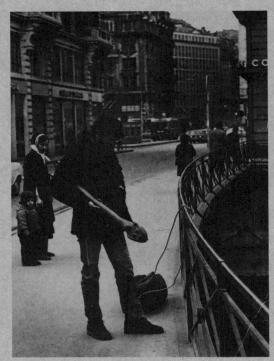

Performance, Geneva, 1971

United Nations, New York. Jimmie Durham, seated, back row, fifth from left

Exhibitions and projects
1977-85

1977
Text, 'Mr Catlin and Mr Rockefeller Tame the Wilderness', essay in *An Anti-Catalogue*, various editors, Artists for Cultural Change, New York

1979
Text, 'American Indians and Carter's Human Rights Sermons', *The Black Scholar*, Sausalito, San Francisco

Text, 'Eloheh, or the Council of the Universe', *IFDA Dossier* No. 6, April, Lausanne, Switzerland. Published in French, Spanish, Portuguese, Italian, German, Finnish

1980
Leaves the American Indian Movement and the International Indian Treaty Council

1982
'Beyond Aesthetics',
Henry Street Settlement, New York (group)

'Ritual and Rhythm',
Kenkeleba Gallery, New York (group)
Cat. *Ritual and Rhythm*, Kenkeleba Gallery, text Juan Sanchez

Performance, 'Manhattan Festival of the Dead', No Thanks Festival, New York

1982-1985
Editor of *Art and Artist Newspaper* (formerly *Artworkers News*), published monthly by the Foundation for the Community of Artists, New York

1983
'Invitational',
14 Sculptors Gallery, New York (group)

Poetry, 'Columbus Day', West End Press, Albuquerque

'Artists Call Against U.S. Intervention in Central America'
Judson Memorial Church, New York (group)

Performance, 'Thanksgiving',
PS 122, New York

1984
'Call and Response: Art on Central America',
Colby College, Waterville, Maine (group)

'Racist America',
Performance, 'A Trick'
Dramatis Personae Gallery, New York (group)

'Art Against Apartheid',
Abyssinian Baptist Church, New York (group)

1985
Returns full-time to his own work

'Forecast: Images of the Future',
Kenkeleba Gallery, New York (group)

'Bedia's First Basement',
22 Wooster Gallery, New York (solo)

l. to r., Jimmie Durham, Bambi Lamb, Diane Burns, Trina, Mashpee Chief, Pauline Haynes, 1978

Selected articles and interviews
1977-85

Jimmie Durham in his office in New York, 1977

Exhibitions and projects
1985-87

'New York Indian Perspectives',
American Indian Community House Gallery, New York
(group)

'Traditions and Modern Configurations',
AAA Art, New York and **Wake Forest University**,
Winston-Salem (group)

Performance, 'Manhattan Give-away',
Franklin Furnace, New York

'Personal History Public Address',
Minor Injury, Brooklyn, New York (group)

'Dimensions in Dissent',
Kenkeleba Gallery, New York (group)

'A Matter of Life and Death and Singing',
Alternative Museum, New York (solo)
Cat. *A Matter of Life and Death and Singing*, Alternative
Museum, New York, catalogue essay by Jimmie Durham

Poetry, 'Yellowbird', *Ikon*, Vol 2 No 1, New York

1986
John Jay College, New York (solo)

'Start Again',
Ground Zero, New York (group)

Text, 'Russell Means is Wrong', *The Washington Post*,
20 March

'New Art, New York',
Harlem School of the Arts, New York (group)

'Ni'Go Tlunh a Doh ka' (We Are Always Turning Around
on Purpose),
curated by Jimmie Durham and Jean Fisher, **State**
University of New York at Old Westbury, New York
toured to North Hall Gallery, Massachussetts College of
Art, Boston, **Central State University**, Edmond (group)
Cat. *Ni'go tlunh a doh ka*, State University of New York,
texts Jimmie Durham and Jean Fisher

'Por Encima El Bloqueo',
Museum del Chopo, Mexico City and **Centro Wifredo**
Lam, Havana, Cuba (group)

Kenkeleba Gallery, New York (group)

'Mixed Media, Mixed Mores',
U.S. Courthouse, New York (group)

Performance, 'The Death of Paul Smith',
Minor Injury Gallery, Brooklyn, New York

1987
Performance, 'I Want to Say Something',
La Mamma Theater, New York

'Rider with No Horse',
American Indian Gallery, New York (group)

'The Law and Order Show',

Selected articles and interviews
1985-87

Fredricks, Charles, *Upfront*, No 10, Fall, New York

Pekar, Harvey, *The Plain Dealer*, Cleveland, 30 January

A MATTER OF LIFE AND DEATH AND SINGING

JIMMIE DURHAM

Alternative Museum, December 19 — January 19, 1985

NEW ART
NEW YORK

I WANT TO SAY SOMETHING
(BI-LINGUAL EDUCATION)

A PERFORMANCE by Jimmie Durham
AT LA MAMA THEATER TWITAS FESTIVAL
MARCH 29, 1987 7:30 PM

TICKETS ON SALE AT LA MAMA BOX OFFICE, E.4 STREET, N.Y.C.
$10

AUTHENTIC HAND-MADE
INDIAN ANNOUNCEMENT

MIXED MEDIA
MIXED MORES

Warren Angle
Ethel Borg
Jimmie Durham
Marilyn J.S. Goodman
Faith Ringgold
Ushio Shinohara

Nov 7 — Jan 15, 1986
Reception: Nov 14 — 5:30-7:30

The U.S. Court House
at Foley Square

Sponsor: The Art Committee of the
Federal Bar Council

Curator: Jane Schneider

Exhibitions and projects
1987-89

John Weber Gallery, **Leo Castelli Gallery**, **Barbara Gladstone Gallery**, **Paula Cooper Gallery**, New York

'The Soaring Spirit',
Morris Museum, Morristown, New Jersey (group)

'We The People',
curated by Jimmie Durham and Jean Fisher, **Artists Space**, New York (group)
Cat. *We The People*, Artists Space, New York, texts Jean Fisher, Paul Smith, essay by Jimmie Durham 'Savage Attacks on White Women, As Usual'

Text, 'Those Dead Guys for a Hundred Years', in *I Tell You Now, Autobiographical Essays by Native American Writers*, editors Brian Swann and Arnold Krupat, University of Nebraska Press, Lincoln

1988
'Re-Visions',
Walter Phillips Gallery, Banff, Alberta, Canada (group)
Cat. *Re-Visions*, Walter Phillips Gallery, Banff, texts Deborah Doxtater, Jean Fisher, Rick Hill and Helga Pakasaar

'Acts of Faith',
toured to **Cleveland State University**, **Southeast Massachussetts University**, North Dartmouth (group)
Cat. *Acts of Faith*, text Lucy R. Lippard

'Pocahontas and the Little Carpenter in London',
Matt's Gallery, London (solo)
Cat. *Pocahontas and the Little Carpenter in London*, Matt's Gallery, London, text Jean Fisher, essay by Jimmie Durham 'A Certain Lack of Coherence'

Orchard Gallery, Derry, Northern Ireland
Broadsheet, '...*very much like the Wild Irish. Notes on a Process which has No End in Sight*', essay by Jimmie Durham, Orchard Gallery, Derry, Northern Ireland (solo)

Performance, 'Four Scenes for the British Army',
Orchard Gallery, Derry, Northern Ireland

Poetry, 'Four Poems', *Harper's Anthology of 20th Century Native American Poetry*, editions Duane Niatum, Harper & Row, New York and San Francisco

1989
'The Bishop's Moose and the Pinkerton Men',
Exit Art, New York toured to **Western Washington University**, Bellingham; **Museum of Civilization**, Hull, Quebec (solo)
Cat. *The Bishop's Moose and the Pinkerton Men*, Exit Art, New York, texts Papo Colo, Luis Cammitzer, Jean Fisher, Lucy R. Lippard and Jeanette Ingberman

Selected articles and interviews
1987-89

Lippard, Lucy, 'Holding Up a Mirror to America', *Guardian*, New York, 16 December, Vol 40, No 12

Fisher, Jean, 'The Health of the People of the Highest Law', *Third Text*, Winter, London

1988

Sparks, Amy, *Dialogue*, Cleveland, July/August

Currah, Mark, *Black Arts*, London, October
Currah, Mark, *City Limits*, London, 13 October
Currah, Mark, *Caribbean Times*, London, 14 October
Philipi, Desa, *Artscribe*, London, No 74, March 1989

Morgan, Marie, *Vanguard*, April, Canada
Schwendenwein, Jude, *Artscribe*, London, Summer

1989
Levin, Kim, *The Village Voice*, New York, 21 November
Hess, Elizabeth, 'Who is Jimmie Durham', *The Village Voice*, New York, December,
Friedman, Ann, 'Word Power', *Reflex*, Seattle, May 1990
Farr, Sheila, 'Scavenger and Sculptor', *The Bellingham Herald*, Bellingham, Washington, 25 February 1990
Jones, Amelia G, 'Jimmie Durham: Exit Art', *Artscribe*, London, March 1990
Reid, Calvin, 'Jimmie Durham: Exit Art', *Art in America*, New York, May 1990

RE·VISIONS

Jimmie Durham
Zach Kanak
Alan Michelson
Joane Cardinal-Schubert

Edgar Heap of Birds
Mike MacDonald
Edward Poitras
Pierre Sioui

January 8 - 28, 1988
public opening: January 7, 7:30 pm
panel discussion: January 8, 10:00 am

WALTER PHILLIPS GALLERY
Box 1020, Banff, AB. T0L 0C0 Canada
Tel: (403) 762-6281
Hours: 12 - 7 daily

The Banff Centre
Financial Assistance from The Canada Council

Pinkerton

Security Officer's
General Orders
And Regulations

MATAOKA AKE ATTAKULAKULA
ANEL GULEDISGO HNIHI

POCAHONTAS AND THE LITTLE CARPENTER IN LONDON

Jimmie Durham

MATT'S GALLERY
10th OCTOBER – 19th OCTOBER 1988

'The Reading Room', Exit Art, New York, 1989

Exhibitions and projects
1990-91

Performance, 'Hermeneutical Considerations of the
Bishops Moose', **Exit Art**, New York

1990
Actor in, *Color Schemes*, a film by Shu Lea Cheang,
New York

Performance, 'Crazy for Life', presented at **Dance
Theater Workshop**, New York as part of 'The Decade
Show', toured to **The Museum of Contemporary
Hispanic Art**, **The New Museum of Contemporary Art**,
The Studio Museum of Harlem (group)
Cat. *The Decade Show*, The New Museum of
Contemporary Art, New York, essay by Jimmie Durham,
'A Central Margin'

Performance, 'The Self-Taught Artist',
Exit Art, New York

Performance, 'Catskills Give-away',
Art Awareness Lexington, New York

'Savoir Faire, Savoir Vivre, Savoir Etre',
**Centre International d'Art Contemporain de
Montreal**, Québec, Canada (group)

Text, 'Cowboys and ...', essay in *Third Text*, No 12,
Autumn, London

Performance, 'Savagism and You',
Whitney Museum Downtown, New York

'Holy Wars',
Exit Art, New York (group)

Text, 'Cowboy S-M', essay in *New Observations*, No 80,
editons Dorothy Cross, New York, November

Performance, **Orchard Gallery**, Derry, Northern Ireland

1991
'Souvenir of Site Seeing; Travel and Tourism in
Contemporary Art',
Whitney Museum of American Art - Downtown (group)
Cat. *Souvenir of Site Seeing; Travel and Tourism in
Contemporary Art*, Whitney Museum of American Art,
New York, texts Jonathan Caseley, Karin M. Higa and
Pamela M Lee

Lecture, part of lecture series 'Rethinking Borders',
San Diego Museum of Contemporary Art, La Jolla,
California

Performance, 'Savage', Time Festival, **Museum van
Hedendaagse Kunst**, Gent, Belgium

'The Subversive Stitch',
Simon Watson, New York (group)

Selected articles and interviews
1990-91

1990

Duncan, Ann, *The Gazette*, Montréal, Canada, 1
September
Molin Vasseur, Anne, 'Ecol-logique, echo-politique:
savoir-vivre, savoir-faire, savoir-être', *etc.* Montreal,
No 13, December

Rushing, W. Jackson, 'Another Look at Contemporary
Native American Art', *New Art Examiner*, Chicago, Vol.
17, No 6, February
Smart, Paul, *Woodstock Times*, Woodstock, 28 June
Canning, Susan, 'Jimmie Durham', *Art Papers*, Atlanta
Vol 14, No 4

1991

Smith, Roberta, 'The Subversive Stitch', *The New York
Times*, 12 July

Exhibitions and projects
1991-92

'John Rollin Ridge, Zorro and the Joad Family Players',
The Luggage Store, San Francisco, California (solo)

'Jimmie Durham and Brian Tripp',
C. N. Gorman Museum, University of California, Davis,
California

'Spiritual Cargo: Shamanistic Manifestations',
Atrium Gallery, Connecticut (group)

'The Interrupted Life',
curated by France Morin, **The New Museum of
Contemporary Art**, New York (group)
Cat. *The Interrupted Life*, The New Museum of
Contemporary Art, New York, essay by Jimmie Durham,
'The Immortal State'

Text, 'Fast wie die wilden Iren' (German translation of
'...very much like the Wild Irish'), *Der offentliche Blick*,
Jahresring 38, Munchen, Verlag Silke Schreiber

Text, 'The Search for Virginity', essay in *The Myth of
Primitivism. Perspectives on Art*. Edited and compiled by
Susan Hiller, Routledge, London and New York

1992
Text, 'To be a Pilgrim: Walton Ford', *Artforum,* New
York, Vol. XXX, No 5, January

'America, Bride of the Sun, 500 Years Latin America
and the Low Countries',
Royal Museum of Fine Arts, Antwerp (group)
Cat. *America, Bride of the Sun*, Royal Museum of Fine
Arts, essay by Jean Fisher, 'The Savage Gift'

'Documenta IX',
Kassel, Germany (group)
Cat. *Documenta IX,* essay by Jimmie Durham, 'Approach
in Love and Fear'

'Dissent, Difference and the Body Politic',
Portland Art Museum, Oregon; **Otis Parsons School
of Art and Design**, Los Angeles (group)
Cat. *Dissent, Difference and the Body Politic*, Portland
Art Museum, Oregon, texts John S. Weber and Simon
Watson

Text, 'On the Edge of Town', essay in *Art Journal*, New
York, Vol 51, No. 2, Summer

'Will/Power',
Wexner Center for Visual Arts, Columbus, Ohio (group)
Cat. *Will/Power*, Wexner Center for Visual Arts, essay on
Jimmie Durham by Bart de Baere

'Land, Spirit, Power',
National Gallery of Canada, Ottawa (group)
Cat. *Land, Spirit, Power*, National Gallery of Canada,
text Diana Nemiroff, Robert Houle and Charlotte

Selected articles and interviews
1991-92

Milman, Barbara, 'Jimmie Durham and Brian Tripp',
Artweek, Davis, California, December, Vol 22, No 41
Moyle, Marilyn, 'Turbulence at home and abroad marks
show', *Enterprise Weekend*, Davis, California,
7 November

Smith, Roberta, 'The Faces of Death', *The New York
Times*, 13 September

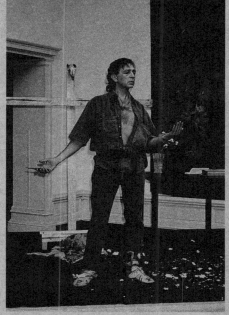

Savage, 1991, performance, 'Time Festival', Museum van
Hedendaagse Kunst, Ghent, Belgium

Cembalest, Robin, 'What's in a Name?', Indian Arts and
Crafts Act signed by President Bush, *Art News,* New
York, September
Pontello, Jacqueline, 'A Call to Harms', *Southwest Art*,
Vol 21, October

1992

Cameron, Dan, 'On the Road to Nowhere?', *Art and
Action*, USA, June
Kuijken, Ilse, Review, *Kunst and Museumjournaal*,
Amsterdam, Vol 3, No 6

Lippard, Lucy, 'Jimmie Durham: Postmodernist
'Savage', *Art in America*, New York, February 1993

Page from 'Cooking for Documenta IX', Kassel, 1992

Exhibitions and projects
1992-93

Townsend-Gault

'Regarding America (Ante America)',
Biblioteca Luis Angel Arango, Bogotá, Columbia;
Queens Museum of Art, New York (group)
Cat. *Regarding America (Ante America)*, Biblioteca Luis
Angel Arango, essay on Jimmie Durham by Rachel Weiss

'For the Seventh Generation: Native American Artists
Counter The Quincentenary',
Golden Artists Colors Gallery, Columbus, New York
(group)
Cat. *For the Seventh Generation: Native American Artists
Counter the Quincentenary*, Golden Artists Colors
Gallery, essay by Jimmie Durham, 'Savage Attacks on
White Women As Usual'

Nicole Klagsbrun Gallery, New York (solo)

'Mistaken Identities',
toured to **University Art Museum**, University of
California, Santa Barbara, California, **Museum
Folkwang**, Essen; **Forum Stadtpark**, Graz; **Neues
Museum Weserburg**, Bremen; **Louisiana Museum
of Modern Art**, Humlebaeck, Denmark (group)
Cat. *Mistaken Identities*, University of California,
text Abigail Solomon Godeau

Installation and performance with Maria Thereza Alves
and Alan Michelson, Edge 92 Festival, Madrid, London

Installation and performance with Maria Thereza Alves
at Museo de Monterry, Monterry, Mexico

Text, 'Geronimo', published in *Partial Recall:
Photographs of Native North Americans*, edited by Lucy
Lippard, The New Press, New York

Performance and installation, 'Edge 92', Madrid

1993
'Rendez (-) vous',
Museum van Hedendaagse Kunst, Ghent (with Ilya
Kabakov, Henk Visch, Huang Yong Ping) (group)
Cat. *Rendez(-)vous*, Cantz, Stuttgart, text Bart de
Baere with essays by the artists

'Whitney Biennial',
Whitney Museum of American Art, New York (group)
Cat. *Whitney Biennial*, Whitney Museum of American
Art, text Elisabeth Sussman

'Ricardo Brey, Jimmie Durham, Michelangelo
Pistoletto',
curated by Denys Zacharopoulos, **Centre d'Art du
Domaine de Kerguéhennec**, Bignan-Locminé, France
(group)

Selected articles and interviews
1992-93

Levin, Kim, *The Village Voice*, New York, 1 December
Mahoney, Robert, 'Jimmie Durham: Art World Word
Art', *Flash Art*, Milan, January/February, 1993, No 168

Jimmie Durham, Guillermo Gómez-Peña, Theresa Hak Kyung Cha, Connie Hatch, Mary Kelly, Glenn Ligon, Yong Soon Min, Adrian Piper, Armando Rascón, Marlon Riggs, Martha Rosler, Lorna Simpson, Mitra Tabrizian & Andy Golding, Carrie Mae Weems, Pat Ward Williams

FORUM STADTPARK GRAZ 30. 4. – 30. 5.1993, täglich 11 bis 18 h

Shiff, Richard, 'The Necessity of Jimmie Durham's
Jokes', *Art Journal*, New York, Autumn, Vol 51 No. 3
Rushing W., Jackson, 'Jimmie Durham. Trickster as
Intervention', *Artspace*, Los Angeles, January/April
Fisher, Jean, 'In Search of the Inauthentic: Disturbing
Signs in Contemporary Native American Art', *Art
Journal*, New York, Vol 51, Autumn

1993

Smith, Roberta, 'At the Whitney, a Biennial with a
Social Conscience', *The New York Times*, 5 March
Rush, Michael, 'New York, The 1993 Biennial
Exhibition', *Art*, New England, June/July
Margot, Mifflin, 'What do artists dream?' *Art News*, New
York, Vol 92, October

Zacharopoulos, Denys, 'The Unknown Magnitude', *Arti*,
Athens, Vol 17

'Jimmie Durham, David Hammons, Pedro Cabrita Reis',
Kunsthalle, Fribourg, Switzerland (group)

'Various Gates and Escape Routes',
L.A. Louver, Venice, California (solo)

Boller, Gabrielle, Review, *Artefactum*, Antwerp, Vol 2,
December/January
Crockett, Tobery, 'Terms of Endearment', *LA Village
View*, 10 - 16 September
Rugoff, Ralph, 'Laminated Warrior', *LA Weekly*, 10 - 16
September
Kandel, Susan, 'Durham's works Explore the Edge of
Absurdity', *Los Angeles Times*, 2 September
McKenna, Kristine, 'Money Can't Buy This Guy's Love',
Los Angeles Times/Calendar, 22 August
Urban, Hope, 'The Road to Nowhere', *Los Angeles
Reader*, 27 August
Muchnic, Suzanne, Review, *Art News*, New York, Vol 92,
December
Pagel, David, 'Jimmie Durham at L.A. Louver', *Art
Issues*, Los Angeles, November/December

Text, 'Covert Operations, A Discussion between Jimmie
Durham, Michael Taussig with Miwon Kwon and Helen
Molesworth', *Documents*, New York, Summer No. 3

'A Certain Lack of Coherence',
Palais des Beaux-Arts, Brussels (solo)

Bauwelinck, Bert, 'Jimmie Durham in Brussels PSK, Is
de nieuwe Beuys gearriveerd?', *Gazet van Antwerpen*,
28 November
de Boodt, Kurt, 'Wantrouw Simpele Samenhang', *Kunst
& Cultuur*, Belgium, December
de Kerchove, Fabrice, 'Visuele Valstrikken', *Kunst &
Cultuur*, Belgium, October
Vuegen, Christine, 'Jimmie Durham', *Deze Week*,
Brussels, 3 November

'On taking a normal situation and retranslating into
overlapping and multiple readings of conditions past
and present',
Museum of Contemporary Art Antwerp (MUHKA)
(group)
Cat. *On taking a normal situation and retranslating it
into overlapping and multiple readings of conditions
past and present*, MUHKA, texts Bart Cassiman, Carolyn
Christov-Bakargiev, Iwona Blazwick, Yves Aupetitallot,
Bruce Ferguson, Reesa Greenberg, Sandy Nairne, Homi
Bhabha, Mauro Ceruti and Hugo Soly

La Liberté Couverte, 1993

"*Vertrekken vanuit een normale situatie
en deze hervertalen
in elkaar overlappende en meervoudige lezingen
van condities uit heden en verleden*"

"*On taking a normal situation
and retranslating it
into overlapping and multiple readings
of conditions past and present*"

JUDITH BARRY
ZARINA BHIMJI
SYLVIA BOSSU
PATRICK CORILLON
FAUSTO DELLE CHIAIE
MARK DION
EUGENIO DITTBORN
JIMMIE DURHAM
MARIA EICHHORN
ANDREA FRASER
RENÉE GREEN
BETHAN HUWS
ANN VERONICA JANSSENS
LAURIE PARSONS
MATHIAS POLEDNA
LUCA VITONE

Book, '*A Certain Lack of Coherence - Writings on Art and
Cultural Politics*', Kala Press, London, edited by Jean
Fisher

Cubitt, Sean, 'A Certain Lack of Coherence: Writings on
Art and Cultural Politics', *frieze*, London, No 18,
September/October, 1994
hooks, bell, 'Book Forum – A Certain Lack of
Coherence', *Artforum*, New York, Summer, 1994

'Original Re-runs',
Institute of Contemporary Arts, London, toured to
Douglas Hyde Gallery, Dublin; **Kunstverein Hamburg**,
Germany (solo)
Book, *The East London Coelacanth*, ICA and Book Works
publishers, London, essay by Dan Cameron

Barker, Nicola, 'Strange tales of a moose head',
The Observer, London, 19 December
Feaver, William, 'Chasing the Cherokee tail', *The
Observer*, London, 9 January, 1994
Holmes, Brian, 'Original Re-runs', *Galleries Magazine*,
London, February/March, 1994
Gisbourne, Mark, 'Interview at the ICA', *Art Monthly*,
London, No 173, February, 1994
Curtis, Nick, 'Funny Peculiar', *The Independent*,
London, 17 December

Performance, **Institute of Contemporary Arts**, London

'States of Loss - Migration, Displacement, Colonialism,

Haller, Emanuel, 'Multi-ethnic exhibit focuses on

and Power',
Jersey City Museum, New Jersey (group)
Cat. *States of Loss*, Jersey City Museum, texts Gary
Sangster, Martha Rosler, Maria Davila, Amalia Mesa-
Bains and Michael Lipson

1994
'don't look now',
Thread Waxing Space, New York (group)
Cat. *don't look now*, Thread Waxing Space, text Joshua
Decter

'Outside the Frame: Performance Art and The Object',
Cleveland Center for Contemporary Art, Cleveland,
Ohio (group)
Cat. *Outside the Frame: Performance Art and The Object*,
Cleveland Center for Contemporary Art, Ohio, texts
Robyn Brentano and Olivia Georgia

Performance, 'Fire! Or, Imperialism!,' part of 'Outside
the Frame: Performance and The Object', Cleveland
Performance Art Festival at **Cleveland Center for
Contemporary Art,** Cleveland, Ohio

'Beelden Buiten '94',
Centrum Gildhof van Tielt, Belgium (group)
Cat. *Beelden Buiten '94*, Centrum Gildhof van Tielt,
texts Bart de Baere and Piet Vanrobaeys

Fire! Or, Imperialism!, 1994, performance, Cleveland Center
for Contemporary Art, Cleveland, Ohio

'Economies',
Galerie Roger Pailhas, Marseille (group)

Micheline Szwajcer Gallery, Antwerp, Belgium (solo)

'Ashley Bickerton, Jimmie Durham, Walton Ford,
Jeff Wall',
Nicole Klagsbrun Gallery, New York (group)

'Raw and Cooked' (Cocido y Crudo),
Museo Nacional Centro de Arte Reina Sofia, Madrid
(group)
Cat. *Cocido y Crudo*, Museo Nacional Centro de Arte
Reina Sofia, texts Dan Cameron, Mar Villaespesa,
Jerry Saltz, Jean Fisher and Gerardo Mosquera

'Faret Tachikawa Project',
Tokyo

'Transformers: The Art of Multiphrenia',
toured to **Center for Curatorial Studies**, Bard College,
Anandale; **Herbert F. Johnson Museum**, Cornell
University; **University of Michigan Museum of Art**
Cat. *Transformers*, Independent Curators
Incorporated, New York, text Ralph Rugoff

1995
'Ropa vieja Spring Collection',
Nicole Klagsbrun Gallery, New York (solo)

Modulo Centro Difusor de Arte, Lisbon (solo)

De Vleeshal, Middleburg, The Netherlands (solo)

Deprivation', *The Courier News*, 2 January 1994
Watkins, Eileen, 'Group Show Condemns Cultural Cost
of Colonialism', *The Sunday Star-Ledger*, 30 January,
1994

1994

Bauwelinck, Bert, 'Vingeroefeningen in een besloten
hofje in Tielt', *Gazet van Antwerpen*, 7 July
Ruyters, Marc, 'Beelden Buiten', *Knack Magazine
Weekend*, Belgium, 6 July
Lambrecht, Luk, 'Interessate tentoonstelling 'Beelden
Buiten' in Tielt', *De Morgen*, Belgium, 26 July

Risaliti, Sergio, 'Economie, Roger Pailhas, Marseilles',
Flash Art, Milan, No 179, November-December
Leturcq, Armelle, 'Economie, Galerie Roger Pailhas,
Marseille', *Metropolis. M*, France, No 5, October

Danvila, Jose Ramon, 'Arte global, fronteras rotas', *El
Mundo*, Madrid, 10 December
Bufill, Juan, 'Cortina, coche, camisa', *La Vanguardia*,
Spain, 18 December

Osborne, Catherine, 'Breathing Life into a City', *Asian
Art News*, New York, Vol 4, No 4, July/August

Aupetitallot, Yves, *On taking a normal situation and retranslating it into overlapping and multiple readings of conditions past and present*, 1993, MUHKA, Antwerp

de Baere, Bart, *Will/Power*, Werner Centre for Visual Arts, 1992

de Baere, Bart, *Rendez(-)vous*, Cantz, Stuttgart, 1993

de Baere, Bart, *Beelden Buiten '94*, Centrum Gildhof van Tielt, 1994

Blazwick, Iwona, *On taking a normal situation...*, MUHKA, Antwerp, 1993

Boller, Gabrielle, Review, *Artefactum*, Brussels, Vol 2, December/January, 1993

Brentano, Robyn, *Outside the Frame: Performance Art and The Object*, Cleveland Center for Contemporary Art, Ohio, 1994

Cameron, Dan, *The East London Coelacanth*, ICA and Book Works publishers, London, 1993

Cameron, Dan, *Cocido y Crudo*, Museo Nacional Centro de Arte Reina Sofia, 1994

Cammitzer, Luis, *The Bishop's Moose and the Pinkerton Men*, Exit Art, New York,1989

Canning, Susan, 'Jimmie Durham', *Art Papers*, Atlanta Vol 14, No4, 1990

Caseley, Jonathan, *Souvenir of Site Seeing; Travel and Tourism in Contemporary Art*, Whitney Museum of American Art, New York, 1991

Cassiman, Bart, *On taking a normal situation...*, MUHKA, Antwerp, 1993

Christov-Bakargiev, Carolyn, *On taking a normal situation...*, MUHKA, Antwerp, 1993

Colo, Papo, *The Bishop's Moose and the Pinkerton Men*, Exit Art, New York, 1989

Crockett, Tobery, 'Terms of Endearment', *LA Village View*, 10-16 September, 1993

Cubitt, Sean, 'A Certain Lack of Coherence: Writings on Art and Cultural Politics', *freize*, London, No 18, September/October, 1994

Currah, Mark, *Black Arts*, London, October, 1988

Currah, Mark, *Carribean Times*, London, 14 October, 1988

Danvila, Jose Ramon, 'Arte global, fronteras rotas', *El Mundo*, Spain, 10 December, 1994

Davila, Maria, *States of Loss*, Jersey City Museum, 1993

Decter, Joshua, *don't look now*, Thread Waxing Space, New York, 1994

Doxtater, Deborah, *Re-Visions*, Walter Philips Gallery, Banff, Canada, 1988

Durham, Jimmie, poetry published in *Adept*, No 1, No 2, No 3, Houston, Texas, 1964

Durham, Jimmie, 'TVA and the Snail Darter', *The Washington Post*, 9 April, 1975. Reprinted in *The Denver Post, San Francisco Chronicle* and the *Los Angeles Times*, 1975

Durham, Jimmie, 'Untitled Essay on Governmental Infiltration of the American Indian Movement', *Counterspy*, Vol 3 No 1, New York, 1976

Durham, Jimmie, 'Mr Catlin and Mr Rockefeller Tame the Wilderness', essay in An Anti-Catalogue, various editors, Artists for Cultural Change, New York, 1977

Durham, Jimmie, 'American Indians and Carter's Human Rights Sermons', *The Black Scholar*, Sausalito, San Francisco, 1979

Durham, Jimmie, 'Eloheh, or the Council of the Universe', *IFDA Dossier* No. 6, April, Lausanne, Switzerland. Published in French, Spanish, Portuguese, Italian, German, Finnish, 1979

Durham, Jimmie, poetry, 'Columbus Day', West End Press, Albuquerque, 1983

Durham, Jimmie, *A Matter of Life and Death and Singing*, Alternative Museum, New York, 1985

Durham, Jimmie, poetry, 'Yellowbird', *Ikon*, Vol 2 No 1, New York, 1985

Durham, Jimmie, *Ni'go tlunh a doh ka*, State University of New York, New York, 1986

Durham, Jimmie, 'Russell Means is Wrong', *The Washington Post*, 20 March, 1986

Durham, Jimmie, *We The People*, 'Savage Attacks on White Women, As Usual', Artists Space, New York, 1987

Durham, Jimmie, 'Those Dead Guys for a Hundred Years', *I Tell You Know: Autobiographical Essays by Native American Writers*, editors Brian Swann and Arnold Krupat, University of Nebraska Press, Lincoln, 1987

Durham, Jimmie, 'A Certain Lack of Coherence', *Pocahontas and the Little Carpenter in London*, Matt's Gallery, London, 1988

Durham, Jimmie, poetry, 'Four Poems', *Harper's Anthology of 20th Century Native American Poetry*, editions Duane Niatum, Harper & Row, New York and San Francisco, 1988

Durham, Jimmie, '...very much like the Wild Irish. Notes on a Process which has No End in Sight', Orchard Gallery, Derry, Northern Ireland, 1988

Durham, Jimmie, 'Here at the Centre of the World', *Third Text*, London, No 5, Winter 1988

Durham, Jimmie, 'Cowboys and ...', essay in *Third Text*, London, No 12, Autumn, 1990

Durham, Jimmie, 'Cowboy S-M', essay in *New Observations*, No 80, editions Dorothy Cross, New York, November, 1990

Durham, Jimmie, 'The Search for Virginity', The Myth of Primitivism, editor Susan Hiller, Routledge, London, 1991

Durham, Jimmie, 'The Immortal State', *The Interrupted Life*, The New Museum of Contemporary Art, New York, 1991

Durham, Jimmie, poetry, 'To be a Pilgrim: Walton Ford', *Artforum*, New York, Vol. XXX, No 5, January, 1992

Durham, Jimmie, 'On the Edge of Town', essay in *Art Journal*, New York, Vol 51, No. 2, Summer, 1992

Durham, Jimmie, 'Approach in Love and Fear', *Documenta IX*, Kassel, 1992

Durham, Jimmie,'Legal Aliens', *The Hybrid State*, editor Papo Colo, Exit Art, New York, 1992

Durham, Jimmie, 'Geronimo!', *Partial Recall:Photographs of Native North Americans*, editor Lucy Lippard, The New Press, New York, 1992

Durham, Jimmie, *We The People*, 'Savage Attacks on White Women, As Usual', Artists Space, New York, 1987

Durham, Jimmie, *'A Certain Lack of Coherence – Writings on Art and Cultural Politics'*, editor Jean Fisher, Kala Press, London, 1993

Durham, Jimmie, 'Covert Operations, A Discussion between Jimmie Durham, Michael Taussig with Miwon Kwon and Helen Molesworth', *Documents*, New York, Summer No. 3, 1993

Feaver, William, 'Chasing the Cherokee tail', *The Observer*, London, 9 January, 1994

Fisher, Jean, *Ni'go tlunh a doh ka*, State University of New York, New York, 1986

Fisher, Jean, *We The People*, Artists Space, New York, 1987

Fisher, Jean, 'The Health of the People of the Highest Law', *Third Text*, Winter, London, 1987

Fisher, Jean, *Re-Visions*, Walter Philips Gallery, Banff, Canada, 1988

Fisher, Jean, *Pocahontas and the Little Carpenter in London*, Matt's Gallery, London, 1988

Fisher, Jean, *The Bishop's Moose and the Pinkerton Men*, Exit Art, New York, 1989

Fisher, Jean, 'The Savage Gift', *America, Bride of the Sun*, Royal Museum of Fine Arts, Antwerp, 1992

Fisher, Jean, 'In Search of the Inauthentic: Disturbing Signs in Contemporary Native American Art', *Art Journal*, New York, Vol 51, Autumn, 1992

Fisher, Jean, *Cocido y Crudo*, Museo Nacional Centro de Arte Reina Sofia, Madrid, 1994

Fredricks, Charles, *Upfront*, No 10, Fall, New York, 1985

Friedman, Ann, 'Word Power', *Reflex*, Seattle, May 1990

Georgia, Olivia, *Outside the Frame: Performance Art and The Object*, Cleveland Center for Contemporary Art, Ohio, 1994

Gisbourne, Mark, 'Interview at the ICA', *Art Monthly*, London, No 173, February, 1994

Godeau, Abigail Solomon, *Mistaken Identities*, University of California, 1992

Hess, Elizabeth, 'Who is Jimmie Durham', *The Village Voice*, New York, December, 1989

Higa, Karin M., *Souvenir of Site Seeing; Travel and Tourism in Contemporary Art*, Whitney Museum of American Art, New York, 1991

Hill, Rick, *Re-Visions*, Walter Philips Gallery, Banff, Canada, 1988

hooks, bell, 'Book Forum – A Certain Lack of Coherence', *Artforum*, New York, Summer, 1994

Houle, Robert, *Land, Spirit, Power*, National Gallery of Canada, 1992

Ingberman, Jeanette, *The Bishop's Moose and the Pinkerton Men*, Exit Art, New York, 1989

Jones, Amelia G, 'Jimmie Durham: Exit Art', *Artscribe*, London, March 1990

Kandel, Susan, 'Durham's works Explore the Edge of Absurdity', *Los Angeles Times*, 2 September, 1993

de Kerchove, Fabrice, 'Visuele Valstrikker', *Kunst & Cultuur*, October, 1993

Lambrecht, Luk, 'Interessate tentoonstelling 'Beelden Buiten' in Tielt', *De Morgen*, Belgium, 26 July

Lee, Pamela M., *Souvenir of Site Seeing; Travel and Tourism in Contemporary Art*, Whitney Museum of American Art, New York, 1991

Leturcq, Armelle, 'Economie, Galerie Roger Pailhas, Marseille', *Metropolis. M*, France, No 5, October

Levin, Kim, *The Village Voice*, New York, 21 November, 1989

Levin, Kim, *The Village Voice*, New York, 1 December, 1992

Lippard, Lucy, 'Holding Up a Mirror to America', *Guardian*, New York, 16 December, Vol 40, No 12, 1987

Lippard, Lucy R., *Acts of Faith*, Cleveland State University, 1988

Lippard, Lucy R., *The Bishop's Moose and the Pinkerton Men*, Exit Art, New York, 1989

Lipson, Michael, *States of Loss*, Jersey City Museum, 1993

Mahoney, Robert, 'Jimmie Durham: Art World Word Art', *Flash Art*, Milan, January/February, 1993, No 168

Margot, Mifflin, 'What do artists dream?' *Art News*, New York, Vol 92, October, 1993

Mesa-Bains, Amalia, *States of Loss*, Jersey City Museum, 1993

Molin Vasseur, Anne, 'Ecol-logique, echo-politique: savoir-vivre, savoir-faire, savoir-être', *etc.* Montréal, No 13, December, 1990

Morgan, Marie, *Vanguard*, April, Canada, 1988

Mosquera, Gerardo, *Cocido y Crudo*, Museo Nacional Centro de Arte Reina Sofia, Madrid, 1994

Muchnic, Suzanne, Review, *Art News*, New York, Vol 92, December, 1993

Nemiroff, Diana, *Land, Spirit, Power*, National Gallery of Canada, 1992

Osborne, Catherine, 'Breathing Life into a City', *Asian Art News*, New York, Vol 4, No 4, July/August

Pagel, David, 'Jimmie Durham at L.A. Louver', *Art Issues*, Los Angeles, November/December, 1993

Pakasaar, Helga, *Re-Visions*, Walter Philips Gallery, Banff, Canada, 1988

Philipi, Desa, *Artscribe*, London, No 74, March 1989

Reid, Calvin, 'Jimmie Durham: Exit Art', *Art in America*, New York, May 1990

Risaliti, Sergio, 'Economie, Roger Pailhas, Marseilles', *Flash Art*, Milan, No 179, November-December, 1994

Rosler, Martha, *States of Loss*, Jersey City Museum, 1993

Rugoff, Ralph, 'Laminated Warrior', *LA Weekly*, 10-16 September, 1993

Rush, Michael, 'New York, The 1993 Biennial Exhibition', *Art*, New England, June/July, 1993

Rushing, W. Jackson, 'Another Look at Contemporary Native American Art', *New Art Examiner*, Chicago, Vol. 17, No 6, February, 1990

Rushing W., Jackson, 'Jimmie Durham. Trickster as Intervention', *Artspace*, Los Angeles, January/April, 1992

Saltz, Jerry, *Cocido y Crudo*, Museo Nacional Centro de Arte Reina Sofia, Madrid, 1994

Sangster, Gary, *States of Loss*, Jersey City Museum, 1993

Schwendenwein, Jude, *Artscribe*, London, Summer, 1988

Shiff, Richard, 'The Necessity of Jimmie Durham's Jokes', *Art Journal*, New York, Autumn, Vol 51, No. 3, 1992

Smith, Paul, *We The People*, 'Savage Attacks on White Women, As Usual', Artists Space, New York, 1987

Smith, Roberta, 'The Subversive Stitch', *The New York Times*, 12 July

Smith, Roberta, 'At the Whitney, a Biennial with a Social Conscience', *The New York Times*, 5 March, 1993

Sussman, Elisabeth, *Whitney Biennale*, Whitney Museum of American Art, 1993

Townsend-Gault, Charlotte, *Land, Spirit, Power*, National Gallery of Canada, 1992

Vanrobaeys, Piet, *Beelden Buiten '94*, Centrum Gildhof van Tielt, 1994

Villaespesa, Mar, *Cocido y Crudo*, Museo Nacional Centro de Arte Reina Sofia, Madrid, 1994

Watson, Simon, *Dissent, Difference and the Body Politic*, Portland Art Museum, Oregon, 1992

Weber, John S., *Dissent, Difference and the Body Politic*, Portland Art Museum, Oregon, 1992

Weiss, Rachel, *Regarding America (Ante America)*, Biblioteca Luis Angel Arango, Bogatá, 1992

Public Collections

Museum van Hedendaagse Kunst, Antwerp
The Art Institute of Chicago, Chicago
Denver Art Museum, Denver
Wexner Center for the Arts, Columbus, Ohio
Irish Museum of Modern Art, Dublin
Vleeshal Museum, Middelberg, The Netherlands
Whitney Museum of American Art, New York City
San Diego Museum of Contemporary Art, San Diego
Faret Tachikawa, Tokyo